MODERN ART AT THE BORDER OF MIND AND BRAIN

MODERN ART AT THE BORDER OF MIND AND BRAIN

JONATHAN FINEBERG | FOREWORD BY JAMES B. MILLIKEN

UNIVERSITY OF NEBRASKA PRESS | LINCOLN AND LONDON

Support for this publication
is generously provided by the
Office of the President of the
University of Nebraska. ∞

Library of Congress
Cataloging-in-Publication Data
Fineberg, Jonathan David.
[Lectures. Selections]
Modern art at the border of
mind and brain / Jonathan
Fineberg; Foreword by
James B. Milliken.
pages cm
Public lectures delivered
at two separate venues, the
Sheldon Art Museum in
Lincoln, Nebraska, and
Kaneko, in Omaha, Nebraska.
Includes bibliographical
references and index.
ISBN 978-0-8032-4973-8 (cloth:
alk. paper) 1. Art, Modern—
20th century—Psychology.
2. Art, Modern—21st century—
Psychology. I. Title.
N6490.F536 2015
709.04—dc23 2014039234

Set and designed in
Granjon by N. Putens.

contents

foreword

James B. Milliken, former president of the University of Nebraska

Early in my presidency I discovered that one satisfying way to put my own, if limited, stamp on the University of Nebraska was to name a small number of visiting presidential professors who would add to the intellectual life of the university and the community. While I didn't know it at the time, the last such appointment I would make was Jonathan Fineberg. Jonathan is a gifted scholar, a passionate teacher, and a good friend. I could not have asked for a better final act.

As is the case with many good things in my life, my introduction to Jonathan was occasioned by my wife, Nana Smith. Nana had gone to Yale to study art and had the good fortune to be assigned to Timothy Dwight College, the residential college where Jonathan lived at the time with his wife, Marianne Malone Fineberg, and their new baby girl, Maya. Jonathan was a young assistant professor in art history, and in addition to chaperoning undergraduates, including a number of members of the Yale football team, he created and led an innovative seminar on contemporary art. Nana and her classmates had the good fortune to be not only taught by one of the most talented modern art historians of his generation but also taken on Saturday excursions to New York in a rented van to visit the studios and galleries of signifi-cant emerging artists—including Christo and Jeanne-Claude, William Wegman, Alice Aycock, Elizabeth Murray, David Salle, and Julian Schnabel—many of whom Jonathan knew well enough to arrange a personal audience with his crew of undergraduates.

I met Jonathan years later and we spent time together at Art Basel—Miami, at his ambitious Illinois at the Phillips program in Wash-ington DC, and at reunions at Yale. When he took early retirement at the University of Illinois to spend time on his many other projects, I

realized opportunity and good fortune had arrived. We quickly settled on a yearlong appointment at Nebraska that would involve class lectures, critiques, and a series of four public lectures that would be published in a special volume.

Jonathan took to the project as he does everything—with ambition, energy, and contagious good humor. When he announced early on that one thing he really wanted to do was spend time with neuroscientists at our medical center, I was a little uneasy. I wasn't sure how a group of busy scientists would react. The first meeting was terrific—according to Jonathan —or unusual, if somewhat intriguing, according to the neuroscientists in attendance. As usual, through his intelligence, enthusiasm, and good humor, Jonathan prevailed. The ultimate verdict, all around, was that this association was fabulous. Last I heard, Jonathan and the chair of neuroscience were planning to work on a book together.

I was especially pleased with the public lectures, which are contained in this book. They were delivered at two separate venues — the Sheldon Art Museum, the university's outstanding museum of modern American art in Lincoln, and Kaneko, a more recent venture in Omaha launched by the artist Jun Kaneko and his wife, Ree, to promote creativity across disciplines. I am proud of the university's role in this endeavor — namely, providing the occasion for Jonathan to finish a project that had been knocking around in his head for years. What a treat for our students, faculty, and community. And I am proud that the university's own exceptional press is the publisher of this handsome volume memorializing Jonathan's important lectures. I couldn't ask for anything more.

MODERN ART AT THE BORDER OF MIND AND BRAIN

introduction

When I blow, I think of times and things from outa the past that gives me an image of the tune. Like moving pictures passing in front of my eyes. A town, a chick somewhere back down the line, an old man with no name you seen once in a place you don't remember.

—LOUIS ARMSTRONG

Images help us to organize our thoughts and to represent them in our memory. Humans have made images continuously for more than thirty thousand years;[1] the paintings on the walls of the cave at Chauvet, in the South of France, are between six and ten times older than the first known form of written language. We are still making images, I believe, because we need them. We need them to structure our social and psychological concepts of ourselves, and I think that we literally need them to develop the circuitry of our brains. We see the evidence for this over time and across cultures.

A carver in the Kongo made the *n'kisi n'kondi* figure illustrated here in the late nineteenth century. He hollowed out a cavity in its belly: *n'kisi*, the container of the spirit. The upraised arm originally held a spear: *n'kondi*, the hunter who tracks down wrongdoers. A ritual expert placed potent ingredients inside the abdomen for magic and medicine and to enforce legal judgments; then he activated them by blowing on them and sealed them off with a mirror. *Mambu* in the language of the Kongo is a law trial, and each time a dispute was settled in *mambu* an iron spike was driven into this figure to absorb the anger and reorganize the emotions and relations within the community. With every spike,

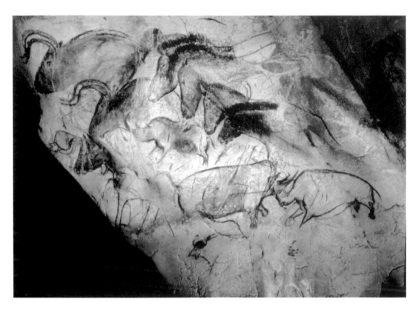

1. Chauvet cave, Ardèche, southern France. Ca. 28,000 BCE. Photo: French Ministry of Culture and Communication, Regional Direction for Cultural Affairs—Rhône-Alpes.

the figure assumes additional authority by absorbing the power of that anger, added to all the power accumulated from previous proceedings. The great Africanist Robert Farris Thompson wrote,

> The specialist takes a blade and drives it into the wooden image to seal a particular covenant or to end an affliction by bringing destruction upon an antisocial being. To nail in one kind of blade can bring an end to an argument about palm wine; nailing a peg can "tie" a matter down; driving a heavy nail of iron deep into an object can signify something serious like a murder. Often the blades and nails indicate that a particular source of hostility has been lifted due to arbitration, and that the formerly opposed parties have sworn in the name of the avenging (literally "hunting") spirit in the *n'kondi* to bind themselves to peace and cooperation. As they do so (or swear to cooperate) they may lick the blade of iron before it is inserted in the image. Should they break the vow, the spirit in the image knows, through traces of the saliva on the iron (or by some other kind of tied-on clue), exactly whom to annihilate or punish, according to the seriousness of the oath or vow.[2]

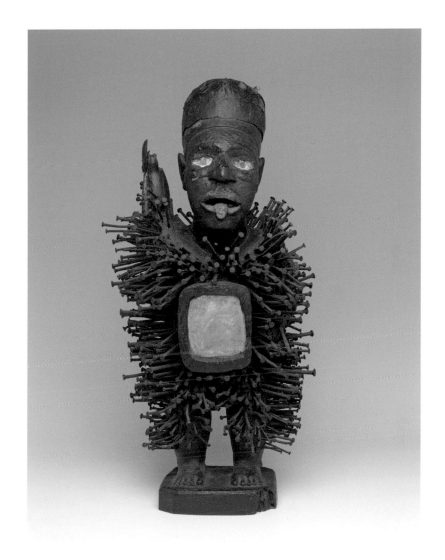

2. Kongo (Solongo or Woyo subgroup), *Power Figure (N'kisi N'kondi)*. Late nineteenth—early twentieth century. Wood, iron, glass, fiber, pigment, bone, 24 in. × 6½ in. × 8½ in. (61.5 cm × 17.0 cm × 21.5 cm). Brooklyn Museum. Gift of Arturo and Paul Peralta-Ramos, 56.6.98.

In the *n'kisi n'kondi*, forms interact in meaningful ways, representing power and specific emotions, yet the representations are abstract. The shapes and materials embody unseen forces (whether we believe that they come from magic or from the unconscious). The *n'kisi* is an object that helps those who believe in its power to reorder themselves

psychologically and socially. This book looks at the ways in which people make and use works of art and why it is that we continue to need them. It lays out a point of view about visual thinking, grounded in paradigmatic examples from the work of specific artists, and it offers some thoughts on what the use of images tell us about the evolving structure of our brains.

I have spent fifty years hanging out in artists' studios, including the studios of some very great artists like Robert Motherwell, Christo and Jeanne-Claude, Robert Arneson, and Elizabeth Murray, whose works appear among the examples in the pages that follow. This book begins, as I began at the outset of my career, by using the tools of psychoanalysis to describe the representational power of abstract forms and the dynamics of their interactions. In an essay for *Artforum* written in 1978, I drew on several years of conversations with my friend Robert Motherwell to articulate a specific iconography in his abstraction.[3] The objective was to illuminate the language of form, not the personal psychology of the artist, and the first chapter in this book, based on that essay, points to the distinction between the person of the artist and the independent integrity of the work of art as an object of knowledge. It focuses on the idea that abstraction has an iconography that may be as nuanced and specific as representation.

At this point the neurobiologist is becoming impatient for me to define my terms—and with good reason. In art criticism we take for granted that we know what we mean by "form." We use the term "form" almost interchangeably with "shape" in describing a collection of lines, colors, textures that cohere into something that seems to aggregate in a stable way in our perception of a work of art. Stepping back to a larger view, we sometimes use the term to describe the recognizable protocols that govern and bring coherence to the making of a work as a whole. We also distinguish between "abstract" and "representational" form in art, reserving the latter to designate those forms that we perceive as visual analogs for discrete physical entities that are (or that we imagine could be) in the world. For this we draw on our memory, on genetic endowments for connecting certain patterns with meanings (the way a baby recognizes a face, for example), and on current input from our senses. But the more we understand about vision the more clearly we

recognize that vision is a creative act of putting together many different bits of memory, sense data, and programmed pattern recognition into a concept of what it is we are seeing.

As we function in the world on a rudimentary level we are in much agreement about what we see. But as we address things with greater nuance our perceptions begin to diverge and we formulate interpretations that are increasingly individualized. The ways in which we connect the data of memory and sensation may vary considerably from person to person and even from time to time for any single person. Moreover, those interactions within the brain seem to create new meanings as connections are made such that our perceptions are always evolving and consist of more than the sum of the parts. I will occasionally use the term "significant form" in the chapters that follow to emphasize the specificity of meanings attached to a form in a particular work of art, with a particular artist or circumstance. This subjectivity of perception and its implications for what we understand "form" to mean is another, important layer of this book that I will leave largely implicit until chapter 4, when I attempt pick up the threads developed in the preceding chapters to understand Dubuffet's conceptual protocols. The way in which data aggregates into form in the brain is nevertheless crucial in how forms interact (the subject of chapter 2) and in how people apprehend form (chapter 3); it is my hope that the reader will keep this set of questions in mind as I build toward that final chapter.[4]

Realizing, in chapter 1, that without imitating the appearance of nature a visual form can nevertheless articulate a specific and profound content, even if we can't describe it in words, led me to the second chapter in this book. There I use psychoanalytic theory again to set out the grammar with which abstract visual thoughts can interact—a grammar that Sigmund Freud thought impossible to find. Using as a starting point the artistic exchange between Alexander Calder and Joan Miró, I attempt to set out the psychodynamics of form as a language of the unconscious, taking up the psychic mechanisms of visual thinking as I have come to understand them. Much of what Calder and Miró "said" to one another, they seem to have said through their materials. In this second chapter I illuminate the way in which the work of art physically embodies psychic processes and symbolic content and

allows us to articulate thoughts in form. I will suggest that the artist reorganizes her or his unconscious by consciously reordering the elements in the work and then reintrojecting that revised structure into the unconscious organization.

Freud had his own reasons for arguing against the idea that abstract form in art articulates unconscious experience sufficiently to constitute a language. He began collecting art—significantly only antiquities—immediately after the death of his father in 1896. He went to see the *Moses* of Michelangelo in 1901 on a trip to Rome and famously wrote about it in the autumn of 1913 (at the same time as he was working on his famous volume *Totem and Taboo*, which applies psychoanalytic methods to anthropology and religion). But he published his 1913 essay on "The *Moses* of Michelangelo" anonymously in *Imago* and didn't attach his name to it until 1924.[5] "Works of art do exercise a powerful effect on me," he wrote at the beginning of that essay.

> This has occasioned me, when I have been contemplating such things, to spend a long time before them trying to apprehend them in my own way, i.e. to explain to myself what their effect is due to. Wherever I cannot do this, as for instance with music, I am almost incapable of obtaining any pleasure. Some rationalistic, or perhaps analytic, turn of mind in me rebels against being moved by a thing without knowing why I am thus affected and what it is that affects me. This has brought me to recognize the apparently paradoxical fact that precisely some of the grandest and most overwhelming creations of art are still unsolved riddles in our understanding. We admire them, we feel overawed by them. But we are unable to say what they represent to us.[6]

Freud went on to say that "this state of intellectual bewilderment is a necessary condition when a work of art is to achieve its greatest effects." And yet "it would be only with the greatest reluctance that I could bring myself to believe in any such necessity."[7]

What Freud describes in his own response to a great work of art is a central subject of this book. It may have been the of loss of control that caused Freud to avoid the "overwhelming" experience of art and prevent him from ever writing about any of the magnificent

contemporary art that was burgeoning all around him in turn-of-the-century Vienna—Gustav Klimt, Oskar Kokoschka, Egon Schiele, and the ubiquitous work of the Vienna Secession. Great works of art, I will argue in the pages that follow, are profoundly disjunctive, and that is precisely their value. In *The Use of Poetry and the Use of Criticism*, T. S. Eliot wrote that "poetry may help to break the conventional mode of perception and valuation . . . and make people see the world afresh, or some new part of it. It may make us from time to time a little more aware of the deeper, unnamed feelings which form the substratum of our being, to which we rarely penetrate; for our lives are mostly a constant evasion of ourselves and an evasion of the visible and sensible world."[8] In chapter 2 I address the dynamics of how this occurs.[9]

If we can talk about an iconography in abstract form—the way in which form articulates the ineffable and sometimes unspeakable content of the unconscious (chapter 1)—and we understand that works of art can open the unconscious to a conscious intervention in reorganizing our sense of the self (chapter 2), then we can talk in a more profound way about the political and social dimensions of art. That is the subject of chapter 3. As Plato notes in *The Republic*, "The modes of music are never disturbed without unsettling of the most fundamental political and social conventions."[10] In chapter 3 I look at how great works of art take us to the threshold of our tolerance for seeing what is new and bewildering about the world and how they help us reorganize our feelings so as to perceive and respond to change.

In this third chapter, I have extended my inquiry on visual symbolization and grammar into the social realm and into politics. In 1926 Mahatma Gandhi wrote that "truth (*satya*) implies love, and firmness (*agraha*) engenders and therefore serves as a synonym for force. I thus began to call the Indian movement '*satyagraha*,' that is to say, the force which is born of truth and love or non-violence, and gave up the use of the phrase 'passive resistance.'"[11] The kind of truth force to which Gandhi refers is the collective power of martialing common pressures that are widely felt by individuals in a society at a given moment and reorganizing them in order to reintegrate individual identity in the changing circumstances of the world. Erik Erikson's book *Gandhi's Truth* argued that in this way a charismatic individual, solving his

or her own psychic conflicts in public, may create a contagious reformulation of identity that leads to ideology.[12] I use Erikson's model to understand the public apprehension of charismatic works of art. Based on my extensive interviews with police, lawyers, waiters, local business people, bystanders, and workers at several of the large-scale art projects by Christo and Jeanne-Claude, as well as my many conversations with the artists themselves, I employ this idea of "truth force" as a way of understanding the political and social impact of art. Those qualities of works that are *not* overtly political are precisely, I will argue, the means by which great works of art render their most profound impact on social and political values.

The fourth and final chapter of this book, "Desire Lines in the Mind," draws on recent work in neuroscience and experimental psychology in combination with the remarkably lucid commentary by the French artist Jean Dubuffet on his own mental processes in the act of painting. Chapter 4 centers on how works of art may alter neural pathways and change the structure of the brain, enhance creativity, and play a central role in the creation of new knowledge. In a 2001 article in *Science*, the neurobiologist Semir Zeki pointed out that the evolutionary function of the visual brain is to seek knowledge of the constant and essential properties of things in the world. Yet the input of information through the senses constantly changes. Thus the brain has to hypothesize the defining qualities of objects and each individual is inherently creative in making sense of visual experience, he explains.[13] Chapter 4 brings together Dubuffet's late works and writings to help us grasp the new work on the science of the brain. As Michael Gazzaniga, the author of a standard text on cognitive neuroscience, has written, "Thinking affects the development of the brain."[14] So, I am arguing, does looking, and in addition, I am proposing that looking is a form of thinking. The complex contribution of how we see to who we think we are and what we think we know has broad implications for education—across all disciplines—and for why human society continues to need works of art.

1

motherwell's mother

AN ICONOGRAPHY IN ABSTRACTION

In 1947 the painter Robert Motherwell wrote in the artist's statement for his second solo exhibition at the Kootz Gallery in New York, "For me the medium of oil painting resists, more strongly than others, content cut off from external relations. It continually threatens, because of its motility and subtlety, to complicate a work beyond the simplicity inherent in a high order of abstraction. I attribute my increasing devotion to oil, lately as against the constructionalism of collage, to a greater involvement in the human world. A shift in one's human situation entails a shift in one's technique and subject matter."[1]

I met Motherwell just as I was finishing my doctoral degree in art history in the early 1970s. I began spending a good deal of time with him in his studios in Greenwich, Connecticut, and Provincetown, Massachusetts, and we got to know one another well, quite quickly, and spoke at length about his life and work. In particular, I asked about certain recurring formal motifs in his abstract painting, and in the course of those conversations it became clear to us both that these forms correlated with specific content from his personal history, that his "technique and subject matter" were profoundly engaged with his "human situation."

Although we shared a deep interest in psychoanalysis and relied on its methods to parse the forms in his work, the objective was never to psychoanalyze Motherwell.[2] Rather, what was at stake was a methodological question that relied on understanding the simultaneous independence and codependence of the subject matter of the paintings and his life experience. What he had managed to do—and it was a brilliant achievement—was to transform content from his childhood memories and from his unconscious conflicts to make a body of great paintings in which others could find meaning and value.

Great paintings express a healthy function of the ego, and they are not identical with the unconscious of the artist, even though they derive content from it. This needs repeating here because in what follows I will delve deeply into details of personal history to understand how the abstract forms in these works carry such a complex and specific iconography. The temptation to see this material as symptoms of a neurosis is great, not least because my methods are founded in a clinical discipline. However, the artist has selectively reconstituted that substance and embodied it in the form of objects that stand on their own and satisfy a variety of conscious intellectual criteria.

Works of art represent conscious thought and knowledge in their formal structure and in their deliberate reference to the history of art and to other sources of subject matter. But every artist also exploits unconscious elements both in her- or himself and in the viewer. Psychoanalytic methods, which assume that no human act, conscious or unconscious, reasoned or irrational, is unintended on some level, permit a sophisticated unveiling of meanings inherent in the structure of artworks.

Motherwell entered into his own psychoanalysis in September 1949 with Dr. Montague Ullman, whom he continued to see off and on for forty-two years.[3] In between, he also saw other New York analysts, in particular Dr. Hans Kleinschmidt, who treated him for five years in the middle sixties and published a perceptive journal article in 1967 about artistic creativity based on the case of "an artist."[4] In it Kleinschmidt points out that "to view the heightened accessibility of infantile material and the marked mobility of cathexis merely in terms of a controlled regression in the service of the ego limits understanding of the creative process.[5] It diminishes creative achievement to one-dimensional language."[6] He goes on to describe "the complexity of the creative process as the result of many possible levels of integration lying *side by side*, which may be the secret of their availability to the artist, because such an artistic achievement represents a high level of integration."[7] But this does not mean, he says, that artists can achieve the same level of integration personally that they achieve in their art. Nevertheless, he likens the work of art to myth, which "seeks to make meaningful and acceptable man's continued failure to achieve perfect ego integration."[8]

While my conversations with Motherwell demonstrated to us both that his abstract painting had a detailed and deliberate iconography, it nevertheless also became clear that although we could talk around much of the meaning embodied in those forms, neither of us could fully articulate that content in words, as Freud had said in writing about "The *Moses* of Michelangelo."[9] Much of the meaning was consciously developed and perceived, but irreducibly visual. That difficulty exists in representational painting too, of course, but there, at least, the critic can begin with an explicit subject. The problem of talking about content in abstract painting, on the other hand, has driven most writers to remain on the level of formal analysis, even as they and the artist acknowledge a deeper level of meaning.

The literature on Motherwell's painting is a case in point; it treats his art largely in intellectual and formal terms. The temptation to do so in Motherwell's case is particularly great, not only because of the inaccessibility of the expressive content to verbal account but because of the artist's methods. He explored the primary visual ideas in his paintings with the precision of a philosopher testing a hypothesis. Like Freud, Motherwell used his powerful analytic tools to keep a bewildering content at bay.

In Motherwell's oeuvre, an individual motif might reappear over and over in one painting after another, each time altered in context and form. The investigation of a single shape or organizational principle often persisted in this way over time, and the presence of such recurrent motifs unites a given group of paintings into one of Motherwell's extended and titled series. One immediately recognizes a work from the *Open* series, for example, by the three-sided box or window motif coming down from the top of the picture, even though the *Open* paintings vary widely in mood and character.

Open No. 24: In Variations of Orange (1968) has a lush and exuberant richness of color, subtly playing "variations of orange" off against one another. *In Plato's Cave No. 1*, from 1972, expresses another, quite different mood; it is brooding in its sober abstinence from color and in the contemplative shadows that evoke the philosopher's cave.

Window over Madrid (1974), another painting from the *Open* series, asserts the defining motif by way of its erasure. Here the artist paints

3. Robert Motherwell, *Open No. 24: In Variations of Orange*. 1968. Acrylic and charcoal on canvas, 81 in. × 108¼ in. (205.7 cm × 275 cm). Museum of Modern Art, New York. Gift of the artist. © 2015 Dedalus Foundation, Inc. / Licensed by VAGA, New York.

4. Robert Motherwell, *In Plato's Cave No. 1*. 1972. Acrylic and charcoal on canvas, 72 in. × 96 in. National Gallery of Art, Washington DC. The Nancy Lee and Perry Bass Fund. © 2015 Dedalus Foundation, Inc. / Licensed by VAGA, New York.

5. Robert Motherwell, *Window over Madrid*. 1974. Acrylic on canvas, 90 in. × 120¼ in. North Carolina Museum of Art, Raleigh. Purchased with funds from the North Carolina State Art Society (Robert F. Phifer bequest) and Arthur Leroy and Lila Fisher Caldwell, by exchange, and gift of the Dedalus Foundation, Inc. © 2015 Dedalus Foundation, Inc. / Licensed by VAGA, New York.

in the three-sided box, disguising it with heavily worked patterns of brushstrokes that dissipate the definition of the geometric order and focus our attention on the semantic exercise, for all of the evident emotionalism. Motherwell overlays the architecture with vigorously expressive gestures, replicates boxes within boxes to complicate the structural system, and begins to paint out the earthy red background with ominous blacks and grays. Erasure, absence, and loss are pervasively important themes in Motherwell's work.

The sobriety of the palette in *Window over Madrid*, as well as the reference to Spain in the title, links the generative train of thought underlying this picture to Motherwell's most famous series, his *Elegy to the Spanish Republic* paintings, characterized by a structural order

6. Robert Motherwell, *Elegy to the Spanish Republic No. 78*. 1962. Oil and acrylic on canvas, 71 in. × 132¼ in. Yale University Art Gallery. Gift of the artist. © 2015 Dedalus Foundation, Inc. / Licensed by VAGA, New York.

of alternating bars and ovals rather than by a single form. *Elegy to the Spanish Republic No. 78*, from 1962, and the *Elegy* of 1958–61 are characteristic examples, with their strong formal frontality in black against white. In *Elegy to the Spanish Republic XXXIV* from 1953–54 the artist added touches of color in the background to flatten the black forms even more rigorously, pushing them up against the picture plane. The French phrase "je t'aime," written across the face of the canvas in the *Je t'aime* pictures, distinguishes that series, as in the painting/collage of 1976, *Je t'aime with Gauloise Blue*.

After Motherwell made several paintings in a series, the central pictorial motif, through its recurrence, evolved a clearly defined personality. This reappearing form or pictorial organization serves as a visual metaphor with multiple layers of meaning, enriched, but also made more specific, every time it appears in another work. Just as the character of a literary protagonist such as Odysseus or Ahab unfolds and gathers significance through his or her interaction with the events of a narrative, so these highly developed pictorial actors in Motherwell's paintings acquire further elaboration with each new work in a series. A range of *Elegy* compositions, from *Elegy to the Spanish Republic XXXIV*

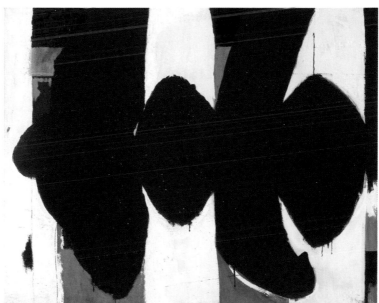

7. Robert Motherwell, *Elegy*. 1958–61. Oil and charcoal on canvas, 68 in. × 99½ in. Philadelphia Museum of Art. © 2015 Dedalus Foundation, Inc. / Licensed by VAGA, New York.

8. Robert Motherwell, *Elegy to the Spanish Republic XXXIV*. 1953–54. Oil on canvas, 80 in. × 100 in. Albright Knox Art Gallery, Buffalo, New York. Gift of Seymour H. Knox Jr., 1957. © 2015 Dedalus Foundation, Inc. / Licensed by VAGA, New York.

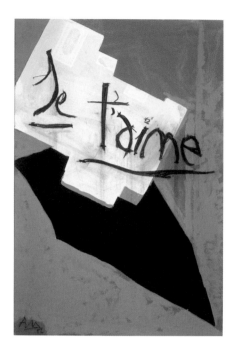

9. Robert Motherwell, *Je t'aime with Gauloise Blue*. 1976. Acrylic, collage, and charcoal on canvas, 36 in. × 24 in. (unframed), 39⅝ in. × 27½ in. × 1¼ in. (framed). Collection of the Modern Art Museum of Fort Worth. Museum purchase, the Friends of Art Endowment Fund. © 2015 Dedalus Foundation, Inc. / Licensed by VAGA, New York.

of 1953–54, to the 1958–61 *Elegy*, to *Elegy to the Spanish Republic No.78* (1962), to the 1983 etching *Running Elegy II*, shows both the consistency and the variation with which Motherwell maintained the defining core of this series over its span of forty-two years. While the organization of works into clearly defined groups and the precision of the identifying principle in each of them is methodical, Motherwell handled the specific instance of the defining motifs for each series instinctively, not intellectually, making each painting a unique and spontaneous experience, set off in bold relief against the defined structure.

Motherwell (like his abstract expressionist colleagues) took inspiration from the European surrealists and other modernists who had come to New York as the Nazis rolled over Paris in 1940. The influence of these Europeans on the younger New York artists was enormous, and of particular importance to them was the surrealists' idea of looking to the unconscious mind as the source of subject matter. The surrealists aspired to reach an uncensored, dreamlike state in their art, and in order to open the hidden levels of the psyche they invented a technique called "automatism" to circumvent the censorship of the ego. Automatism

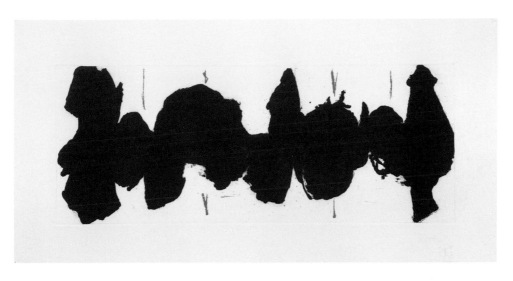

10. Robert Motherwell, *Running Elegy II* (color trial). 1983. Lift-ground etching and aquatint, soft-ground etching on Georges Duchêne Hawthorne of Larroque handmade paper. 18 ⅜ in. × 35 ½ in. © 2015 Dedalus Foundation, Inc. / Licensed by VAGA, New York.

involved writing or making images blindly, by covering their hands as they worked or by painting forms so quickly that there would, in theory, be no interference from the intellect. They also exploited chance, as when the artist Max Ernst did rubbings from random textured surfaces under a piece of paper or canvas, or when the French painter André Masson threw glue and then sand at a canvas and exploited the forms created by the sand sticking to the glue. The arbitrary forms derived from these chance procedures provided a basis for free association, which the surrealists used both to begin and to develop their compositions.

For Motherwell and his contemporaries in the New York school the essential problem in the 1940s was twofold. First, they felt they needed to bring American art out of its aesthetic provincialism and into the mainstream of modernism. Yet modernism was a European movement and they did not want to be "derivative," as they put it. They wanted to make something original and distinctively American. Motherwell, Pollock, and other young New York artists recognized that they could use psychic automatism as a creative principle in an altogether different way than the surrealists had done. Instead of using it to explore the

unconscious, Motherwell and his friends set out to capture a strong emotional experience of which they were highly conscious from the start.

From there, Motherwell later explained, "the artistic struggle involves revision, new points of attack, pondering, changes of mind, duration, endurance and so on. Traces of this conflict often remain in paintings & collages, like the corpses on a battle-field (and sometimes enrichens them with a terrible beauty)."[10] In addition, Motherwell "understood, too, that 'meaning' was the product of the relations among elements, so that I never had the then common anxiety as to whether an abstract painting had a given 'meaning.'"[11] Motherwell and his friends used the immediacy of automatic gesturing to objectify their thoughts, as they developed.

Psychic automatism provided a formal device to convey the subjective content of these works with unprecedented immediacy and directness. This way of recording the spontaneous thought in a brushstroke makes the abstract expressionist painting, even now, after nearly three-quarters of a century, look as though the paint were still wet. "The fundamental criticism of automatism," Motherwell explained in 1944, "is that the unconscious cannot be *directed*, that it presents none of the possible choices which, when taken, constitute any expression's form. To give oneself over completely to the unconscious is to become a slave. But here it must be asserted at once that plastic automatism . . . is actually very little a question of the unconscious. It is much more a plastic weapon with which to invent new forms. As such it is one of the twentieth century's greatest formal inventions."[12]

Motherwell wanted his painting to feel real and present. Each brush-stroke in a Motherwell painting brings associations from his then-present emotional state, from events in the artist's life history, from previous pictures, and from external influences. Every form is charged with layers of meaning and is in dialogue with the other formal features of the canvas that are also permeated with such associations, as well as with other networks of unconscious content. The meaning of Motherwell's

11. Robert Motherwell, *Red Open No. 3*. 1973. Acrylic on canvas, 84 in. × 42 in. Cranbrook Art Museum, Bloomfield Hills, Michigan. Gift of Rose M. Shuey, from the Dr. John and Rose M. Shuey Collection. Photo: R. H. Hensleigh. © 2015 Dedalus Foundation, Inc. / Licensed by VAGA, New York.

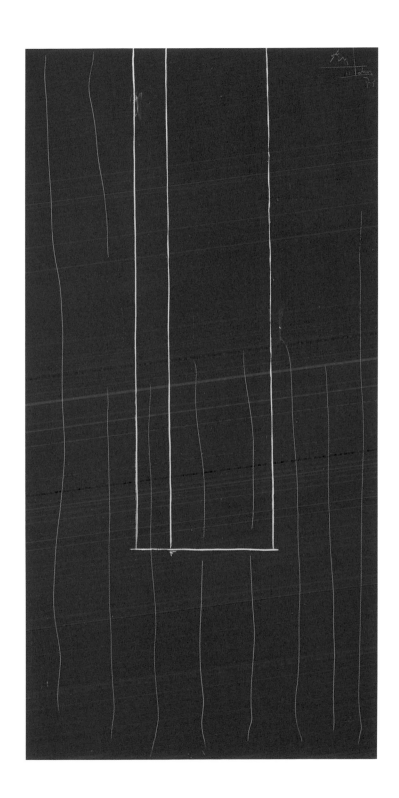

12. Robert Motherwell, *The Little Spanish Prison*.
1941–44/1959–69. Oil on canvas, 27¼ in. × 17⅛ in.
Museum of Modern Art, New York. Gift of Renate
Ponsold Motherwell. © 2015 Dedalus Foundation, Inc.
/ Licensed by VAGA, New York.

work begins to emerge as we closely examine these details and his associations to them—relating specific formal devices with particular emotions and piecing together their dynamic interactions.

Motherwell's *Red Open No. 3* of 1973 offers a rich example for such an examination, uniting a variety of established motifs from the artist's earlier work. Defining visual ideas from the *Elegy to the Spanish Republic* series, *The Little Spanish Prison* of 1941–44, the prison window pictures, and the *Open* series all come together in this work. The association of pictorial metaphors from these disparate series in *Red Open No. 3* indicates the extent to which all of these superficially quite different-looking groups of pictures have in common certain particularly powerful constellations of emotion. But before delving too far into an interpretation of what these metaphors mean, I want to first establish the formal continuities across these various groups of paintings.

In contrast to the rigor of the precise, three-sided-window motif in *Red Open No. 3*, the eccentric, faintly incised, vertical striations provide an intimate presence. These gestural verticals correspond to the visually

similar alternating bars in *The Little Spanish Prison* of 1941–44 (one of Motherwell's earliest paintings). There, as Motherwell wrote in 1977, "the geometry is deliberately freehand, emphasizing sensibility."[13] The tightly controlled white line and the orderly structure of *Red Open No. 3* seem to keep emotion in check, while in the looser incised strokes it emerges freely. The particular quality of the more spontaneous gesturing in this picture carries forward an expressiveness that persists, in varying degrees, from the beginning of Motherwell's career; as a theme, the conflict of gestural intimacy and an imposing formality of organization emerged at its most intense in his series *Elegies to the Spanish Republic*, where it consistently dominates.

The format of the *Elegies* germinated out of a small ink drawing that Motherwell made in the summer of 1948 to accompany Harold Rosenberg's poem "A Bird for Every Bird" in the planned second issue of the little magazine *Possibilities* (which was never published).[14] Some years later, Motherwell retrospectively titled the drawing *Elegy to the Spanish Republic No. 1*. At the end of 1948, over the winter into 1949, he revisited the composition in a small painting on cardboard called *At Five in the Afternoon*. The words for the title came from the opening and refrain in Federico García Lorca's poem "Lament for Ignacio Sánchez Mejías," about a famous bullfighter who was gored in the ring.[15] The title refers to the time of day when the event took place: "At five in the afternoon. / It was exactly five in the afternoon," Lorca writes, setting up for himself a contrast between meticulous precision and disjunctive content.[16] In his repetition of bars and ovals, Motherwell replicates the poem's repetition of the phrase "at five in the afternoon."[17]

In both the drawing and in the first real *Elegy* painting—*At Five in the Afternoon* of 1948–49—the restrained composition, with its regimented cadence of vertical bars and ovals, and the austerity of the monochrome palette stand in opposition to the impulsive, personal elements: the drips, a free irregularity of the gesturing, and the variety of handling. Even within the definition of the structural order itself this contrast exists: the variation in the bars from a column-like member, left of center, to a frail little line, just to the right, reveals a strong drive toward spontaneous expression, a resistance to the systematic ordering. Again, the contrast between controlling order and free, unruly emotion stands out.

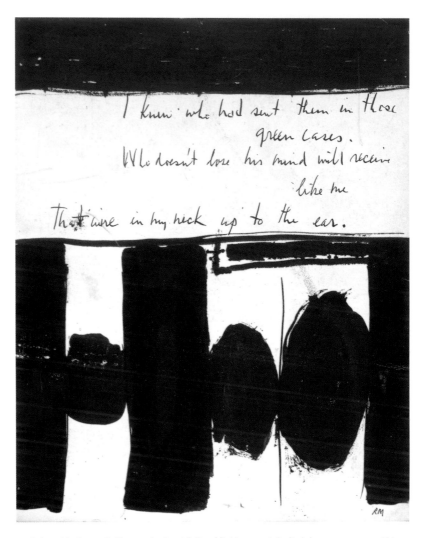

13. Robert Motherwell, *Elegy to the Spanish Republic No. 1.* 1948. India ink on rag paper, 14½ in. × 11 in. Museum of Modern Art, New York. © 2015 Dedalus Foundation, Inc. / Licensed by VAGA, New York.

Just prior to *At Five in the Afternoon* of 1948–49, Motherwell made a small painting on paper called *Dirge* that has the same fundamental structure, with a round form squeezed between heavy uprights all in black. But in this case, there is a deep red background with white in the middle that connects it to the palette of *Red Open No. 3. Dirge* also has a touch of the same blue that appears as a sliver of color in *At Five in the Afternoon*.

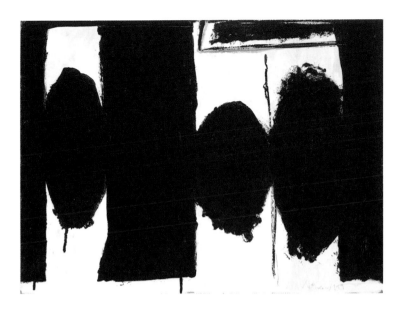

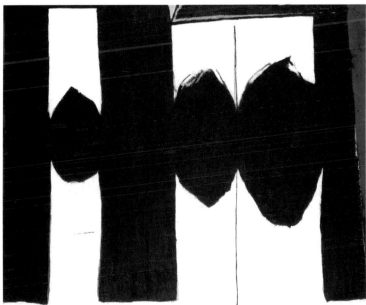

14. Robert Motherwell, *At Five in the Afternoon*. 1948–49. Casein and graphite on paperboard, 15 in. × 20 in. Estate of Helen Frankenthaler. © 2015 Dedalus Foundation, Inc. / Licensed by VAGA, New York.

15. Robert Motherwell, *Granada*. 1948–49. Oil and casein on paper, mounted on masonite, 47 in. × 55½ in. Collection Kykuit, National Trust for Historic Preservation, Nelson A. Rockefeller bequest. © 2015 Dedalus Foundation, Inc. / Licensed by VAGA, New York.

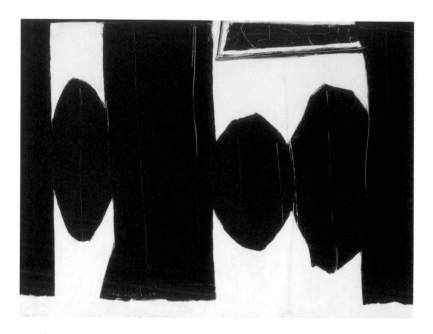

16. Robert Motherwell, *At Five in the Afternoon*. 1950. Oil on hardboard, 36¾ in. × 48½ in. × 1⅛ in. (93.3 cm × 123.2 cm × 2.9 cm). Fine Arts Museums of San Francisco. Bequest of Josephine Morris, 2003.25.4. © 2015 Dedalus Foundation, Inc. / Licensed by VAGA, New York.

After the 1948–49 version of *At Five in the Afternoon*, Motherwell did a much larger picture with the same basic organization entitled *Granada* (which also has a touch of the same blue). Granada, not coincidently, was the birthplace and family home of Lorca and the place where a fascist firing squad executed him in 1936. Next, still in 1949, Motherwell painted a series of works on a similar compositional principle, titled after other Spanish cities; then he renamed all these early pieces *Elegy to the Spanish Republic*, dedicated the entire series to Spain—and especially to Lorca's generation of Spanish intellectuals—and numbered the pictures in sequence, as he continued to do with subsequent works in this idiom to the end of his life.[18]

In *Red Open No. 3*, the reference to the *Elegies* exists not only in the expressive calligraphy of the parallel lines but in their presence as a structural rationale. They create a sequence of vertical bands that relates formally to the most identifying characteristic of the *Elegy* pictures, namely, the cadence of upright bars with forms squeezed in between

17. Robert Motherwell, *Pancho Villa, Dead and Alive.* 1943. Oil, gouache, pasted wood veneer, pasted papers, and ink on paperboard, 28 in. × 35⅛ in. Museum of Modern Art, New York, 1944. © 2015 Dedalus Foundation, Inc. / Licensed by VAGA, New York.

them. *Red Open No. 3* also displays some of the same cubist formality and flatness that predominate in the *Elegies*, where all the forms cling to a single visual plane—the picture plane.[19]

In 1950 Motherwell painted a second version of *At Five in the Afternoon*. This work has scratched-in parallel lines like those in *Red Open No. 3*, further establishing the visual link between *Red Open No. 3* and the *Elegies*. In addition, the incised strokes in the widest bar of *At Five in the Afternoon* (1950) describe an elongated box or window with three sides, in almost the same proportions as in *Red Open No. 3*. As a compositional idea, the parallel bands of *Red Open No. 3* and the *Elegies* began as far back as *The Little Spanish Prison* and recurred, particularly in pictures associated with themes of rebellion, oppression, and death: notably in the *Elegies*, but also in *Pancho Villa, Dead and Alive* (1943), *La Resistance* (1945), and other works with this kind of subject matter.[20]

From the outset, the motif of wavy bands seems to have had a specific expressive character associated with prison bars, as suggested by the

18. Robert Motherwell, *La Resistance*. 1945. Oil and paper collage on cardboard, 36 in. × 47¾ in. Yale University Art Gallery. Gift of Fred Olsen. © 2015 Dedalus Foundation, Inc. / Licensed by VAGA, New York.

title of *The Little Spanish Prison*. In addition to these highly individuated bars in *The Little Spanish Prison*, the small red box in the painting (perhaps already connected to the idea of a window by 1941, as it was later in the *Open* series) suggests yet another visual link to *Red Open No. 3*, both in color and form. Moreover, Motherwell incised the phrase "Je t'aime," almost invisibly with the back of his brush in the wet paint, across *Red Open No. 3*, thus connecting it to the small series of similarly inscribed paintings begun in the middle 1950s.

The French phrase that signals the *Je t'aime* series evokes the aura of French intellectualism, with which Motherwell always felt great affinity. For him, this represented a tradition of intellectual refinement and elegant restraint in both painting and writing. In the *Je t'aime* pictures, the same opposition reemerges once again between the formality embodied in the allusion to European culture and the emotional outpouring in the painterly areas around it and in the signatory gesture of the handwriting. In addition, the "Gauloises" blue is the color of the packages of French Gauloises cigarettes; their now all but vanished

19. Robert Motherwell, *Red Open No. 3*, blow-up detail of the center. 1973. © 2015 Dedalus Foundation, Inc. / Licensed by VAGA, New York.

aroma was inseparable from images of French intellectual life in the Paris cafés of the twentieth century.

Now, what do these recurrent, intertwined metaphors mean? Does their simultaneous presence in *Red Open No. 3* suggest that their content also interrelates in a continuous way? And why does the artist consistently seem to present an opposition between formal devices and more freely emotional elements?

With respect to the *Elegies*, the content of their chief expressive metaphor (the format of alternating bars and ovals in black on white) has a particularly well-defined character. In 1950 Motherwell wrote that the *Elegies* are "all in black and white: they are funeral pictures, laments, dirges."[21] Two decades later he still discussed their intent along similar lines, claiming that "the 'Elegies' treat life and death as fundamentals," and in 1963 he described their content as the "insistence that a terrible death happened that should not be forgot."[22] The reference to Spain in the *Elegies* also carried these kinds of associations. For intellectuals of the 1930s and 1940s, the writings of the modern poets Lorca and Rafael

20. Robert Motherwell, color photograph of studio wall with small *Elegy* studies on it. © 2015 Dedalus Foundation, Inc. / Licensed by VAGA, New York.

Alberti and their contemporaries, as well as Lorca's execution, came to stand for a deeply felt sense of tragedy about the Spanish Republican defeat. To many this event symbolized the plight of the individual against oppression and death. But to Motherwell, Lorca and the Spanish Civil War also represented an exceedingly personal confrontation not only with the finality of death but with a whole range of what the painter described as his own deepest anxieties. The magnitude of these emotions for Motherwell, and the specificity of the *Elegies* as a metaphorical embodiment of them, is demonstrated in an anecdote the artist told me.[23]

Motherwell said that he generally liked to keep the first work in every series as a point of departure for further experimentation, "a lighthouse to return to if I get lost, a way to get back to the original impulse."[24] He always had small versions of the *Elegies* up on the painting wall in the studio that he dedicated to making *Elegy* paintings. For this reason, he felt especially upset in 1971, he told me, at losing the first painted version of the *Elegies* (*At Five in the Afternoon*, 1949) in his divorce

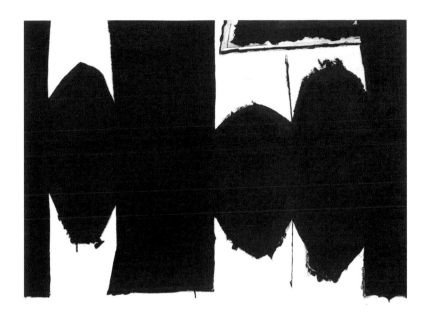

21. Robert Motherwell, *At Five in the Afternoon*. 1971. Acrylic on canvas, 90 in. × 120 in. Private collection. © 2015 Dedalus Foundation, Inc. / Licensed by VAGA, New York.

settlement with the painter Helen Frankenthaler, his third wife. But before he had to let the picture go to her, he received "custody" to make a faithful, although enlarged copy of it for himself—something he had never done before with any painting. Even this first painted version of *At Five in the Afternoon* did not *precisely* copy the first version on the sheet of paper with the poem.

Motherwell worked on this large copy on canvas in the peace of his Provincetown studio and, as he recalled, it was a beautiful July day when he brought the picture near completion. Nothing particular was bothering him, he said, and the work had progressed well that day. He had blocked out the major shapes and was adding the final details when, suddenly, he sank into what he described to me as "a profound suicidal depression." The anxiety drove him downstairs to get a shot of whisky. He had recently had a life-threatening bout of pancreatitis and had completely gone off alcohol by this time. Drinking, as he had been told by his doctors, could have been literally fatal. The intensity and suddenness of these emotions had caught him entirely by surprise;

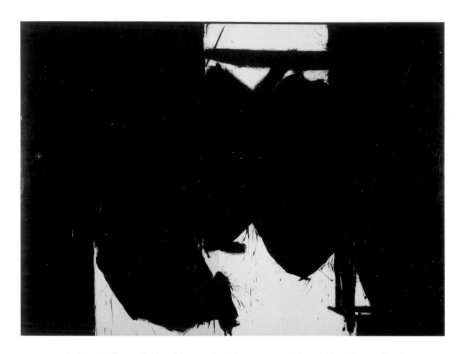

22. Robert Motherwell, *Elegy No.79*. 1962. Oil on canvas, 48 in. × 66 in. Private collection.
© 2015 Dedalus Foundation, Inc. / Licensed by VAGA, New York.

there seemed to be no reason for the attack of anxiety, he said. But then, as he told me, he gradually realized that the only time in his life when he had actually contemplated suicide was in the period during which he had painted the first version of the *Elegies*—the one that he had now undertaken to copy.

The details of the painting—the drips under the large forms, the meeting points of the contours—had vividly re-created all of that earlier emotional state.[25] These details, the artist explained, were "the most important part"—not the larger forms. If we look closely at any classic *Elegy* painting, like *Elegy No. 79* of 1962, the paint application at the edges where the forms meet shows the application of the black in the center of the form to be less nuanced, more routine, and earlier; whereas he painted the outline border, and in particular the passages where the forms meet, on top of, and hence after, the larger central field. In these areas the character of the brushwork is thicker and more expressively gestural.

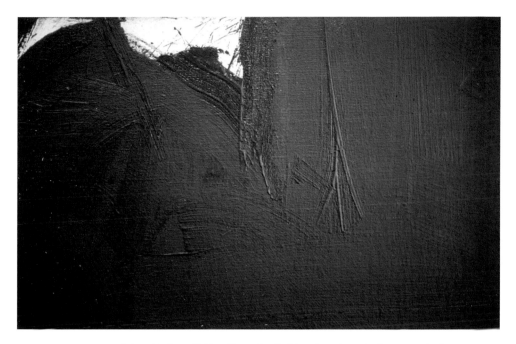

In mid-December 1948—at the time of the first *Elegy* painting— Maria Moyers, Motherwell's first wife, walked out on him. She took his car (which his mother had given him) and left with another man, some- one who lived near them in East Hampton, New York.[26] Motherwell described his feelings at the time as an intense sense of "abandonment, desperation, and helplessness."[27] Then, from December 1948 to Febru- ary 1949, he lived and worked in a room on Fourteenth Street in the city, with a cloud of depression hanging over that entire winter, he said. This period molded the expressive core of the *Elegies* and every *Elegy* picture since then dealt with this oppressive content—some more intensely than others.

Motherwell painted *Granada* (the second in the series of *Elegies*) during a blizzard in that same winter of 1948–49. He did the work in an uninterrupted eighteen-hour session, alone in his Greenwich Vil- lage studio, and this work also commemorates the feelings of rejection and abandonment that pervaded the artist's life at that time.[28] Later,

Bradley Walker Tomlin had to convince Motherwell not to destroy the work.[29] One might imagine why the artist would wish to eradicate the embodiment of those memories. *At Five in the Afternoon* followed soon after and foreshadows the lifelong preoccupation with these forms that would follow.

In *Je t'aime No. II* of 1955 Motherwell brought together the alternation of bars and ovals from the *Elegies* and the defining phrase of the *Je t'aime* pictures, with an anticipation of the red and perhaps even a hint of the geometric configuration of *Red Open No. 3*. The *Je t'aime* pictures coincided with what the artist described as a "Virginia Woolf marriage"—referring to the film *Who's Afraid of Virginia Woolf*—and the series temporarily stopped at about the time that marriage (his second) ended, though he took up the motif from time to time again later.[30] The works were, needless to say, "not love poems to my wife," as he put it, but a kind of "compensation."[31] Literally, of course, the phrase means "I love you," but Motherwell explained that when he used these words he really intended to convey "I am capable of love"—that the potential was there, frustrated.[32]

As an isolated statement directed at no one in particular, this phrase sounds desperate, like the cry of a child who feels insecure about being loved. It is a demand for affection, with the unconscious reasoning going roughly like this: "I love you and therefore I deserve to be loved in return." This statement is a kind of protest that expresses a feeling of deprivation, a hunger for love that would result from a childhood in which one's mother in some way neglected, or was perceived to neglect, one's needs. That seems to have been the case with Motherwell. When I suggested this interpretation to him, he confirmed that it was right and commented that Mark Rothko had told him, "'Je t'aime' doesn't mean 'I love you' but 'love me.'" Motherwell went on to describe his mother as a beautiful but vain and severely disturbed woman who "used to beat the hell out of me until my head was bleeding."[33]

I couldn't help wondering where the artist's father was when such events occurred? Motherwell portrayed him as distant, completely absorbed in his business at the bank where he worked. The artist described his father to his psychoanalyst around 1950 as "owned and manipulated."[34] Motherwell's unsatisfied need for love, his anger, and

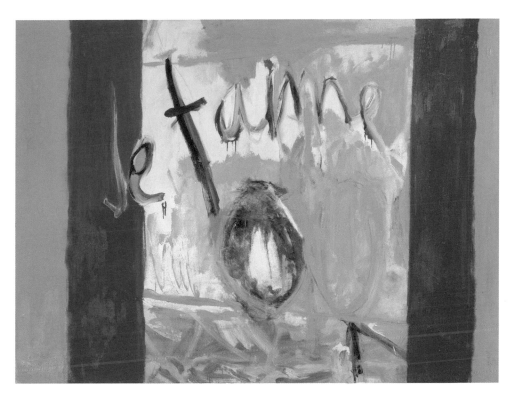

24. Rubert Motherwell, *Je t'aime No. II*. 1955. Oil and charcoal on canvas, 54 in. × 72 in. Mr. and Mrs. Gilbert W. Harrison. © 2015 Dedalus Foundation, Inc. / Licensed by VAGA, New York.

his defensive tendency to detach himself from intimate relationships with other people—recorded by the two psychoanalysts, Ullman and Kleinschmidt, who worked with him at different times—persevered into adulthood, and clearly no marriage could have fulfilled this longing.[35] Fulfillment would have required making up for an entire early life in which consistent maternal love was, or was perceived to be, in short supply. It seems likely that Motherwell chose or manipulated his relationships so as to cause them to fail because, as Kleinschmidt, the psychoanalyst who treated him in the 1960s, observes, "To accept love means loss of identity through the breakdown of his major defense, the narcissistic detachment. In his continued anticipation of rejection the accumulated anger [his own anger] becomes threatening and subsequent guilt over this anger leads to symptom formation and to the belief that death is the only just punishment."[36]

Children begin life with a demand for the absolute attentions of their mother; they need to be fed and cared for almost constantly. Only gradually does a child adjust to the ever-increasing recognition of separation. But as that occurs, the child normally also emulates the parent, incorporating the caregiving into an increasing feeling of self-sufficiency. For boys, the father has the ambiguous position of presenting an admired role model and yet simultaneously an obstacle for the child's acquisition of the mother's undivided affections. From the vantage point of a child's fantasy, the competition with the father involves a desire to eliminate him but also a fear of anger and retribution in response. This creates a complicated sense of self-annihilation in the imagined destruction of the father (with whom the child has identified) and in the imagined punishment for wishing to do so. (Freud called this the "Oedipus complex" and made it the cornerstone of his early psychological writings.)[37]

With the young Motherwell, the uncertain affections of his mother exaggerated this classic childhood crisis and left him with the intense vulnerability and the feeling of maternal deprivation that seem to express themselves explicitly in the *Je t'aime* paintings. The artist's first three marriage experiences reaffirmed the same lack of trust, since, as he told me, in each instance the woman broke up the relationship and deserted him, always with another man in the background.[38] Symbolically, this reenacts the Oedipal betrayal.

To complete the childhood fantasy, one would expect the artist to imagine his father as threatening and powerful: he, after all, has the imagined position of standing in the way of success (which is first conceived in terms of the child's acquisition of total access to his mother) and of obstructing self-realization (which consists of the fulfillment of the child's identification with the model of the father, who has the desired access to the mother). Yet Motherwell described his father as a gentle if unavailable man, despite some conflicts they had over Motherwell's career and lifestyle. I had a glimpse of a thinly veiled alternate vision in the artist's mind, however, in his description for a 1942 article in the first issue of the surrealist magazine *VVV*, of a painting appropriately called *The Child's Brain*, by Giorgio de Chirico. Motherwell wrote,

Standing before these late (1939) gouaches . . . what remains now of the expressiveness in that work of 1914 symbolizing the content of *The Child's Brain*, with its father-image? Yes, the father! Shockingly naked but unrevealed, hairy, immovable, inescapable, standing like a massive rock unseeing, with its closed eyes, but a rock resisting all attempts to pass beyond, a rock to burrow into, if that is the only possibility of getting beyond, but a rock eternally waiting, waiting for when it will be at once judge and executioner, judge of the guilt inherent in killing the origin of one's being in order to be, and executioner by virtue of one's fear of being free.[39]

The images Motherwell read into the painting parallel those of the Oedipal father whom one must eliminate (to kill "the origin of one's being") in order to realize oneself; he is the rock, the impassive, omnipresent obstacle; he is "judge and executioner." At the time that Motherwell and I were discussing the content of this essay he was in the process of editing his collected writings. When he came across this essay for *VVV*, he photocopied it, put a series of exclamation points in the margin next to this passage I have just quoted, and mailed it to me.

In addition, the cultural heroes with whom Motherwell identified all had similar experiences with mothering. The mothers of Lorca, André Gide, and Marcel Proust were frightening and coldly distant. Charles Baudelaire—a guiding inspiration for Motherwell from the beginning of his career—was an illegitimate child who felt outcast by birth and shared a great mutual animosity with the French general whom his mother had married. In the *Three Tragedies*, Lorca presents a series of terrifying maternal images: in *Blood Wedding* the woman runs away with an old lover on the day of her wedding to another man, causing a fight that results in the death of both men; in *Yerma* the woman causes the death of her husband for frustrating her maternal desires; in *The House of Bernarda Alba* the widowed mother thwarts the passions of her four daughters until the youngest is driven to kill herself.

The strong need for maternal affection also reveals another conflicting factor at work in the *Elegies* as well as in the *Je t'aime* series. One writer, from conversations with the artist, stated that the black forms

in the *Elegies* "have repeatedly been likened to *cojones*, gonads of a bull, emblems of the defeated and the death, which are removed and tacked on a wall after a valorous bullfight."[40] Characteristically, a boy's childhood anger toward the Oedipal father involves an anticipation of reciprocal anger, which Freud describes as commonly manifest in a child by the fear of castration. For Motherwell, the decision to paint must have aroused such unconscious feelings (namely, the Oedipal challenge to his father and the castration fears), since this necessitated a defiance of his father's adamant wishes against a career in art. His father responded as though according to a textbook script, offering the young artist a choice either of giving up art for a $25,000-a-year job in his father's bank (a lot of money at the end of the Depression) or of receiving $50 a week to paint—with the proviso that he *never have children*![41]

The deep sense of depression expressed in the *Elegy* paintings is thus formally connected here with the castration fears, the related anger (which frequently becomes self-directed), and the sense of maternal abandonment. In the captions to a major monograph on his work published in 1977, Motherwell described *The Little Spanish Prison* as embodying a similar mixture of emotions: "The basic feeling is oppressive, compassionate, and yet the picture displays a certain assertiveness."[42] The "oppression" and the "assertiveness" parallel the psychic fear and anger—the submission to the aggressive father, as well as the wish to become him and to take his place. The "compassion" may include not only the love the artist felt for his mother and for his idealized father (with whom he identified) but also that which he must have wished to receive. At the same time, there is an element of self-pity in the feelings of being injured by the mother's perceived inadequacies. As a whole, Motherwell's work of the 1940s was dominated by such feelings of deprivation and abandonment. He reflected in 1977: "Thirty years later, only half remembering the original impulse, what strikes me now is that the true subject-matter of these three early works [*Personage (Autoportrait)*, 1943; *Ulysses*, 1947; and *Pancho Villa, Dead and Alive*, 1943] is a 'wounded person.'"[43]

Through the echo of formal devices from the *Elegies* and *The Little Spanish Prison*, *Red Open No. 3* also carries reference to their emotional content. In addition to the cadence of parallel bars, the incised window

motif in the second (1950) version of *At Five in the Afternoon*, and the general opposition between a formal structuring and free, expressive gesture, *Red Open No. 3* relates to the development of the expressive content in the *Elegies* and *The Little Spanish Prison*, even, albeit obliquely, through its color scheme. The red in *Red Open No. 3* and in *The Little Spanish Prison*, the whites in *Red Open No. 3*, and both the white and the black of death in the *Elegies* also find interlocking parallels in the colors in Lorca's "Lament for Ignacio Sánchez Mejías." In the first parts of the poem, dealing with the dramatic moment when Mejías has been gored by the bull and lies dying in the ring, the dominant color is the red of the blood; the later parts of the poem, more reflective and mournful, call upon the austerity of whites (a white shroud, white lilies, and white snails).[44] The red in *Red Open No. 3* and the blacks in the *Elegies* both function as active agents of anger, passion, and death, whereas the whites are the controlled emotions of passivity, reflection, and grieving.[45]

Motherwell's marriage to Betty Little, his second wife, dissolved in 1957. In 1958 he married Helen Frankenthaler and the third major structural series of Motherwell's career, the *Opens*, commenced in March 1967, by which time his marriage to Frankenthaler may already have begun disintegrating (they divorced at the end of 1970).[46] The idea came from seeing canvases stacked against one another in the studio and then spontaneously drawing the outline of the top of one onto a larger canvas behind it. What is left, of course, is an absence that recalls the erasure and recovery of the edge in the *Elegies*, the virtual fading out to invisibility of the phrase "je t'aime" in *Red Open No. 3*, the prevailing sense of loss of the elegant but unreliably present mother. It is perhaps also the loss of primal oneness with the mother to which Freud refers as "oceanic feeling." Freud writes of this longing for the ego completeness of infancy in *Civilization and Its Discontents*.[47]

The austere clarity in the drawing and structural architecture that characterize the *Open* series also responds to the highly geometric work of the minimalists, whose art was pervasive in the art world at that time, just as the austere black and white of the *Elegies* had earlier responded to Pablo Picasso's *Guernica*. Nevertheless, the instantaneous decision about the proportion, the gestural backgrounds, and often even the

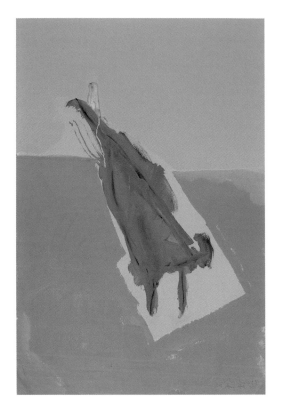

25. Robert Motherwell, *The Wild Duck*. 1974. Acrylic and charcoal on Upson board, 36 in. × 24 in. Private collection. © 2015 Dedalus Foundation, Inc. / Licensed by VAGA, New York.

drawing of the *Opens* has great spontaneity (like the gestural elements in an *Elegy*).

In sum, *Red Open No. 3*, in bringing together the central expressive metaphors from the *Elegies*, *The Little Spanish Prison*, the *Je t'aime* pictures and the *Opens*, embodies perhaps the most terrifying personal content of this artist's psychology. But it also reorganizes those powerful emotions into a visual analogue for freshly reintegrating them. An opposition of coolly calculated white lines to the sensuousness of not only the stripes but of the rich red surface recapitulates what the artist himself described as his response to danger. In the spring of 1974 Motherwell had been extremely ill and was told that in the following fall he would have to undergo a series of life-threatening surgeries.[48] Faced with what he felt was an immediate threat of death, he expected to paint a summer full of angry pictures—works with intense colors and strong contrasts. Instead, he made cool, controlled paintings in pink

and blue and gray, like *The Persian No. 1* of August 4, 1974, and *The Wild Duck* of August 18, titled after the play by Henrik Ibsen (which revolves around a marital betrayal and suicide).

Motherwell responded to his fears with great formality—an almost ritualistic restraint. Throughout the hospitalization he behaved, as he later described it, like "an English butler," with excessive politeness and decorum.[49] This response characterizes the fundamental order of *Red Open No. 3*. The recurrence of the motifs also seems to have reassured the artist in the face of intense emotion. Indeed, the almost obsessive attachment to a single recurrent shape or visual order in each series resembles the dependence that children develop on a particular, reliably present plaything for security, what the psychoanalyst D. W. Winnicott named "the transitional object."[50] An adult depression may also foster an intense fixation on an object or person, as if for want of stability.

Using psychoanalytic tools and coming to this body of work with the history and associations provided by the artist, it is tempting to turn our attention onto the confrontation with death and abandonment, as explored in the *Elegies*, and on the cry for maternal love in the *Je t'aime* paintings, and even on the obsessive reworking of the structural devices as symptoms, and to lose our larger methodological aim.

These works were constructed by an individual, to be sure, and a man with many conflicts, of which he was remarkably well aware. But the interesting revelation in this study is the way in which Motherwell—and by extension other great artists—transformed his unconscious energies, with a conscious brilliance at visual articulation, in order, as he said, to "reflect the nature of our understanding of how things really are."[51] A Motherwell painting is, finally, not identical with the psyche of the artist. Rather, it is a discrete object, structured as a system of metaphors, embodying a specific instance of a conscious worldview. As viewers, we can all take an empathic leap into this language and use it to help order our own conflicts. The fact that we can do that demonstrates the iconographic integrity of the abstract forms in these paintings. What I hope I have shown is the specificity and detail with which abstract forms can be fashioned to articulate content.

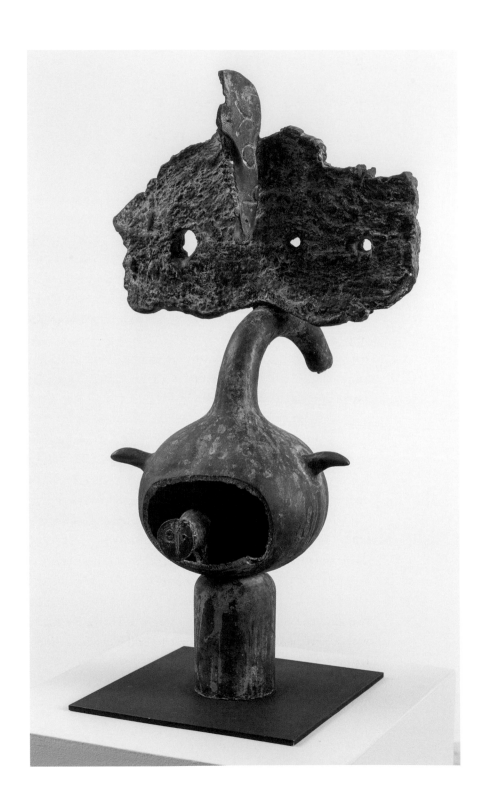

2

The Ineffable, the Unspeakable, and the Inspirational

A GRAMMAR

In the first chapter of this book, I showed how abstract forms can have meanings that are specific and sufficiently elaborated to constitute an iconography, like representational images. In this chapter I want to address myself to the structural relationships between such abstract forms, forms that articulate nonverbal thoughts and even bring unconscious thoughts into consciousness by giving them a tangible identity. This dynamic between images is what permits artists not simply to represent but to engage discursively through such content. In this chapter, I will draw my examples from the works of Alexander Calder and Joan Miró and from their interaction.

Miró and Calder met in December 1928, commencing a lifelong friendship. Miró never learned English, but they managed to share a great deal of conviviality when they met and occasionally sent one another postcards and messages. They had in common only an awkward French, riddled with grammatical errors, and yet a fluent, nuanced, and profound "conversation" took place through their work, and in particular through their use of materials.[1] In the foreword to the catalog for a 2004 exhibition that paired these two great artists, their grandsons recounted the recent discovery of an old animal jawbone that Calder had inscribed and given to Miró. It was found in the Parellada Foundry where Miró had worked and where he had it cast (as a kind of "nose") for his bronze sculpture *Maternité* of 1969.[2]

As with Miró's work, everyone loves Calder's sculptures. That his

26. Joan Miró, *Maternité (Maternity)*. 1969. Cast bronze, 30³⁄₁₀ in. × 16⁹⁄₁₀ in. × 12½ in. (77 cm × 43 cm × 31 cm). Edition of six. Chazen Museum of Art, University of Wisconsin — Madison. Bequest of Alexander and Henrietta W. Hollaender, 1992.232. © 2015 Successió Miró / Artists Rights Society (ARS), New York, ADAGP, Paris.

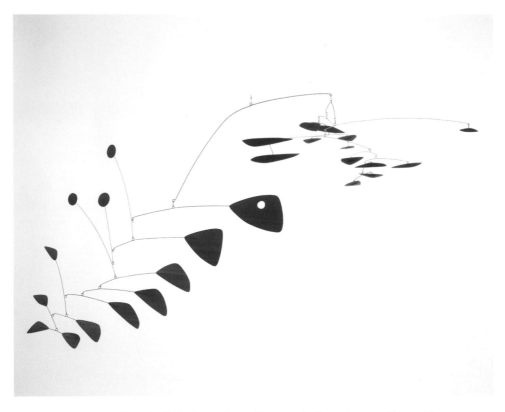

27. Alexander Calder, *Sumac II*. 1952. Sheet metal, wire, and paint, 29¼ in. × 48 in. × 35 in. (variable). Sheldon Museum of Art, University of Nebraska — Lincoln. Nebraska Art Association, gift of Mr. and Mrs. Frederick S. Seacrest, N-529. © 2015 Calder Foundation, New York / Artists Rights Society (ARS), New York.

work should be, at the same time, among the most intellectually challenging artworks of the twentieth century is a conundrum designed to baffle categorizers. A great Calder mobile, like *Sumac II* of 1952, is so accessible on one level and so difficult to penetrate on another. In 1958, at UNESCO in Paris, Calder stood beside his just completed standing mobile *Spirale*, when an interviewer asked him if there was any symbolism in it. "There's no history attached . . . sorry," Calder replied. His wife, Louisa, added, "Sandy is about as unsymbolic a person as I know."[3]

Calder never offered a verbal account of any deep meaning in any of his work, and to make matters still more complicated for the art historian, an irrepressible connection to the childlike keeps coming up.

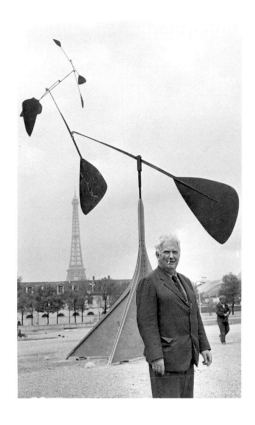

28. Calder with *Spirale* at UNESCO in Paris, 1958.
© 2015 Calder Foundation, New York / Artists Rights
Society (ARS), New York.

Calder himself remarked on this; looking back on his November 1964 retrospective at the Guggenheim Museum in New York, for example, he said, ironically, "There had been few large stabiles and many very small objects suitable for children to bat and crush. To this, I attribute my success. My fan mail is enormous—everybody is under six."[4]

The art historian Albert Elsen, struggling to articulate Calder's achievement, called the mobiles "interactions of events" and perceptively pointed to their existential search for balance—literally and figuratively—as central to their meaning. He also cited this anecdote reported in the *Atlantic Monthly*, as though it were necessary to add gravitas by association: Albert Einstein went to the Museum of Modern Art in 1943 to see Calder's motorized sculpture *A Universe*, of 1934, and after standing in front of it for forty-five minutes and waving away everyone who approached, Einstein reportedly muttered, "I wish I had thought of

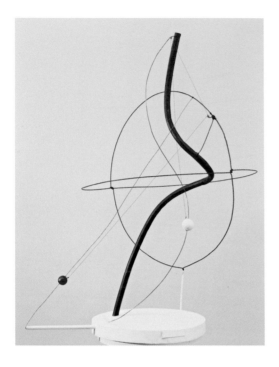

29. (*left*) Alexander Calder, *A Universe*. 1934. Painted iron pipe, steel wire, motor, and wood with string, overall: 40½ in. × 30 in. (102.9 cm × 76.2 cm). MoMA, New York. Gift of Abby Aldrich Rockefeller (by exchange). © 2015 Calder Foundation, New York / Artists Rights Society (ARS), New York.

30. (*right*) Alexander Calder, *Numbered One to Seven*. 1950. Sheet metal, wire, and paint, overall: 82 in. × 62 in. Joslyn Art Museum, Omaha NE. Gift of the Joslyn Women's Association. © 2015 Calder Foundation, New York / Artists Rights Society (ARS), New York.

that." Elsen then quoted Calder speculating that Einstein was "waiting to see the same combinations come up again so that he could work out the ratios of the different parts. I had set the movements in a ratio of, I think, nine to ten, so that the whole machine had to do ninety cycles before it repeated itself." Elsen remarked on Calder's ability to visualize a work that involved such complex compositional permutations among the parts, in cycles lasting as long as forty minutes; it was, he noted, an extraordinary feat of conceptualization.[5]

But Calder was, after all, trained as an engineer, and his albeit remarkable ability to conceptualize what he wanted to do in these terms is not a revelation of the symbolic content underlying it. Then Elsen went on to say that "Calder's vision has a certain innocence which, childlike, makes impossible analogies, is always optimistic, and regards its creations as self-evident in logic and meaning. There is no conscious symbolism in an art that is based on Calder's principle of full disclosure."[6] If Calder's work seems at first "self-evident in logic and meaning,"

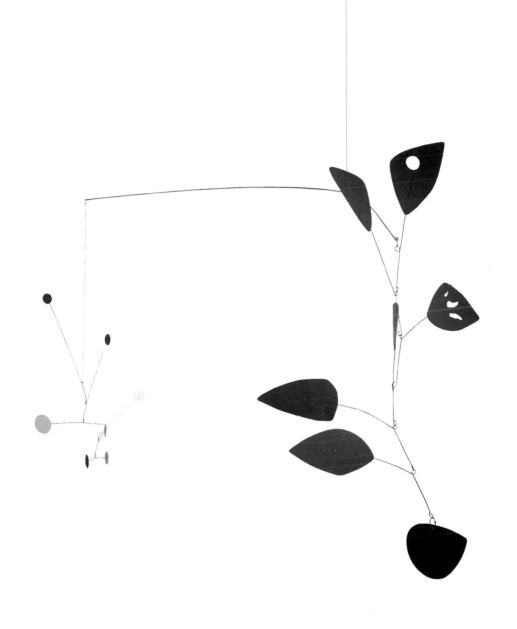

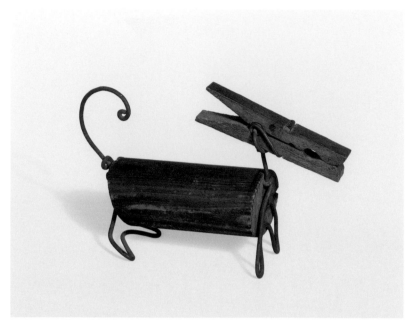

31. Alexander Calder, *Dog*. 1926–31. Clothespin, wood, and wire. Estate of Alexander Calder, New York. © 2015 Calder Foundation, New York / Artists Rights Society (ARS), New York.

this is a subterfuge for work that is deeply engaged in a sophisticated investigation of man's place in nature.

Like so many of Calder's works, his 1950 mobile *Numbered One to Seven* has a disarming simplicity to its title. It describes two sides of a numerical equation—seven elements on each side, count them, "one to seven." Calder made his *Dog* with the same directness out of a clothespin, a wooden dowel, and some wire. He made it around 1926–31; it belongs to a playful vein in his work that had begun with his *Cirque Calder* and toys in the 1920s. The reference to childhood in the reception of the work of Calder takes impetus in part from the aspects of his style, methods, and materials that seem especially simplified or spontaneous in expression. The palette of primary colors and the simple construction in the mobile as well as the transformation of found objects in a work such as *Dog* foster this association.

Calder's sister reported that, as a child, he was already predisposed with the same drive to "make things" from scavenged scraps that

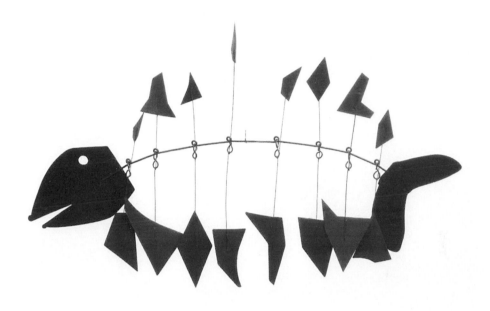

32. Alexander Calder, *Nervous Reck*. 1976. Private collection. © 2015 Calder Foundation, New York / Artists Rights Society (ARS), New York.

pervaded his mature career.[7] On one occasion, she recalled, after a storm "which necessitated extensive repairs to telephone and electric wires, the eight-year-old Sandy had triumphantly returned to his basement workshop bearing armfuls of copper wire scraps."[8] This was understood by her and by others to prefigure the bricolage with which Calder constructed the performers in his wire *Cirque Calder*, works of found parts like *Dog*, and the continuing thread of humor in the surprising overlays of unpretentious mechanical construction, representational allusion, and metaphor that persisted right to the end of his career in mobiles like *Nervous Reck* of 1976.

In addition to the untransformed materials, the flat, unmodulated color, and the reduction of the palette to primaries with black and white in so many of his works, Calder's rudimentary twisting of wire into simple articulated joints, as seen in a detail of *Sumac II*, gives the impression of a naïve lack of artifice in his sculpture. The undisguised, rough means with which Calder tacked the pieces together also enhance

33. Alexander Calder, *Sumac II*, detail of twisted joints and welds. 1952. © 2015 Calder Foundation, New York / Artists Rights Society (ARS), New York.

the visibility of spontaneity in his process. Children, with less experience of the world, see objects with fewer preconceptions, putting them together and describing them in fresh and unexpected ways. Children also rely more on tactile experience: Babies put everything in their mouths. Young children need to touch things.

Like so many great modern artists, from Wassily Kandinsky and Paul Klee to Mark Rothko, Calder and Miró aspired to reconnect with the childhood unconscious; they did this not to reduce the complexity of their subject matter but rather to probe it to a deeper level.[9] Calder took inspiration from the natural world, as in *Sumac II* and *Lobster Trap and Fish Tail* (1939), and from his persistent fascination with the solar system, as in *A Universe* and his 1931 stabile *Croisière* (Cruising). He also took inspiration from mechanical devices for visualizing the universe, like the eighteenth- and nineteenth-century planetary models found in science museums.

Calder's exploration of the cosmos, with its overwhelming scale, expresses the relentless curiosity and awestruck admiration of the scientist-engineer, who has certain affinities with the child in his or her openness and sense of wonder. Calder seems intent on mastering the

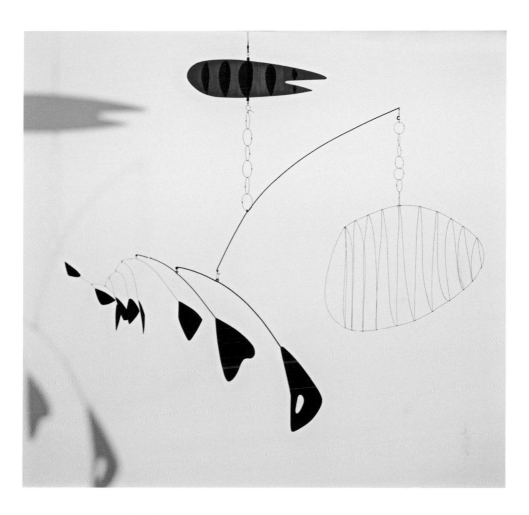

34. Alexander Calder, *Lobster Trap and Fish Tail*. 1939. Museum of Modern Art, New York.
© 2015 Calder Foundation, New York / Artists Rights Society (ARS), New York.

solar system, and in his sculpture we feel the powerful hands of this bear of a man showing us how to make it do what he wants. The insistently handmade, do-it-yourself style of Calder's work evokes our memories of our childhood drive toward mastery and the fantasies of omnipotence in an imagined world where things mean what we want them to mean and where we can make them do anything we care to imagine.

Certain specific rites of passage in Calder's life inform the cosmic themes. As a boy of seven, Calder had experienced a yearlong separation from his parents when his father had gone to a sanitarium in Arizona

35. Alexander Calder, *Croisière*. 1931. Estate of Alexander Calder. © 2015 Calder Foundation, New York / Artists Rights Society (ARS), New York.

seeking a dry climate for his tuberculosis.[10] In his autobiography, Calder remembered his exhilaration at their reunion, looking at stars under the clear night sky on the Arizona ranch. In another vivid memory, Calder recalled when, at the age of twenty-three, he hit a dead end in his engineering career and took time off to reflect. He signed up for a stint as a common seaman on a merchant ship heading through the Panama Canal and later condensed that period of soul-searching into a signal memory of a night at sea—*on a cruise (une croisière)*: "It was early one morning," he wrote, "on a calm sea, off Guatamala, when over

36. Brass orrery by Gilkerson and Co., London. Ca. 1810. © Armagh Observatory.

my couch—a coil of rope—I saw the beginning of a fiery red sunrise on one side and the moon looking like a silver coin on the other. . . . It left me with a lasting sensation of the solar system."[11]

Neither Calder's excitement at seeing the stars in the night sky over Arizona nor this epiphany of the sublime in the dawn at sea seems to have evoked anything of the terror of the sublime that Edmund Burke famously described on encountering the overwhelming power and scale of nature that reduces the individual to existential insignificance.[12] Instead, Calder described the dawn on one side and the night sky on the other as a kind of balance—like his mobiles. Calder brilliantly transformed what might have been an unsettling subject into something playful, instilling a sense of control and mastery.

Yet, on occasion, Calder's materials and his construction protocols intimate something else. In 1937 Calder made *Mercury Fountain* for the Spanish Republican Pavilion at the Paris World's Fair. A photograph from the period shows Calder standing behind his *Mercury Fountain*, with Picasso's *Guernica* in the background. The *Mercury Fountain* has the same improvisational innocence of style in its construction as his mobiles.

So how do we make sense of Calder's *Mercury Fountain* in the program of the Spanish Republican Pavilion, which was designed to condemn the rise of Francisco Franco's Nationalist army and to affirm the legitimacy of the Spanish Republic in the Spanish Civil War that was

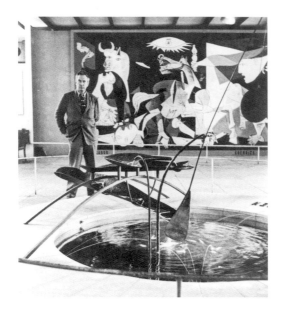

37. Calder standing behind his *Mercury Fountain* in the Spanish Republican Pavilion at the 1937 Paris World's Fair, with Picasso's *Guernica* in the background. © 2015 Calder Foundation, New York / Artists Rights Society (ARS), New York. Photo: Hugo P. Herdeg.

then raging. The architect Josep Lluis Sert commissioned three major works for inside the entrance to the building: Picasso's 1937 *Guernica* (referring to the people of the little Spanish town whom the German Luftwaffe massacred earlier that year, testing its weapons in support of the fascist insurgency of General Franco), Miró's angry painting *Segador* (The Reaper), *Catalan Peasant in Revolt,* of a reaper wielding a frightening scythe, and Calder's *Mercury Fountain*.

Whereas *Guernica* and Miró's *The Reaper* are both monumental, grim, and savage works of violence and protest, Calder's *Mercury Fountain* outwardly has all the playfulness of his other mobiles. The mercury is pumped up from a pool at the bottom and trickles down from one large, leaf-like, sheet metal trough into another, collecting again in the pool at the bottom. The fountain rests on two arched pipes of the same linear profile as the pipe that spurts the mercury out at the top, giving the sculpture as a whole the delicate, attenuated form and motility of a giant praying mantis. A long rod, with a paddle-shaped petal as a counterweight on one end, leans out, balancing a finer line of black iron with mobile forms that dance on either end. A quivering wire script spelling out the word "Almadén," hovers in the air, dangling off one end of this fine black line, and a single red spot—the only touch of

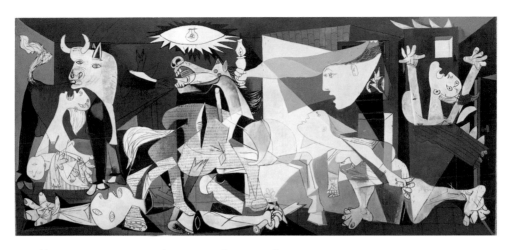

38. Pablo Picasso, *Guernica*. 1937. Oil on canvas, 11 ft. 6 in. × 25 ft. 8 in. (3.5 m × 7.8 m). Photographic Archives, Museo Nacional Centro de Arte Reina Sofía. © 2015 Estate of Pablo Picasso / Artists Rights Society (ARS), New York.

39. Joan Miró, *Segador, Catalan Peasant in Revolt* (*The Reaper*). 1937. Destroyed black-and-white photograph. © 2015 Successió Miró / Artists Rights Society (ARS), New York / ADAGP, Paris.

40. Alexander Calder, *Mercury Fountain*. 1937.
© 2015 Calder Foundation, New York / Artists
Rights Society (ARS), New York. Photo: Jonathan
Fineberg.

color in the entire work—floats at the other end. On the stone rim of
the pool, Calder inscribed "Spanish Mercury of Almadén," referring
again to the world's most abundant, and centuries-old, mercury mine,
located in Spain between Madrid and Seville.

The reference to the mercury mines at Almadén would have evoked
then-recent memories of Franco's brutal subjugation of the 1934 Astur-
ian miners' uprising and of the commune of Almadén, which rose in
resistance to Franco's fascist Nationalists. The dark, brooding heavi-
ness of the mercury seems to express this ominous theme. Its mirrored
surface is impenetrable. Pooling heavily in the black metal fronds of
the insect- and plant-like fountain and dripping with the viscosity of
blood, the mercury gives this work an unsettling bodily atavism. The
superficial playfulness of this piece draws us in and opens us up to a state
of innocent pleasure. Then the materiality of the work settles in—the
unstable, disturbing physicality of the mercury, calling on our early
sense of "touch." This brings up tactile memories, accessed through
vision, which take us to a darker place, to deep unspeakable meanings.[13]

41. Alexander Calder, *Mercury Fountain*, detail. 1937. © 2015 Calder Foundation, New York / Artists Rights Society (ARS), New York. Photo: Jonathan Fineberg.

As with Calder, Joan Miró and his work have been repeatedly described as childlike. In 1929 Michel Leiris—a writer and ethnographer who knew Miró well—talked about him as walking around wide-eyed like an "amazed child."[14] In 1941 André Breton, the patriarch of surrealism, characterized Miró as having "a certain arresting of his personality at an infantile stage."[15] Miró was more forthcoming in verbal accounts of his work than Calder and gave us more representational imagery to examine. It is nevertheless hard to avoid thinking of a child's openness in writing about Miró's oeuvre too.

At first the bright color and poetic lyricism of works like *Hirondelle/ Amour* (*Swallow/Love*) of 1933, generated through spontaneous free association, like a doodle, from line to word to form, evoke the liberated train of thought common in children. As with Calder's work, the art of Joan Miró is widely popular and thought of as delightful, humorous, and innocently sympathetic by most nonspecialists. Yet to serious scholars he was also "an artist of aggression," as one curator recently wrote, "an artist of violence and resistance."[16] The savage revelation of

42. Joan Miró, *Hirondelle/Amour (Swallow/Love)*. 1933. Barcelona, late fall 1933–winter 1934. Oil on canvas, 6ft 6½ in. × 8ft 1½ in. (199.3 cm × 247.6 cm). Museum of Modern Art. Gift of Nelson A. Rockefeller, 723.1976. © 2015 Successió Miró / Artists Rights Society (ARS), New York / ADAGP, Paris.

the unspeakable straight from the repressed unconscious is pervasive in his work.

While the works of Calder and Miró, more than those of any other major masters of the twentieth century, are persistently perceived as childlike, the childhood drawings of Calder and Miró are less fanciful, more soberly focused on mastering an account of reality than those of most children of comparable age. Miró's 1901 *Umbrella* and other works done by him at the age of eight, like Calder's childhood drawings, seem dryly descriptive. For all the charming awkwardness of Calder's *Self Portrait*, done in 1907 at the age of nine, he represents himself matter-of-factly, on his knees, sawing a piece of wood, with his tools lying on

43. (*left*) Joan Miró, *Umbrella*. 1901. Pencil on paper, 18.5 cm × 11.6 cm. Fundació Joan Miró, Barcelona. © 2015 Successió Miró / Artists Rights Society (ARS), New York / ADAGP, Paris.

44. (*below*) Alexander Calder, *Self Portrait*. 1907. Estate of Alexander Calder. © 2015 Calder Foundation, New York / Artists Rights Society (ARS), New York, ART370752.

45. Joan Miró, *The Tightrope Walker*. 1970. Bronze and steel, 53 cm × 28 cm × 13 cm. Tate. Purchased 1982 / Fundació Joan Miró, Barcelona. © Tate, London 2013. © 2015 Successió Miró / Artists Rights Society (ARS), New York / ADAGP, Paris.

the floor beside him. The free play of childhood imagination that both artists seem to have expressed less than one might have expected when they were children was assiduously cultivated and central to what marks them apart as adult artists.

In Miró's works, like those of Calder, a deliberate exploration of childlike modalities of thought was already pervasive by the mid-1920s. Far from childlike, these works are deadly serious in their use of childlike procedures to explore unconscious content. In technique, Miró connects most profoundly with childhood in the appropriation and redefinition of found objects and in the physicality of sculpture. "I have a need to mold things with my hands," he told the curator James Johnson Sweeney in 1948, "to pick up a ball of damp clay like a child and to squeeze it."[17]

46. Joan Miró, *Spanish Dancer*. 1928. Sandpaper, paper, string, nails, drafting triangle, hair, cork, and paint on flocked paper, mounted on linoleum on wood boards, 43⅛ in. × 28 in. (109.5 cm × 71.1 cm), Private collection. © 2015 Successió Miró / Artists Rights Society (ARS), New York / ADAGP, Paris.

Miró made his *Tightrope Walker* of 1970 from a mixture of modeled clay forms (like the ones in the upper left), an inverted baby doll, nails, and a perforated metal disc in the doll's torso, all bound together into what he described at the time as an "unlikely marriage of recognizable forms."[18] As in the cast pipe and the broken pot, the jawbone, and the molded forms in *Maternité*, the unlikeliness of the juxtapositions in *The Tightrope Walker* is a surrealist-inspired exploitation of free association to evoke poetic meaning and bring otherwise hidden unconscious thoughts into view.

Miró began bronze casting and modeling in clay for the first time in 1944, but he had already started incorporating found materials into his work in the 1920s. He assembled his *Spanish Dancer* of 1928 from a scrap of sandpaper, string, nails, hair, an architect's triangle, and paint on a sheet of flocked paper, mounted on a wood board. The 1928 *Portrait of a Dancer* consists of just a feather, a cork, and a hatpin on a painted panel.

47. Joan Miró, *Portrait of a Dancer*. 1928. Feather, cork, and hatpin on wood panel with Ripolin (original feather has been replaced), 39⅛ in. × 31½ in. (100 cm × 80 cm). MNd'AM, Centre Pompidou, Paris. © 2015 Successió Miró / Artists Rights Society (ARS), New York / ADAGP, Paris.

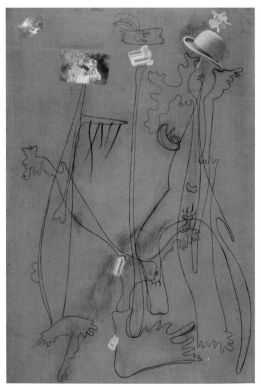

48. Joan Miró, *Drawing-Collage*. Montroig, September 25, 1933. Conté crayon, printed paper, and postcards on flocked paper, 42 in. × 27½ in. Private collection. © 2015 Successió Miró / Artists Rights Society (ARS), New York / ADAGP, Paris.

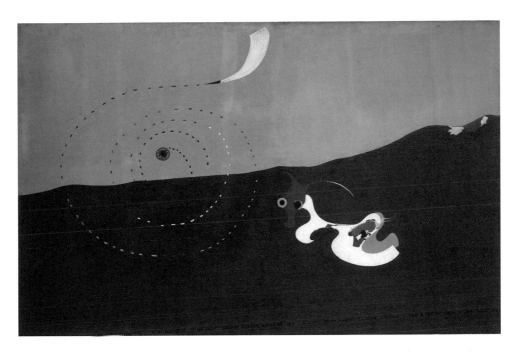

49. Joan Miró, *Landscape (The Hare)* (*Paysage [Le Lièvre]*). Autumn 1927. Oil on canvas, 51 in. × 76⅝ in. (129.6 cm × 194.6 cm). Solomon R. Guggenheim Museum, New York, 57.1459. © 2015 Successió Miró / Artists Rights Society (ARS), New York / ADAGP, Paris.

When Calder visited Miró's Montmartre studio for the first time in December 1928, he focused right away on the materials in Miró's new work and on Miró's poetic process of intuitive construction. Calder's account of this first visit, in his autobiography, centers on a work Miró showed him that consisted, as Calder recalled, of "a big sheet of heavy gray cardboard with a feather, a cork, and a picture postcard glued to it. There were probably a few dotted lines, but I have forgotten. I was nonplussed; it did not look like art to me."[19]

The work Calder remembered was *Portrait of a Dancer*—no other work remotely resembles this description. But over the intervening years—between his first visit to the studio in 1928 and the autobiography that he dictated to his son-in-law nearly forty years later—Calder appears to have conflated the work with one of the later postcard paintings, such as *Drawing-Collage* of September 25, 1933.[20] Miró used the trajectories of broken lines in several paintings of the time, such as *Landscape (The Hare)* of 1927.[21] The dotted lines create a radical shift in language

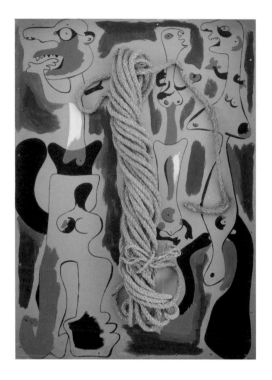

50. Joan Miró, *Rope and People, I*. Barcelona, March 27, 1935. Oil on cardboard mounted on wood, with coil of rope, 41.25 in. × 29.375 in. (104.8 cm × 74.6 cm). MoMA. © 2015 Successió Miró / Artists Rights Society (ARS), New York / ADAGP, Paris.

within the composition, from the landscape and the rabbit, which are representational (however abstracted), to diagrammatic notation like the broken line of the bird's spiral flight path. He meant these works to be read like poems, with the symbols and images juxtaposed rather than narratively laid out.

What struck Calder most in this first encounter of 1928, as he described it, was the unconventionality in Miró's use of materials. In *Portrait of a Dancer*, the materials so surprised Calder as to make the work "not look like art" at all. The conjunction in Calder's memory of the *Portrait of a Dancer* with works like *Landscape* and the postcard paintings (which he had to have seen at least half a dozen years later) suggests that something in these works connected them in a fundamental way in Calder's mind and that a related sensation of surprise with regard to the materials and syntax occurred again for Calder when he first saw the paintings with postcards and perhaps also when he first saw the semiotic shifts in paintings like *Landscape*. Miró, by the way, also said of Calder's work that "when I first saw Calder's art very long ago, I thought it was good, but not art."[22]

Rather than borrowing motifs or techniques from one another over the course of their forty-five-year friendship, Calder and Miró seem to have developed an exchange that had more to do with the surprise each experienced in the spontaneity of the other's unconventional methods and materials. That sense of surprise continued to open up deeper and deeper content, each in the other. This aspect of their ongoing encounters with one another's work pushed both of them, I think, to venture further toward the boundary where art and "not art" meet, into a kind of radical disjunctiveness.

"For me," Miró told an interviewer in 1959, "an object is alive. . . . This bottle, this glass, a big stone on a deserted beach—these are immobile things, but they unleash a tremendous movement in my mind. . . . As Kant said, it is a sudden irruption of the infinite into the finite."[23] The disconcerting materiality in works like Miró's *Spanish Dancer*, *Portrait of a Dancer*, and *Rope and People, I* (1935) seems to have prompted that "sudden irruption," reconnecting artist and viewer alike not only to an external infinite but to the internal depths of the preverbal world of early body memory and sensation in the unconscious. As Miró told the French critic Dora Vallier in 1960, "The older I get and the more I master the medium, the more I return to my earliest experiences. I think that at the end of my life I will recover all the force of my childhood."[24]

In Miró's 1938 painting *Shooting Star*, the figures seem to emerge from a polymorphous field of tactile color sensations. Beyond the superficial exuberance of its color and the freedom of its formal invention, this painting, like most of Miró's work, is also filled with an unsettling bodily instinctuality. That tendency is still more evident in a work like Miró's March 1937 charcoal drawing *Nude Ascending the Staircase*. The *Nude* is beautiful and grotesque at the same time, with unutterable revelations of the unconscious in the distortion of the figure's bodily attributes. This is the duality of the beautiful; it *is* beautiful precisely because it gives formal control and organization to the grotesqueness of the uncontrolled in the repressed unconscious.

Miró's *Nude* goes, conceptually, in the opposite direction from Marcel Duchamp's famous *Nude Descending a Staircase* of 1912, on which it comments ironically. Whereas Duchamp dehumanized the body into mechanized movement, Miró accentuated the organic qualities of the

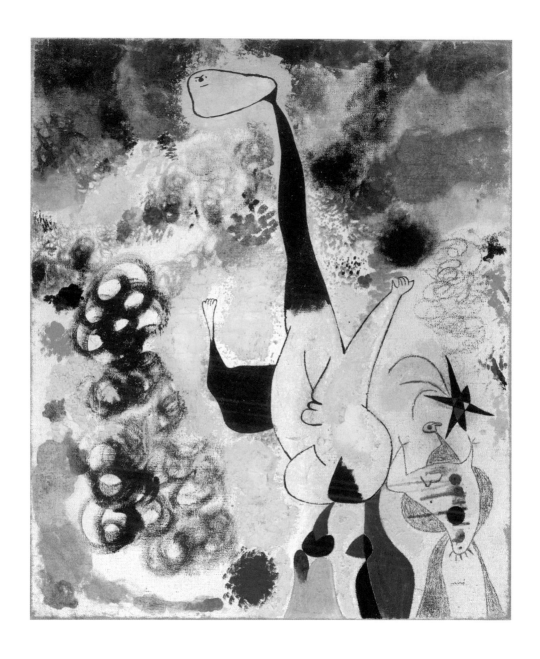

51. Joan Miró, *Shooting Star*. October 20, 1938. Oil and pencil on canvas, 25¹¹⁄₁₆ in. × 21⁷⁄₁₆ in.
(65 cm × 54 cm). National Gallery of Art, Washington DC. Gift of Joseph H. Hazen, 1970.36.1.
© 2015 Successió Miró / Artists Rights Society (ARS), New York / ADAGP, Paris.

52. Joan Miró, *Nude Ascending the Staircase*. March 1937. Charcoal on paper, 77.9 cm × 55.8 cm. Fundació Joan Miró, Barcelona. © 2015 Successió Miró / Artists Rights Society (ARS), New York / ADAGP, Paris.

body. "I often work with my fingers," Miró reported, emphasizing tactile memory. "I feel the need to dive into the physical reality of the ink, the pigment. I have to get smeared with it from head to foot."[25]

Picasso provides a brilliant gloss on this dynamic of visual mastery with a particularly detached clarity in a drawing of 1933 called *The Studio*, in which the living model overflows with a simultaneously delicious and repulsive, all-too-real vulgarity, while the painting of her on the easel is a classically idealized and formally controlled rendering of the nude female body. What Picasso illuminates in this drawing is the way in which the image represents the focus and order that permit us to tolerate, even to enjoy, the chaos, disorganization, and bodily realism that belong to the living subject. In the Miró, the beauty of the draftsmanship helps us to overcome the disturbing reality of the subject. Picasso seems to suggest that on the easel the artist's classicizing technique achieves this with regard to the living subject that is posed on the model stand beside him.

53. Pablo Picasso, *The Studio*. Paris-Boisgeloup, February 22, 1933. Pencil, 26.2 cm × 34.3 cm. Musée Picasso, Paris, M.P.1088. © 2015 Estate of Pablo Picasso / Artists Rights Society (ARS), New York.

While on occasion one can also find explicit allusions to a more unsettling bodily reality even in Calder's work, as in the *Mercury Fountain* or in his 1943 *Wooden Bottle with Hairs*, our empathic relation to Calder's sculpture mostly centers on the satisfying physicality of the process, on our fascination with the mechanics and materials, and on our wondering with him at the cosmos and at the beauty of nature. "I think best in wire," Calder told his sister Peggy, stressing his direct connection with his materials and their capacity to bring forms to life for him.[26] The tangibility of the wire and wood seems to have evoked for Calder a palpable, psychic realism. The physicality of his work puts it in touch with the world of body sensation, too, and that gives it a deep feeling of authenticity. His formal playfulness and the physical act of bending the wire to his wishes pushes the spontaneous act of making to the foreground in works like *Lobster Trap and Fish Tail*, *Croisière*,

54. Alexander Calder, *Wooden Bottle with Hairs*. 1943. Wood, steel wire, and nails, overall: 21¼ in. × 15¾ in. × 12⅛ in. (54 cm × 40 cm × 30.8 cm). Whitney Museum of American Art, New York. Fiftieth anniversary gift of the Howard and Jean Lipman Foundation, Inc. 80.28.2a-l. © 2015 The Calder Foundation / Artists Rights Society (ARS), New York. Photo: Jerry L. Thompson.

Numbered One to Seven, and *Sumac II* and returns us to the empowering world of childhood fantasy.

Miró, on the other hand, used the physicality of his work to look inward. "As for my means of expression," he wrote in 1933, "I struggle more and more to achieve a maximum clarity, force, and plastic aggressiveness—in other words, to provoke an immediate physical sensation that will then make its way to the soul."[27] Of course, Miró's work is also playful and exuberant on another level, and even when he turns to overtly "savage" subjects, as he himself called them, his mastery of such overtly disturbing subject matter is exhilarating.

What is at stake in the work of both Calder and Miró is not a buried psychological subject or specific childhood memories but a process of transformation. In Calder's case, it is his breathtaking genius at overwhelming any revelation of the unconscious with a powerful focus on the process of making and mastering things and on the sensation of delight in doing so. He never appears to look inward. Whereas Miró deliberately exposes unconscious material, and his innovative mastery over form, composition, color, balance—all the things that make a

great painter's work great—gives us that exhilarating sense of control in another way. What Miró saw on his first visit to Calder's Paris studio was a performance of the Calder *Cirque Calder* that simply did not fit Miró's mind-set about the boundaries of what constitutes a work of art; Calder's first sight of work in Miró's studio pushed him out of *his* comfort zone with the use of materials. They both persistently did this for one another over the course of forty-five years, and they both continued to find the encounter thrilling. Whether it was Calder's simplified two-dimensional planes violating their two-dimensionality by moving in three-dimensional space or Miró's stunningly base materiality, these artists each recognized that the other took him beyond the internal hierarchies of his own work. They continued to surprise one another, and all surprises reverberate with revelations of the early unconscious.

My purpose, I have said, is not to interpret the iconography of particular works by Calder or Miró but to understand the grammar of visual thinking by looking at how these two artists constructed a dialogue with one another through forms and materials. Our inability to summarize either Miró's *Nude Ascending the Staircase* or the most inspirationally optimistic of Calder's mobiles, despite the vividness of our feelings about them, tells us something important about the nature of this grammar. "We are," as Freud said, "unable to say what they represent to us."[28]

Instead of reading writers for their ostensible subjects, Roland Barthes, in a remarkable little book called *Sade, Fourier, Loyola*, proposes for the writings of these three authors an intuitive, almost bodily acquisition of their content by following the rituals of each writer's protocols of thinking.[29] He asks us to read the Marquis de Sade's lists of tortures as a grammar with a syntax, to focus on the texture of Ignatius Loyola's regimens in the *Spiritual Exercises* rather than on the questions and the answers he never receives in his conversation with God. It is by following the protocols of making in a Calder that we assimilate its meaning.

Most of us recognize from our personal experience that a variety of visceral sensations, impossible to verbalize, are commonly evoked by a deep encounter with a work of art. In describing his response to the *Apollo Belvedere*, the great eighteenth-century art historian Johann Joachim Winckelmann wrote that "my chest seems to expand with veneration and to rise and heave."[30] In a 1964 article for the *Nation*,

exactly two hundred years later, Max Kozloff wrote that "ultimately, Pollock . . . gave visual *flesh* to a whole era of consciousness in mid-century" (my emphasis).[31] Baudelaire, in his review of the Salon of 1846, called the pictures of Horace Vernet a "brisk and frequent masturbation in paint, a kind of itching on the French skin."[32] Miró wrote in a letter of 1922 that "when I paint, I caress what I am doing, and the effort to give these things an expressive life wears me out terribly. Sometimes after a work session I fall into a chair, totally exhausted, as though I had just made love!"[33]

The fact that a visual form can elicit such bodily sensations hints that works of art articulate body memory. The inaccessibility of art to verbal account leads me to the further surmise that this bodily experience may respond to the revelation of primary process—the term Freud gave to the preverbal world of primal bodily memory and repressed instinct in the unconscious. Something in the mechanisms of artistic expression allows the artist to overcome some of the barriers between the ego and the repressed. But the accessibility of the experience to the viewer implies not only that the viewer can also breach this wall in her- or himself but, as Freud theorized in "Creative Writers and Day-Dreaming," "the essential *ars poetica* lies in the technique of overcoming the feeling of repulsion in us which is undoubtedly connected with the barriers that rise between each single ego and the others."[34] These barriers that encapsulate the ego also separate the conscious and the unconscious through repression, making it possible for the individual to interact with the social world. It is the pleasure in the beauty of the work, its mastery, that allows us to overcome the repression and explore that content.

A central thesis of the landmark work on creativity by Ernst Kris is that "the integrative functions of the ego include self-regulated regression and permit a combination of the most daring intellectual activity with the experience of passive receptiveness."[35] Our sense that creative inspiration "just comes" to us seems to confirm Kris's observation of this regulated use of the repressed by the ego. As the ego of the artist delves into the unconscious, it exposes repressed material, incompatible with the ego. This clash produces anxiety, and such anxiety is familiar to all artists. They recognize it as part of the creative process, and their

willingness to tolerate it in order to make a work of art sets them apart from most other people.[36]

Writing to Michel Leiris in 1929, Miró talked of the frustration of not having "the plastic means necessary to express myself; this causes me atrocious suffering."[37] The American painter Phillip Guston described a similar anxiety to his friend Ross Feld, sometime around 1970. Feld had gone up to see Guston in his studio in Woodstock, New York, and, looking at a group of Guston's radical new figurative paintings, he reported, "There was silence. After a while Guston took his thumbnail away from his teeth and said, 'People, you know, complain that it's horrifying. As if it's a picnic for me, who has to come in here every day and see them first thing. But what's the alternative?'"[38] Even for Calder this anxiety existed, though he attempted to dismiss it. A *Life* reporter asked if he ever felt sad and Calder replied, "No, I don't have the time. When I think I might start to, I fall asleep. I conserve energy that way."[39]

Freud pointed out that the first ego is the body ego, derived from early bodily sensations.[40] The British psychoanalyst D. W. Winnicott described identity in terms of "true" and "false" selves, writing that "the spontaneous gesture is the True Self in action. Only the True Self can be creative and only the True Self can feel real. . . . The True Self comes from the aliveness of the body tissues and the working of body functions, including the heart's action and breathing. It is closely linked to the idea of Primary Process, and is, at the beginning essentially not reactive to external stimuli. . . . The True Self appears as soon as there is any mental organization of the individual at all."[41]

Artists literally give form to perceptions and relationships that are too primal to be verbalized. As Robert Motherwell said: "Through the act of painting I'm going to find out exactly how I feel."[42] Freud was well aware that art opens an exceptionally traversable "path that leads back from phantasy to reality."[43] The French psychoanalyst Jacques Lacan emphasized the fluidity and ongoing dialogue with the bodily atavism of early memory as continuing throughout life. What he called the "family complexes" (models of interaction, like Freud's family romances) are modified through life experience, he wrote, and these representations may reenter the world of the unconscious and serve to reorganize the motile energies of primary process.[44]

55. Philip Guston, *The Canvas*. 1973. Oil on canvas, 67 in. × 79 in. Courtesy McKee Gallery, © The Estate of Philip Guston.

Art also relies on this kind of introjection for both artist and viewer. The artist augments these representations not only with life experience but with a high degree of deliberate intervention in a conscious mode of organizing and contemplating experience as symbolized in form. The sculptor Jacques Lipchitz told Paul Dermé in 1920 that "the work of art should go from the unconscious to the conscious, and then finally to the unconscious again, like a natural, even though unexplainable, phenomenon."[45]

The experience of art involves an integration of unconscious memory and energies with current events. Artists simultaneously reveal otherwise inaccessible unconscious material in the unique theater of their work and introject the formal structures they devise for this content

back into the unconscious in the same manner as Lacan describes for his "family complexes." The fluidity of this interchange and the way in which it continually modifies the individual's unconscious organization—whether that individual is the artist or the viewer—is the key to what I am proposing here. Nearly half a century ago, Rudolf Arnheim made the point that the child artist uses art to examine and bring coherence to her or his encounter with the world.[46] The same is true for the adult artist. Baudelaire's famous remark that "genius is nothing more nor less than *childhood regained* at will," might, in psychoanalytic terms, be better understood as "childhood reintegrated," because the kind of genius that pertains to the creativity of the artist involves, first, a radical exposure—a general lowering of the artist's psychic defenses so as to have liberal access to this material—and second, a newly coherent reorganizing of unconscious content, as represented in visual form.[47]

Art exists on the edge of consciousness and has much in common with child's play. The fantasy that directs a child's play allows the child to lend every element a vivid sense of reality and to transform everything at hand into the necessary elements of the fantasy. This ability to reconfigure reality with total conviction annihilates semiotic categories, as, for example, in Miró's *Drawing-Collage* of 1933, where we follow seamlessly the metamorphosis of the woman's body from the psychic automatism of the line drawing to Miró's use of a postcard for the head with a fancy hat. It also overcomes the fixity of meaning in objects, known through experience and reason, as in Calder's *Dog*, where we accept without question the clothespin as a head. Art revitalizes our emotional connection to recognizable materials and objects by destabilizing their identity and thereby making them available for new meanings.

The act of genius that puts us in awe in such works is the artist's ability to open the memories and modalities of childhood so profoundly and extensively, and to bring them into rapport with the artist's current state of being. We are in awe because we all recognize ourselves in this exposure and in this reintegration; and we accept the exposure because of the pleasure and reassurance we derive from the agility with which the artist masters it.[48]

There is always a sense of discovery in art as we bring together unconscious thought and memory with present experience. Willem de

Kooning remarked that "there is no plot in painting. It's an occurrence which I discover by, and it has no message."[49] Indeed, the signal innovation of the abstract expressionist painter is *thinking in paint*, rather than in pictures, though it was prefigured in Kandinsky's prewar abstraction and paralleled in the spontaneous use of materials in David Smith's welding and in Calder's construction. For de Kooning, "content is a glimpse of something," he said, "an encounter like a flash."[50] That epiphany of content, embodied in a form that cannot be verbalized but is mastered through artistic process, is what we value most in a work of art.

One of the things that works of art do is to open the doors we have closed on aspects of our memory and thoughts. In that momentary opening, we not only reexperience normally undisclosed feelings, but we find ourselves able to reconnect them to the realities of both the present and the past in fresh ways, just as we may do with verbal insights that present themselves in the course of psychoanalysis. This highly charged experience that comes in the successful encounter with a work of art always has the exhilarating sensation of surprise.[51] It involves the momentary exposure of the undefended material of the unconscious. The reorganization of the defenses in the artist is mirrored in the experience of the viewer. Friedrich Nietzsche wrote of the overwhelming power of a glimpse of such "truth" as eliciting nausea.[52] In *Naked Lunch*, William Burroughs wrote of this raw sense of exposure as "a frozen moment when everyone sees what is on the end of every fork."[53]

In *The Ego and the Id* of 1923, Freud rejected the idea that a cogent thought process, much less conscious intellectual work, could exist amid the unruliness of visual experience because "the relations between the various elements of this subject-matter, which is what specially characterizes thoughts, cannot be given visual expression."[54] I think that the discourse in form between Calder and Miró shows us otherwise. This is clear in each of their first encounters with the other's work. Visual thinking can be innovative, rigorous, and conscious, without necessarily succumbing to verbal explanation. The greater proximity of visual expression to unconscious material is precisely what gives the best works of art their privileged sense of authenticity.

If we attempt to describe Miró's *Nude Ascending the Staircase* to someone who isn't looking at it, we can't even come close to communicating

in words what is communicated so vividly in visual form. Works of art give immediately recognizable form to experiences for which we do not quite have words. They create a discourse on these experiences through multiple simultaneous overlays of time and materiality, and other formal devices, in a metonymic construction like what Freud called the "dream work."[55] This is commonly visible in children's art, and it is also a persevering remnant of early thought processes, present in the way in which adults—in particular, artists—organize and interpret their experience.

One of the outstanding features of visual thinking is that it fosters the reordering of experience in a way that reveals connections hidden or dismissed by verbal logic. Visual and verbal thinking coexist and interact in works of art, as they do in dreams; we pass fluidly back and forth in our thoughts from the metonymic to the metaphoric to the logical. For example, a woman familiar with psychoanalysis once remarked to an analyst in her acquaintance, of whom she was quite fond, "I had a dream last night and you were in it! I was playing the piano and you kept saying to me, 'B-flat, B-flat!'" "B-flat" becomes "be flat," unconsciously making clear her wish to be on the analyst's couch, perhaps for more than an interpretation!

Visual thinking has the ability to bypass the conscious control of language in articulating experience and to tap directly into the language of primary process—that uncensored cauldron of repressed memory, body experience, and metonymic logic.[56] "I don't think one can explain it," the English painter Francis Bacon told David Sylvester. "It would be like trying to explain the unconscious," he said. "It's also always hopeless talking about painting—one never does anything but talk around it—because, if you could explain your painting, you would be explaining your instincts."[57]

In *Against Architecture*—a book centered on the writings of Georges Bataille—Denis Hollier points out that "the nameless is excluded from reproduction, which is above all the transmission of a name." He then describes Bataille as "relentlessly" attempting to achieve "the perverse linguistic desire to make what is unnameable appear within language itself."[58] Hollier's point is that Bataille introduces a powerful, disintegrating force that is intuitively recognizable and undeniable, yet it

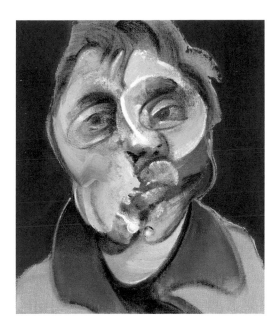

cannot be described fully in verbal language; he introduces this force into the very ordering and naming, the reproductive structure of language itself, thus thrusting language into a perpetual state of dynamic instability from within.

The ineffable, the unspeakable, and the inspirational are at the heart of the visual arts. There are no words to describe a work such as Miró's *Nude Ascending the Staircase* in all its vivid repugnance and simultaneous beauty or the well of conflict in Bacon's *Self-Portrait*. No manner of words could reproduce the mixture of emotions—it is an almost bodily sensation of repulsion, mixed with the pleasure of mastery, that we experience if we really allow ourselves to dwell in these images. Viewers respond with revulsion to such an exposure of unconscious content in a work of art. Yet that uneasy encounter is at the essence of art.

Works of art articulate, in form, profoundly sensual feelings rooted in the most primitive level of bodily memory. Artistic beauty both invokes the pleasures of early bodily sensation and revisits *unpleasure*. Art contains that essential ambivalence, calling up deep resonances of the pleasure principle and, at the same time, vulnerabilities and definitively unattainable longings, and this introduces a fundamental instability into

the psychic organization.[59] Lacan points us to this implication of dynamic instability in Freud's model and to its essential open-endedness.[60]

The German painter Gerhard Richter has said, "A picture presents itself as the Unmanageable, the Illogical, the Meaningless. It demonstrates the endless multiplicity of aspects; it takes away our certainty, because it deprives a thing of its meaning and name. It shows us the thing in all the manifold significance and infinite variety that precludes the emergence of any single meaning and view."[61] Part of what makes art so important to us is this destabilizing undecidability. Art opens areas of unconscious material otherwise inaccessibly shielded by a formidable system of psychic defenses, and in this moment of vulnerability, it creates a state of openness. What we experience as childlike in a work by Calder or Miró is precisely this. The motility of unconscious forces—their adaptability to the changing roles assigned them by shifting structures of unconscious representation and organization—allows the work of art to function as an organizing paradigm. Artists give their viewers a form with which to articulate experience for which neither viewer nor artist has, until that moment, had a vocabulary. The fluid communication art provides between the unconscious and consciousness helps the individual (both artist and viewer) to regroup psychologically in response to the relentless pressure of change and conflict in the world. Moreover, the work of art offers itself not only to the artist but to anyone who is able to recognize what has been given form in the work. Art, like falling in love, simultaneously disorganizes and nurtures the self toward a creative reordering, like a Calder mobile, perpetually regaining equilibrium in the constantly unpredictable currents of air.[62]

3

The Nature Theater

In 1983 the artist Buzz Spector made a work entitled *Shell Book* by slicing through the pages of an old book, as though he were cutting a block of wood. He cut out a set of steps on one side and glued their mirror image to the opposing cover.[1] He then arranged a collection of small shells (all of the same kind and scale) along the steps of one side and pocket-size stones (tumbled smooth in the waves of Lake Michigan) on the steps of the other side. For me, this work immediately evokes nostalgic memories of my own trips to the beach in childhood and it has the deeply satisfying orderliness that reminds me of my preadolescent collections of coins, butterflies, rocks, stamps, and all of the other items one so neatly arranges around the age of nine.

While every detail in the construction of this work seems to point in the direction of childhood, the artist told me that, remarkably, he himself was aware of no such association, until his mother came into his studio just after he finished the work and told him that as a youngster he used to arrange stones and shells from that very same beach in Rogers Park (on the North Side of Chicago) where he had recently gathered these. At that moment, he said, he had a sudden rush of emotional recognition, as feelings from childhood flooded in.[2]

Spector's *Shell Book* reminds us of how the form, materials, and structure of an ostensibly nonrepresentational work of art may give us an opening to our past and allow us to bring it into a fresh relationship with the present. It reaffirms my conclusions, in the first chapter of this book, that abstract forms and compositional systems may carry specific constellations of meaning like representational form and, as set out in the second chapter, that artists can consciously manipulate significant form, composition, and even the materials themselves to reorganize the

57. Buzz Spector, *Shell Book*. 1983. Altered book with stones and shells, 8 in. × 11¾ in. (20.3 cm × 29.8 cm). Museum of Contemporary Art Chicago. Restricted gift of Ira G. Wool and Illinois Arts Council, Purchase Grant, 1984.10. Photo: Nathan Keay, © 2015 Buzz Spector / Museum of Contemporary Art Chicago.

relations between the meanings embodied in forms. At the moment in which the feelings of childhood came into consciousness, Spector instantly assimilated them into his present sense of being in the world.

What if the reintegration of childhood that occurred in Buzz Spector's work, cascading from that moment of recognition, changed the way in which he responded to new events more broadly? What if that experience tapped into a set of psychological issues that was widely shared by others, so that they could immediately and robustly empathize with the satisfactions he found in that arrangement? Could such a collective experience change the outlook of a number of other people in the same way that it changed the outlook of the artist? Could it provide a communicable reorganization of the psyche with a social and political impact?

In this chapter my subject is art and politics, and I want to examine the way in which the symbolic embodiment and reordering in works

58. Diego Rivera, *Man, Controller of the Universe*, detail with Leon Trotsky holding a banner that says, "Workers of the World Unite in the 4th International." 1934. (Originally, *Man at the Cross Roads*. 1933. Rockefeller Center, destroyed.) © 2015 Banco de México Diego Rivera Frida Kahlo Museums Trust, Mexico, D.F. / Artists Rights Society (ARS), New York.

of art may reframe the way in which we engage with the world, not only as individuals but as a society. I don't want to argue that Buzz Spector's work is intended as a political statement, but only that my own immediate empathic leap into his reconnection with childhood points toward what I believe is the underlying mechanism by which works of art may have an even more profound political influence than overt representations of political content. There is a consistent, formal structure in a great work of art that directs us on a defined path that largely parallels the thoughts of the artist. What follows is a close look at a few examples of different ways in which this can happen.

When we think of art and politics we naturally turn first to artists who deliberately set out an explicit political agenda. In one section of the famous fresco of 1934 *Man, Controller of the Universe*, painted by Diego Rivera for the Palace of Fine Arts in Mexico City, the artist shows the Marxist expatriate Leon Trotsky holding a red banner that says, "Workers of the World Unite in the 4th International." The explicit

59. Diego Rivera, *Man, Controller of the Universe*. 1934. Palacio de Bellas Artes, fresco. (Originally, *Man at the Cross Roads*. 1933. Rockefeller Center, destroyed.) © 2015 Banco de México Diego Rivera Frida Kahlo Museums Trust, Mexico, D.F. / Artists Rights Society (ARS), New York. Photo by Bob Schalkwijk.

political agenda is clear. The Third International, or Comintern, was organized by Vladimir Lenin in March 1919 in Moscow as an international communist organization to overthrow the bourgeoisie and create an international Soviet republic, and ultimately to abolish the state altogether. Leon Trotsky, expelled by Stalin and exiled to Mexico in 1929, was hoping to build a Fourth International to oppose Stalin. But Rivera's mural, like all genuinely great works of art, goes beyond sloganeering and illustration. It engages the viewer on a visceral level, opening us up to the content in less obvious but more profound ways.

Rivera's brilliant description of individual character, the mastery of drawing so that each moment of every line is deliberate and purposeful, the way he orchestrates the color (giving each face a hint of the red in the banner, for example, to bring them together visually, intuitively, and conceptually), the compositional energy of the dynamically angled flag set off against the static horizontal line of figures in the front—all of these formal choices open the viewer up unconsciously to the content, while at the same time enlisting her or him intellectually through the imagery. To return to my example of Buzz Spector's *Shell Book*, we find ourselves unwittingly making an empathic leap with Rivera purely on the level of form in this mural. It may not take us all the way with him politically, but it does open us more to his argument. He situates

us so we feel a part of the masses of individuals—both well-known and unknown—whom he describes in his painting. That too conveys an important social and political message.

The psychoanalyst Erik Erikson, in his book *Gandhi's Truth*, shows us how the inspirational founder of a nation marshaled his own inner anxieties to shape a self-definition that in turn provided a paradigm of selfhood for a whole people.[3] Ideology and charismatic leadership, Erikson argues, rest on an organization of identity in which others can also find themselves. If we identify with Gandhi, it is because his powerful and creative reorganization of reality for himself has inspired in us a fresh posture toward the exigencies of our own lives. "I read in Gandhi's autobiography," Erikson writes,

> of the method he came to call "truth force." . . . The man, his method, and some of his first followers converged in Ahmedabad in 1918 in such a way that his philosophy of militant nonviolence became a *political instrument* ready to be used on a large scale and reaching far beyond the issue of industrial peace in the city of Ahmedabad. Only then can we see the place of such events in man's psychosocial evolution and recognize the singular importance of Gandhi's Truth in a future which will pit man's naked humanity against the cold power of super machineries.[4]

We make a similar empathic projection in reading the highly charged structure of a great work of art.[5] We allow ourselves to try on the perspective of the artist in a setting that is at a safe remove from reality. Rivera is, perhaps, the greatest fresco painter since the Italian Renaissance precisely on account of his mastery at eliciting empathy through formal effects on a mural scale. Rivera originally painted *Man, Controller of the Universe* for the lobby of Rockefeller Center in New York City and titled it *Man at the Crossroads*, but when John D. Rockefeller saw the portrait of Lenin, just to the right of the center, he had Rivera removed from the premises and destroyed the mural. Rockefeller's reaction is a testament to Rivera's effectiveness in communicating his meaning.

Using formal devices to move viewers unconsciously, with a political agenda, is not new in the history of art. Another storied example is that of the builders of the cathedral at Chartres, at the end of the

60. Chartres Cathedral, west façade (Royal Portal). Ca. 1145–70. Photo: Achim Bednorz, Köln.

twelfth century. They developed a programmatic political message by alternating figures of kings and saints on the main entrance. Already by the thirteenth century the west façade of Chartres was known as the "Royal Portal" because the sculptures lining the doorjambs across the front depict Old Testament kings and prophets as well as the "Ancestors of Christ, men and women mostly in royal attire."[6] People at the time immediately understood these figures to symbolize the assertion that the lineage of the modern kings of France was rooted in the Old Testament, lending further legitimacy to their power.

In Chartres, the king and the clergy wanted to present a unified front in opposition to a population that was increasingly restive about bearing the heavy costs of all the building that was going on and of the armies that had gone off to the Crusades.[7] Like today, it was all about

61. Chartres Cathedral, interior of the nave looking up. Ca. 1145–70. Photo: Achim Bednorz, Köln.

taxes: who had rights to tax whom and how much the citizens would tolerate. "The tensions at Chartres created by the bishop, canons, and count competing for town jurisdiction did affect the fabric and imagery of the cathedral," writes the art historian Jane Williams in her book on Chartres. The "peaceful images in stained glass of the kings, nobles, bishops, canons, merchants, and tradesmen . . . belied the social reality."[8]

Disputes boiled over repeatedly between, on the one hand, the town and the nobility that owned the land and, on the other side, the church and the king. In 1195 the pope himself had to send emissaries to try to resolve the conflicts at Chartres. But the discord continued to simmer and it erupted again in a violent revolt in 1210 and again in 1215.[9] Even the king (the powerful Phillip II) paid a visit to quiet things down but barely stayed an hour when he saw how volatile things had become.

62. Chartres Cathedral, close-up view of jamb figures, central portal, right. Ca. 1145–70. Photo: Achim Bednorz, Köln.

Modeled on Abbot Suger's program for the Church of St. Denis, the message of the sculpture, stained glass, and architecture of Chartres Cathedral was an affirmation of the ascendant authority of the king and the church, bound together.

Who could fail to be awestruck by the overpowering verticality of the architecture, the intimidating heights, the structural lightness of Chartres Cathedral, even today? The magnificent realism of the carved stone faces and hands of the jamb figures, set off against the expressive elongation of the bodies and the beautiful abstract patterns of line in the flowing robes, and the decorative richness of the alternating columns and capitals behind them, must also have inspired a sense of authority by the mastery with which they were created. We are urged "onward from the material to the immaterial," Abbot Suger had said of his church at St. Denis.[10] Even the "dull mind," he said, "rises to truth through that which is material."[11] Here at Chartres it was clearly understood by the builders that the aesthetic affects played a role in winning hearts and minds. It was effective propaganda because of the brilliance of its material execution.

In the photomontage of 1990 called *Subspecies Helms Senatorus*, by

63. David Wojnarowicz, *Subspecies Helms Senatorus*. 1990. Cibachrome, 12½ in. × 19 in. Courtesy of the Estate of David Wojnarowicz and P.P.O.W Gallery, New York.

the American artist David Wojnarowicz, it is again the visual mastery that makes the viewer receptive to its political message. Wojnarowicz portrays North Carolina senator Jesse Helms as a frightening, poisonous spider with a Nazi swastika on its back, lurking in a lush garden of orchids and morning glories. Helms led a chorus of radical right-wing ideologues who pushed their personal social and religious agendas onto the rest of the country through public policy for thirty years, beginning in the 1970s. Wojnarowicz took it personally. He used this image as the announcement card for an exhibition of his work in New York, and his gallery mailed it out to a long list of people all over the country. The text on the back side of the card reads, "In the garden (sub-species Helms Senatorius) found in North Carolina and Washington DC; this arachnid is responsible for cutting all Federal funding for safer-sex education designed to inform Lesbians and Gay Men, thereby leaving scores of the population at risk of contracting AIDS."

The political impact of this work depends on our intuitive response to the color affects and the startling overlay of images, which engage our feelings ahead of whatever we might think about the overt message. Set against the beautiful flowers, the jarring contrast of the orange and

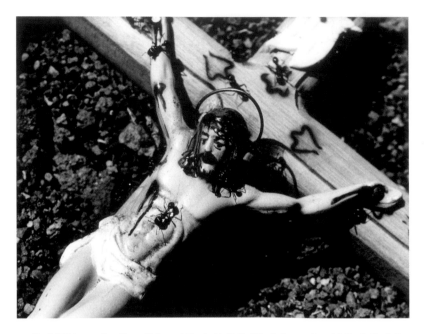

64. David Wojnarowicz, film still from *A Fire in My Belly (Film in Progress)* and *A Fire in My Belly Excerpt*. 1986–87. Super 8mm film transferred to video (black and white and color, silent). 13:06 min. and 7:00 min, respectively. Courtesy of the Estate of David Wojnarowicz and P.P.O.W Gallery, New York, and the Fales Library and Special Collections, New York University.

yellow with the midnight blue on the sharp-tipped legs of the outsized spider is disturbing, making the face of Jesse Helms uncomfortable to look at, even if you were sympathetic to the senator's views.

David Wojnarowicz was a brilliant manipulator of images. Twenty-five years after the fact, the layering of pictures in his brief, silent video clip from 1986–87, *A Fire in My Belly*, caused a national political stir. In 2011 it was shown in a large exhibition about gay identity at the National Portrait Gallery in Washington DC and the Republican majority leader of the U.S. House of Representatives was so outraged that he threatened to shut down funding for the entire Smithsonian Institution if the work was not removed from display.

The particular image that so upset Congressman Cantor is a crucifix, lying on the ground, with ants crawling over it. It appears for a few seconds at a time, altogether less than a minute, on a thirteen-minute, 8-millimeter film. Like many of his favorite images, Wojnarowicz used the image again and again in other works, as in his 1991 painting *Why*

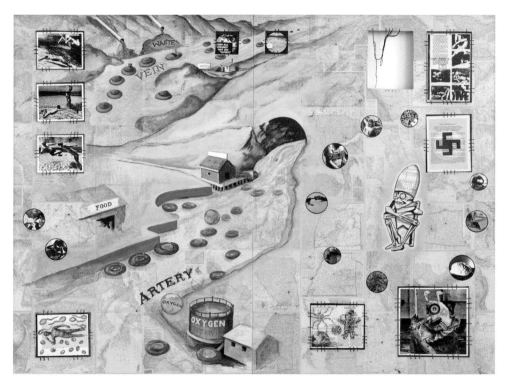

65. David Wojnarowicz, *Why the Church Can't/Won't Be Separated from the State; or A Formal Portrait of Culture.* 1991. Black-and-white photograph, acrylic, spray paint, photostat, lithograph, string, and collage on masonite, 8 ft. × 12 ft. Courtesy of the Estate of David Wojnarowicz and P.P.O.W Gallery, New York.

the Church Can't/Won't Be Separated from the State; or, A Formal Portrait of Culture. The images in this painting come from disparate sources and we understand them in their accumulation and juxtaposition, as in a poem, rather than as a linear logic. The three photographs in the upper left, for example, depict an underwater rescue illustrated in a manual on swimming safety.[12] In the two circular insets below these images, the artist inserted pictures lifted from gay pornography.[13]

All of the rectangular images in the painting are sewn with a bright red string into windows cut through the Masonite support, lending a handmade physicality to the entire work. In that way, Wojnarowicz added another level of language (another semiotic level); "stitching" the work connects it to the kind of experience that is perceived in terms of a body experience. The square in the lower left depicts an idealized,

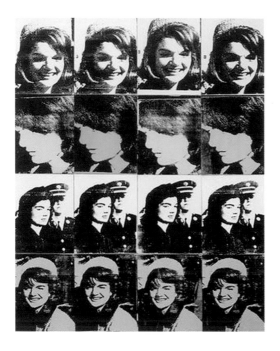

66. Andy Warhol, *Sixteen Jackies*. 1964. Acrylic, enamel on canvas, 80⅜ in. × 64⅜ in. Walker Art Center, Minneapolis. © 2015 The Andy Warhol Foundation for the Visual Arts, Inc. / Artists Rights Society (ARS), New York.

naked male statue, set sideways and surrounded with drawings of sperm and blood platelets. Taken together, all the images in this work evoke aspects of the AIDS crisis—the need for emergency rescue, the communication of the disease through unprotected sex, the emphasis on body physicality, the role of bodily fluids (sperm and blood).[14]

Wojnarowicz constructed the overall backdrop for this painting from a grid of U.S. state maps, and over the maps he painted a desolate landscape that is, at the same time, a schematic diagram of his bloodstream, poisoned by his illness. The blue river, labeled "VEIN," has pipes disgorging piles of toxic waste on its shore; the rich red "ARTERY" is bordered by a storehouse of food and an "OXYGEN RECEIVER" tank. The painting is complex, with constantly shifting languages and layered frames of reference, from the fleshy landscape, to the maps, to photographic images, to texts.

In the generation before Wojnarowicz, Andy Warhol had taught us how to read media images as detached from stable meanings in the world of things. His 1964 *Sixteen Jackies*, for example, was not really about Jackie Kennedy. Instead, it refers to the media images taken of her. He makes us think of these pictures of Jackie—at one moment

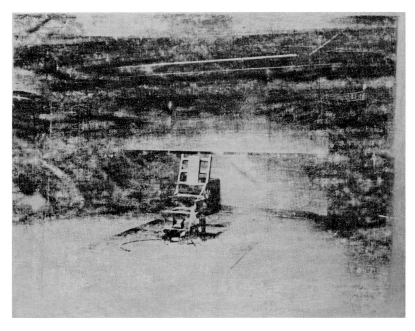

67. Andy Warhol, *Electric Chair.* 1964. © The Andy Warhol Foundation for the Visual Arts, Inc. / Artists Rights Society (ARS), New York.

smiling and at the other mourning—as all, in some way, equivalent. The *Electric Chair* (of 1964) is also a familiar image, detached from the reality of what it alludes to in the world. Instead, he presents it as something we can repeat over and over on a flat plane or screen of images, in different colors, and manipulate as we wish, giving it an entirely different meaning in whatever context we create for it.

Wojnarowicz takes this lesson in reading images one step further, focusing not just on the detachment of the images but on what it does to our thought processes to assimilate and rearrange images constantly and in arbitrary abundance. The explicit subject of the painting by Wojnarowicz is the way in which religious views have invaded civic life in America and how that affected the artist himself as a gay man with AIDS. But the way in which he juxtaposes and layers the images and techniques—the sense of dislocation and its ethical implications—is even more fundamentally disturbing than the images themselves. His talent at recontextualizing images—pictures from media, packaging, the flood of things we see around us every day and remember as pictures

68. Andrea Fraser, *Official Welcome*. 2001/2003. Live performance at the Kunstverein Hamburg and video. Video still. Courtesy the artist.

in our heads—taught everyone who has looked seriously at his work to see the world differently, to see the disorienting profusion, rather than reductively ordered categories and sequences. Layering his political message in metaphors of the body, transforming maps, text, and the bloodstream into a landscape, Wojnarowicz causes the viewer to restructure his or her own experience and opens our eyes to a world that is overwhelming in its complexity and simultaneity. It feels out of control. His political message about AIDS then follows naturally out of our openness to his bewildering shifts in perspective.

The Los Angeles—based artist Andrea Fraser models her work on the methods of psychoanalysis, performing different roles, using texts, even directly using her own body to reveal the contradictions and ethical conflicts of the art world and, by extension, of society at large. As in psychoanalysis, these interventions almost unaccountably provoke moments of insight that reveal the political structures inherent in our social relations and in our political norms. Here the aesthetic medium is not an object but a public action. In *Official Welcome* of 2001, for example, she delivered what one critic described as "a wickedly funny play on the self-congratulatory, aren't-we-all-fabulous nature of introductory remarks."[15] In the words of another writer, the piece "takes the form of oratory, composed largely of quotations from relatively well-known figures in the art world such as Benjamin Buchloh, Gabriel Orozco, Kirk Varnedoe, Vanessa Beecroft, Michael Kimmelman, Larry Gagosian, Charles Saatchi, and Kara Walker."[16]

In *Official Welcome*, Fraser stands at a podium in front of an intimate

69. Andrea Fraser, *Official Welcome*. 2001/2003. Live performance at the Kunstverein Hamburg and video. Video still. Courtesy the artist.

audience in a wealthy collector's living room (or, as in a 2003 performance of the piece, in a private dining room at the Museum of Modern Art in New York). Her remarks begin as though she were a curator introducing an artist she has invited to speak at this intimate but formal dinner. Seamlessly, her voice metamorphoses into that of the unspecified artist. "I am not a person today. I'm an object in an artwork," she says, not for a moment pausing in her talk as she takes off all her clothes and stands naked in front of the smartly dressed dinner guests.[17] The private nature of the venue makes this performance particularly uncomfortable.

"One of the most important legacies of Minimalism and Conceptualism for me," Fraser told an interviewer in 2004, "is the idea that what constitutes an art work is not just the thing, but all the conditions of the production and presentation and distribution of the thing. Because, to a large extent, that's where the meaning, the social meaning, of an art work is made."[18] It's worth quoting at length her description of presenting a video of *Official Welcome*, the performance I have just described, and of her surprise at discovering the strong irrational emotion laden in the piece for her. She writes,

> When I went back up to the podium after the screening I actually was weeping. . . . It occurred to me that the destabilizing potential of *Official Welcome* might lay precisely in affect, in the excess of affect as well as in what may be excessive about affect itself. That is, that what we want and what we feel is not contained within the structures of economic exchange, or within institutionalized structures of recognition, or by the rewards and forms of satisfaction we are offered

70. Andrea Fraser, *Untitled*. 2003. Project and video (60 minutes, color, no sound). Video still. Courtesy the artist.

in our field. And those affects, those feelings, are destabilizing. . . . The role of art is like that of psychoanalysis: it's about bringing us to the question of what we want. And one of the ways it does that is through the release of affect that's gotten displaced, misplaced, alienated, and bound up with things it doesn't really have anything to do with.[19]

The affect she describes is the out-of-control aspect of the emotional content in the work. Here again it's like Spector arranging his stones and shells, but instead of mastering the content symbolically on a canvas or in an object, she masters the content in the form of her theoretical analysis and in her control of the protocols of the presentation. And yet the suppressed thoughts circumvented all the theory and logic, causing her to weep unaccountably.

In 2003 Fraser scandalized the art world by rigorously following this line of inquiry to the next logical step in a piece innocuously called *Untitled*. Fraser asked her dealer, Friedrich Petzel, to find a collector willing to pay to have sex with her in a stylish hotel room, on camera, and let the gallery produce a DVD of the event for sale. "The amount

was not set as a 'price' for sex with me," Fraser points out. "It was set according to what the dealer who brokered the commission thought a single-channel videotape by Andrea Fraser, produced in an edition of five, would be worth at that time—irrespective of content. It was for the first exemplar of that edition that the participating collector was billed."[20]

As Susan Cahan notes in an essay on the work, "There is no sound, and the piece uses none of the conventions of pornography, such as close-ups, heavy breathing, and 'money shots.'" Moreover, the artist and collector, who had never met before, "appear to enjoy the experience."[21] *Untitled*, Cahan explains, investigates the relationship between the artist, her work, and what happens in the exchange between an artist and collector when the work becomes a material object for sale, independent of the artist's control and individual action. As Fraser explains it, "That piece attempts to circumvent the normal situation in which the artist's work is treated as a material commodity."[22]

In the usual exchange between a collector and an artist, the work is an object, and the relation between the collector and artist is displaced onto each person's relations with things. From a Marxist point of view, this alienates the artist from her labor. Whereas in *Untitled*, "the relations between artist and collector have been stripped of material mediation," Cahan writes. "The social relation between Fraser and the collector is the work of art. Moreover, the collector is implicated as a participant in the creation of the work as the resulting piece is both his and the artist's 'labor.'"[23] Fraser notes that "what constitutes *Untitled* in my mind is precisely the confrontation of these conditions of economic exchange . . . with an interpersonal exchange that I do believe resists and transforms those economic conditions."[24] She continues:

> The fact is, we are always selling ourselves—whenever we work for pay. Artists are sometimes considered exempt from the alienation entailed by the commodification of labor because of the control we have over our production. The personal investment we make in our labor is rewarded by the privilege of being recognized and recognizing ourselves in and through its products. However, . . . prostitution has also been evoked as a metaphor for the sale of something as

personal and dear as art should be for artists: parts of ourselves, our creations, our children, our labors of love. . . . The participating collector was less a buyer or a john than a collaborator without whom that work could not have been made. He contributed not only by entering into an economic but also an interpersonal and a physical exchange, and finally, by performing in front of the camera himself, along with me. . . . Without that affective dimension, without that confrontation between economic and human exchange, *Untitled* could be just another extension of market rule.[25]

Fraser's *Untitled* is certainly no more graphic than any number of films we've all seen in movie theaters or on cable TV. The style of the footage and of the display — by contract, on a small monitor, in the middle of a well-lit gallery, where the viewers have to stand to watch it — pointedly minimizes the prurient aspects. Yet it is nevertheless shocking. It isn't the sex that's shocking, however, it's the politics of the situation. As Fraser explains it,

It's like someone who sneaks up behind you, shouts into your ear, and makes you laugh suddenly or brings you pain, and then disappears again. It's an eruption of completely unexpected understanding. I do think that's how a "critique" or "critical intervention" should work. . . . But I can't project what kind of understanding it might be. That's how *Untitled* may differ most from all of my other work. . . . With *Untitled*, I had to accept from the start that I wouldn't be able to control its meaning, in part because when I started I wasn't sure what it would mean. I still can't say that I know.[26]

Fraser's work is what the artist Robert Arneson so graphically suggested in his 1982 drawing *Eye of the Beholder*: it's a poke in the eye. It's uncomfortable to look at and at the same time beautiful precisely because the mastery in its execution makes the content not just palatable, but disconcertingly satisfying. We are attracted by Arneson's handling of color and line and that opens us to the content. In Andrea Fraser's *Untitled*, the mastery is on the level of verbally articulating the subject and orchestrating the circumstance in which she is (and we are) brought to a moment of disorganizing experience and insight. The exquisite

71. Robert Arneson, *Eye of the Beholder*. 1982. Acrylic, oil pastel, alkyd on paper, 52 in. × 42 in. (132 cm × 107 cm.). Private collection. © 2015 Estate of Robert Arneson / Licensed by VAGA, New York, NY.

control with which she articulates the power relations between the artist and the art consumer allows us cover to look at something transgressive. The content that she discovers in the work but did not expect, nor fully understand herself, is where the revelation takes place. Artists are often drawn to such difficult subject matter precisely because they recognize that it is there, and they feel compelled to come to terms with it.

The encounter with that kind of content—with repressed wishes and

thoughts, with subject matter that society forbids—produces anxiety. The famous postwar composer Morton Feldman writes that "while in life we do everything we can to avoid anxiety, in art we must pursue it."[27] Yet there is also elation, real joy, in the success of the work for both artist and viewer. We identify with the artist in feeling the pain and the anxiety but also in the way in which the artist masters them symbolically.

Increasingly, today we also see political art that, instead of leading us to identify with a personal moment of introspection and mastery, enlists us to political and social activism as part of communities (defined by either physical proximity or group identification).[28] In the late 1960s and 1970s American feminists began using the phrase "the personal is political" to point to the way in which abortion rights, in particular, made a woman's body the site of political conflict. David Wojnarowicz in the 1980s and 1990s used the gay body as a political site. In the twenty-first century the idea of the body or the person as an art medium has been expanded in recognition of the way individuality itself has been colonized by large, anonymous corporate and governmental entities. In 2006 Theaster Gates, an artist on the South Side of Chicago, purchased a former "crack house" at Sixty-Ninth and Dorchester Streets and leveraged loans to begin renovating it into a beautiful neighborhood art space. He reframed the way the place was framed in the imagination to literally change its definition. By changing the way buildings in this previously blighted neighborhood are perceived in the neighborhood and among the art world he fundamentally changed the actual neighborhood. As Chicago mayor Rahm Emanuel said, "Theaster is creating a culture zone, a cultural central point on the South Side."[29] Gates built *12 Ballads for Huguenot House* as part of Documenta XIII (an internationally famous art exhibition in Kassel, Germany) using pieces from the renovation of the house at 6901 South Dorchester; in this case he transformed an abandoned house in Kassel into a performance space.

The work of Buzz Spector, Diego Rivera, the builders of Chartres Cathedral, David Wojnarowicz, Robert Arneson, Andrea Fraser, and Theaster Gates exemplify different ways in which aesthetic experience has opened our patterns of thought and given us mastery over the content they reveal. They speak to the singularity and unpredictability of

72. Theaster Gates, 2012 Dorchester Projects, 6901 S. Dorchester, Chicago. Courtesy Kavi Gupta Gallery, Chicago.

our encounter with a work of art. "It is not that the artwork represents an immutable truth exterior to the subject," Manuel Borja, the director of the Reina Sofía in Madrid, told his auditors in a lecture in 2007. "It is an enigmatic signifier whose radical ambiguity allows and even demands mobility of relations, the contingency of beings and things."[30]

Borja's observation underscores a fundamental change in culture since 1970 that we have come to call postmodernism. It is a broad assimilation of the startling implication of quantum mechanics from the teens and twenties of the last century: the idea that there can be multiple overlapping universes of truth—like quantum mechanics on a subatomic level and Newtonian physics in the macro world—that have fundamentally different rules that cannot be reconciled. This prompted the Nobel Prize—winning physicist Richard Feynman to tell his Caltech freshmen in 1961, "*Yes! Physics has given up. We do not know how to predict what would happen in a given circumstance*, and we believe now that is impossible—that the only thing that can be predicted is the probability of different events. It must be recognized that this is a retrenchment in

73. Tuileries Gardens, Paris. Courtesy of John and Anne D. Hedeman.

our earlier ideal of understanding nature. . . . We suspect very strongly that it is something that will be with us forever—that it is impossible to beat that puzzle—that this is the way nature really is."[31]

In a 1972 novel called *Journey to Ixtlan*, Carlos Castaneda writes about his purported conversations with an enigmatic Native American mystic named Don Juan, who teaches the author in the ways of shamanism. "In order to arrive at 'seeing,'" Don Juan tells him, "one first had to 'stop the world.'" It is a state, Castaneda writes,

> of awareness in which the reality of everyday life is altered because the flow of interpretation, which ordinarily runs uninterruptedly, has been stopped by a set of circumstances alien to that flow. . . . Don Juan's precondition for "stopping the world" was that one had to be convinced; in other words, one had to learn the new description in a total sense, for the purpose of pitting it against the old one, and in that way break the dogmatic certainty, which we all share, that the validity of our perceptions, or our reality of the world, is not to be questioned.[32]

74. Tuileries Gardens, Paris, sculpture damaged in the *événements de mai*. 1968. Photo: Jonathan Fineberg.

"Stopping the world" was precisely what the radical students and workers in Paris had in mind when they revolted against the government in the 1968 *événements de mai* and ran through the Tuileries Garden throwing red paint on the eighteenth-century statues. These meticulously landscaped royal gardens of the Palais du Louvre stand for the stable perpetuity of the French ancien régime. The students recognized that with red paint they could appropriate the statues into their own new movement as powerful symbols. The great achievements in modern art are likewise triumphs of disruption and appropriation that mean to break up our perceptual habits and open a fresh perspective on events and on the language in which we frame them.

Figures like Gandhi, as well as great artists, are needed precisely because our "reality of the world" is constantly failing in regard to the evolving state of existence. It is in the symbolic reordering of our experience in a work of art or in the contagious moment of psychic reorganization prompted by a public event like Gandhi's satyagraha—his "truth force"—that we realign our inner selves with our circumstances.

The American artists Christo and Jeanne-Claude have deliberately

75. Christo, *Running Fence (Project for Marin and Sonoma Counties, State of California)*. 1976. Pencil, pastel, charcoal, wax crayon, topographic map, technical data, tape, and ballpoint pen, drawing in two parts, 15 in. × 96 in. and 42 in. × 96 in. (38 cm × 244 cm and 106.6 cm × 244 cm). Photo: Eeva-Inkeri, © 1976 Christo.

embraced the "mobility of relations" to which Borja alludes. Not only have most of their projects (largely because of their scale) been physically impossible to apprehend, except over time, but the perplexing multiplicity of perspectives colliding with one another is intrinsic to the conception of these works. "There's not one vantage point which should be seen or a unique point of perception," Christo explains. Every individual has her or his own account of experience in relation to any one of these projects. "They're all slices of different types of interpretations. I think this is how the work is."[33]

For this reason, Christo and Jeanne-Claude assiduously avoid ever talking about "the meaning" of any of their projects. "Our art has absolutely no purpose except to be a work of art," Jeanne-Claude explains. "We do not give messages."[34] They made these projects because they wanted to see them, and "the only way to see it is to build it."[35] Nevertheless, the large public projects of Christo and Jeanne-Claude do disrupt the ordinary flow of interpretation, to use Castaneda's metaphor; they fundamentally alter the reality of everyday life for entire communities. "I don't think any of the museum exhibitions," Christo told me in 1977, "have touched so profoundly three hundred people (as our ranchers),

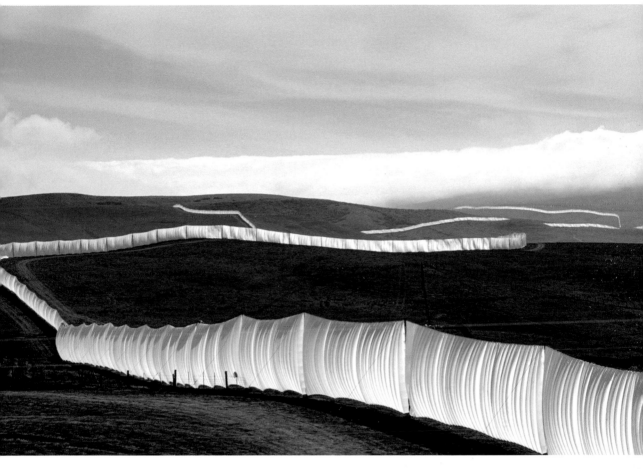

76. Christo and Jeanne-Claude, *Running Fence, Sonoma and Marin Counties, California, 1972–76.* 1976. Photo: Wolfgang Volz, © 1976 Christo.

or three hundred thousand cars who visited *Running Fence*, in a way that half a million people in Sonoma and Marin counties were engaged in the making of the work of art for three and a half years."[36] Robert Arneson, who lived near the project, quipped, "When the *Fence* was up it was great! The checkout ladies in the supermarket were arguing about the definition of art!"[37]

The 18-foot-high, 24½-mile-long *Running Fence, Sonoma and Marin Counties, California* was completed in September 1976 and then removed after two weeks. It traversed private ranches, intersected fourteen roads and a major highway, passed through the middle of the town of Valley

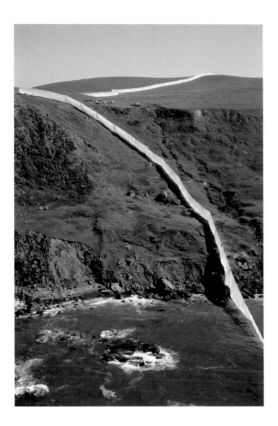

77. Christo and Jeanne-Claude, *Running Fence, Sonoma and Marin Counties, California, 1972–76.* 1976. Photo: Wolfgang Volz, ©1976 Christo.

Ford, and descended into the ocean at Bodega Bay, just north of San Francisco. It was too large to be seen in its entirety even from an airplane. The permissions required four years of negotiations with fifty-nine ranchers, a 450-page environmental impact report, eighteen public hearings (including three sessions of the Superior Courts of California), and it cost $3.2 million, which—as in all the projects of Christo and Jeanne-Claude—the artists paid for entirely by the sale of Christo's collages, drawings, sculptures, and models.[38] They never accepted grants nor sold souvenirs, posters, movie rights, or even photo rights for their projects (they gave all of these things away).

Christo and Jeanne-Claude constructed *Running Fence* with 2,152,780 square feet of heavy, woven, white nylon fabric, hung from a steel cable strung between 2,050 steel poles (each 21 feet tall and 3.5 inches in diameter). The poles were embedded 3 feet into the ground, using no concrete, and braced laterally with guy wires (made from 90 miles

of steel cable) attached to 14,000 earth anchors. The top and bottom edges of the 2,050 fabric panels were secured to the upper and lower cables by 350,000 hooks. The team of engineers designed all parts of the structure of *Running Fence* so that everything could be completely removed, and today no visible evidence of *Running Fence* remains on the hills of Sonoma and Marin Counties. It had been agreed with the ranchers and with county, state, and federal agencies that the removal of *Running Fence* would start fourteen days after its completion and that the ranchers would receive all the materials for their use. Some ranchers covered trailers of manure with the fabric and others made wedding dresses. Christo and Jeanne Claude loved reciting all of this factual data.

Christo and Jeanne-Claude not only formed a collaborative practice with one another, they collaborated with teams of engineers and workers, and they attempted to enlist everyone in the community for these vast collective projects. Like Franz Kafka's imagined land of opportunity in his unfinished novel *Amerika* — a utopia where one could reinvent oneself and escape from the traditional hierarchies of class and morality — Christo and Jeanne-Claude stood ready to sign up one and all for their version of what Kafka called "The Nature Theater of Oklahoma," an "almost limitless" theater where everyone gets hired.[39]

In the 1960s Christo began to imagine large-scale projects, packaged buildings, and walls of oil barrels. In 1968 and 1969 he and Jeanne-Claude created giant air packages, wrapped public monuments and art museums, and covered a mile-long stretch of rocky coastline in Australia with fabric and ropes. In 1972 they stepped into the popular media by hanging a 1,250-foot-wide, bright-orange curtain across a mountain valley in Rifle, Colorado, between Grand Junction and Glenwood Springs. They worked on *Valley Curtain* for over two years and finished on August 10, 1972. On the first try, the previous summer, winds in the valley had shredded the fabric, and when they came back with a new curtain in the summer of 1972, they barely managed to install it before a sixty-mile-an-hour gale tore through the valley and forced them to take it down. But they displayed the finished project for twenty-eight hours and it was a big story on the nightly television news across America. The engineering specifications, the fabric samples, and

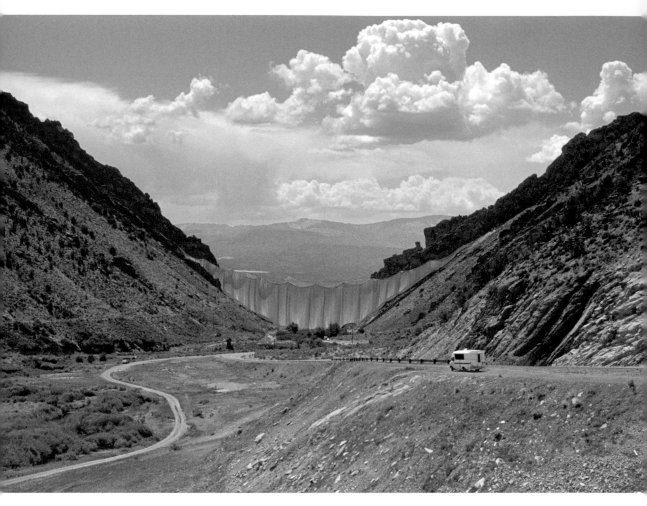

78. Christo and Jeanne-Claude, *Valley Curtain, Rifle, Colorado, 1970–72.* 1972. Photo: Wolfgang Volz, © 1972 Christo.

the drawing of the envisioned finished project, shown here, convey a sense of reality, like an architectural rendering, persuading the viewer of the artists' serious intention to build this quite unbelievable construction. Christo and Jeanne-Claude continued to do enormous projects both in the landscape and in cities, dramatically escalating the cost and ambition and the celebrity of their work over time.

In May 1983 Christo and Jeanne-Claude unfurled their *Surrounded Islands* project in Miami around eleven of the fourteen islands in Biscayne

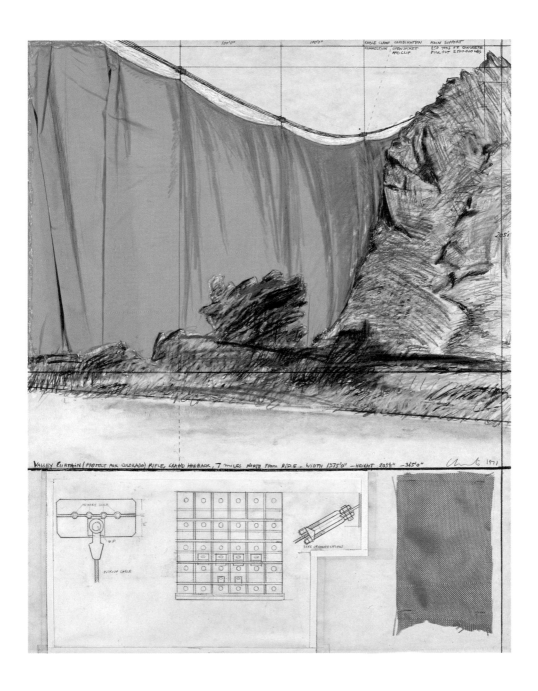

79. (*left*) Christo, *Valley Curtain (Project for Colorado)*. 1971. Collage, pencil, fabric, wax crayon, hand-drawn technical data, fabric sample, tape, and staples, 28 in. × 22 in. (71 cm × 56 cm). Photo: Harry Shunk, ©1971 Christo.

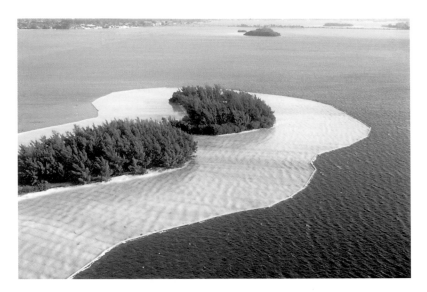

80. Christo and Jeanne-Claude, *Surrounded Islands (Project for Biscayne Bay, Greater Miami, Florida), 1980–83,* detail of island no. 3 from helicopter. May 1983. Photo: Jonathan Fineberg.

Bay. The Army Corps of Engineers created the islands in 1936 when it dredged the shallow bay for a navigational channel and dumped the dirt in fourteen piles off to one side. The artists had to solve a myriad of problems, like engineering a fabric that the hot Miami sun would not bleach white in a matter of hours and figuring out how to install the work without touching the endangered sea grasses that had grown up around these man-made islands. Moreover, the protracted battles in the courts about everything from endangered wildlife to the political payoffs made all aspects of the project extraordinarily public—and problematic. Over the two years of planning, *Surrounded Islands, Biscayne Bay, Greater Miami, Florida* gradually engaged more and more people in the process of making the work of art, regardless of whether they were for it or against it.

The construction data and photographs on Christo's drawings and collages add a sense of reality to the idea for each project at a point when it still exists only as a concept in people's minds. This builds the momentum that will eventually lead to the realization of the work, or not. Christo and Jeanne-Claude's projects complicate the boundary between art and life and make it difficult to segregate the work of art

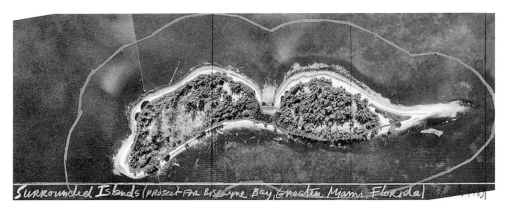

Surrounded Islands (PROJECT FOR Biscayne Bay, Greater Miami Florida)

woven polypropylene fabric (7 × 7 per inch) covering the surface of the water extending into the bay 200 Feet
Island #3, width 225 Feet length 1075 Feet

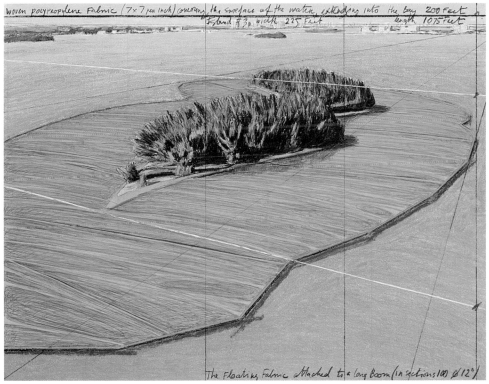

The Floating Fabric attached to a long Boom (in sections 100 @ 12')

81. Christo, *Surrounded Islands (Project for Biscayne Bay, Greater Miami, Florida)*. 1983. Pencil, fabric, charcoal, wax crayon, pastel, enamel paint, and aerial photograph, collage in two parts: 11 in. × 28 in. and 22 in. × 28 in. (28 cm × 71 cm and 56 cm × 71 cm). Collection of Betty and Joseph Fleming, Miami Beach FL. Photo: André Grossmann, © 1983 Christo.

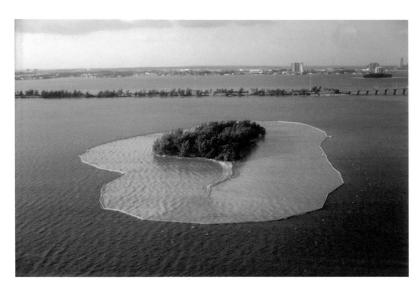

82. Christo and Jeanne-Claude, *Surrounded Islands (Project for Biscayne Bay, Greater Miami, Florida)*, 1980–83, detail of island no. 2 from helicopter. May 1983. Photo: Jonathan Fineberg.

from the public sphere. They prompt people to do a double take in the space of the everyday by fitting seamlessly into the real environment—physically, politically, economically, aesthetically. As early as the *Dockside Packages* of 1961, constructed on the functioning river docks in Cologne, this has been a central premise of their projects. One wouldn't at first distinguish the *Dockside Packages* from the normal stacks of cargo unloaded on the quays every day.

Confronted by something so unbelievable as the *Surrounded Islands*, *The Pont Neuf Wrapped*, or *Wrapped Reichstag* in the midst of a busy city makes reality itself seem like theater. It also brings us together, like those strange times when we're thrown into one another in a giant but beautiful snowstorm; it disrupts our normal activities, breaks down social hierarchies that separate us, and causes us to open up to strangers. In addition, these projects are simply so beautiful that we find our emotions somehow more accessible and we suspend our disbelief. That, in turn, makes us look at the most ordinary things around us as if we are seeing them for the first time.

"I think the project has some kind of subversive dimension," Christo has pointed out, speaking about *Surrounded Islands*, "and this is why we

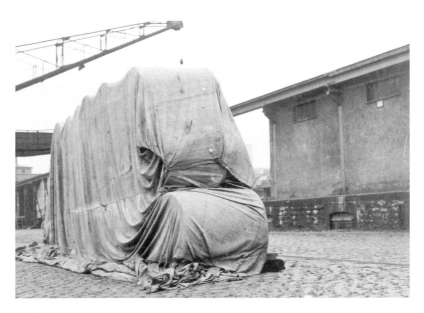

83. Christo and Jeanne-Claude, *Dockside Packages, Cologne Harbor*. 1961. Photo: Stefan Wewerka, © 1961 Christo.

have so many problems. Probably all the opposition, all the criticism of the project is basically that issue. If we spend $3 million for a movie set there would be no opposition. They can even burn the islands to be filmed and there would be no problem. The great power of the project is because it is absolutely irrational. This is the idea of the project, that the project put in doubt all the values."[40]

When I turned in my rental car at the airport the day after *Surrounded Islands* came down, the young man who drove me to the terminal for my flight home told me he had heard that Christo made $4 million on the project already. I pointed out that nobody paid admission, that the project was destroyed so nobody could buy it, and that the artists don't accept grants or sponsorships or take any of the income from the films and souvenirs. As I explained to the young man, Christo even stops making drawings and collages for his projects once they are realized. In addition, it cost the artists $3.5 million to build *Surrounded Islands*. So how, I asked him, did he think they might be making money on this? At that moment the young man really started to think about it for himself.

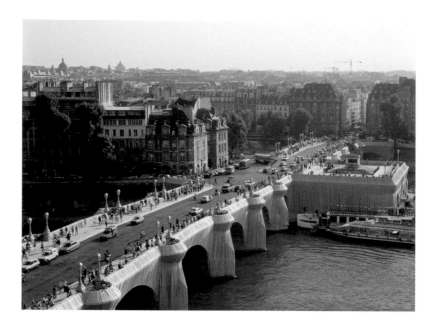

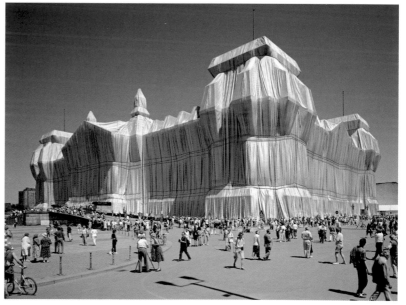

84. Christo and Jeanne-Claude, *The Pont Neuf Wrapped, Paris, 1975–85*. 1985. Photo: Wolfgang Volz, © 1985 Christo.

85. Christo and Jeanne-Claude, *Wrapped Reichstag, Berlin, 1971–95*. 1985. Photo: Wolfgang Volz, © 1995 Christo.

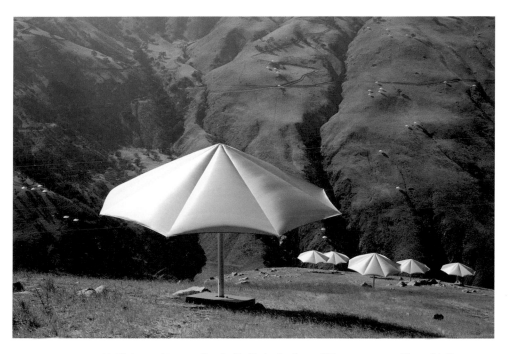

86. Christo and Jeanne-Claude, *The Umbrellas, Japan–USA, 1984–91*. 1981. Photo: Wolfgang Volz, © 1991 Christo.

Part of what makes these projects so subversive is that they engage the common practices of contemporary economics—marketing, finding collectors to invest by buying the studies, contracting manufacturers, managing public relations. The artists even simplified their names to "Christo" and "Jeanne-Claude" in order to market the brand. Then they negate capitalism's most distinctive feature: the accumulation of capital. The artists spend everything they have and even borrow money to do the projects and they make all of this transparent for everyone to see.

Millions of people came out to see *The Pont Neuf Wrapped* on September 22, 1985, when Christo and Jeanne-Claude completed it. As in all the projects, the very public process of the permitting and construction made the mechanisms of the place in which it went up exceptionally visible. People became involved as the process went along, and they continued to think about the project and all the events that unfolded around it long after the physical object was gone. In 1991 Christo and Jeanne-Claude installed *The Umbrellas, Japan-USA* at a cost of $26

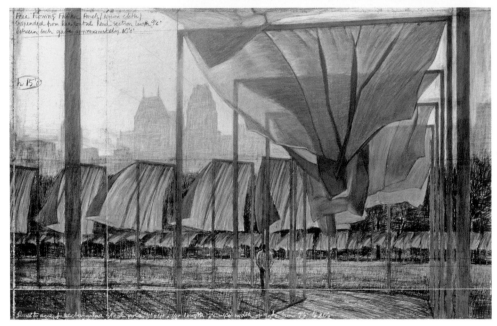

87. Christo, *The Gates (Project for Central Park, New York City)*. 2001. Pencil, charcoal, pastel, wax crayon, enamel paint, and aerial photograph, drawing in two parts: 15 in. × 65 in. and 42 in. × 65 in. (38 cm × 165 cm and 106.6 cm × 165 cm). Photo: Wolfgang Volz, © 2001 Christo.

million, in 1994 they spent more than $15 million wrapping the German parliament building (*Wrapped Reichstag, Berlin*), and on Saturday, February 12, 2005, Christo and Jeanne-Claude's workers unfurled 7,503 gates, sixteen feet tall, approximately twelve feet apart, along twenty-three miles of walkways in New York's Central Park. It was up for sixteen days.

Then, on November 18, 2009, Jeanne-Claude died from a ruptured aneurism in the brain. But they had planned for the eventuality of one them dying, and Christo has continued on with the two still-unfinished projects that they had planned together, as well as the giant air package

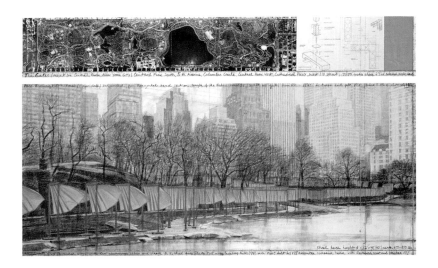

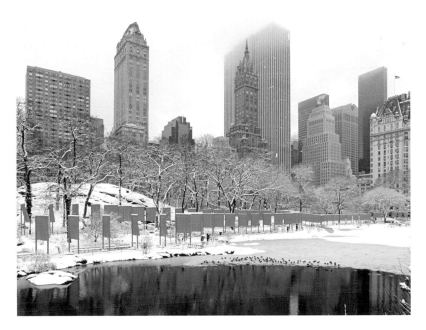

88. Christo, *The Gates (Project for Central Park, New York City)*. 2003. Pencil, charcoal, pastel, wax crayon, fabric sample, aerial photograph, and hand-drawn technical data, drawing in two parts: 15 in. × 96 in. and 42 in. × 96 in. (38 cm × 244 cm and 106.6 cm × 244 cm). Whitney Museum of American Art, New York. Gift of Melva Bucksbaum and Raymond Learsy. Photo: André Grossmann, © 2003 Christo.

89. Christo and Jeanne-Claude, *The Gates, Project for Central Park, New York City, 1979–2005*. 2005. Photo: Wolfgang Volz, © 2005 Christo and Jeanne-Claude.

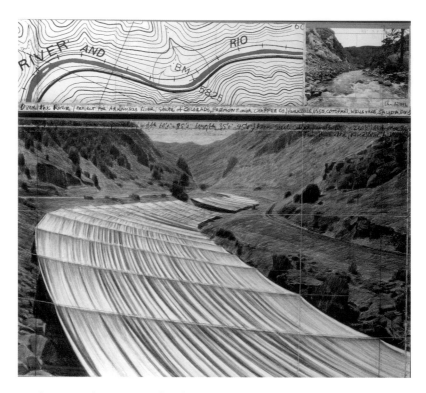

90. Christo, *Over the River (Project for Arkansas River, State of Colorado)*. 1999. Pencil, charcoal, pastel, wax crayon, topographic map, and tape, drawing in two parts: 15 in. × 65 in. and 42 in. × 65 in. (38 cm × 165 cm and 106.6 cm × 165 cm). Photo: Wolfgang Volz, ©1999 Christo.

that he conceived and built in Oberhausen, Germany, in 2013. The two major works in progress at this writing are *Over the River (Project for the Arkansas River, State of Colorado)* and *The Mastaba of Abu Dhabi (Project for the United Arab Emirates)*. At 492 feet high—higher than the Great Pyramid in Egypt—*The Mastaba*, made from 410,000 multicolored oil barrels, will be at once the largest sculpture in the world, a spectacular feat of engineering, and a global tourist attraction, by perhaps the world's most widely celebrated living artist. But it will likely be the extraordinary feat of funding this project that really opens people's eyes most dramatically. Christo and Jeanne-Claude's only permanent large-scale work, it has all the complexity of building a skyscraper both in its construction and in its economics.

The artists first proposed the project in 1978, thirty-seven years ago,

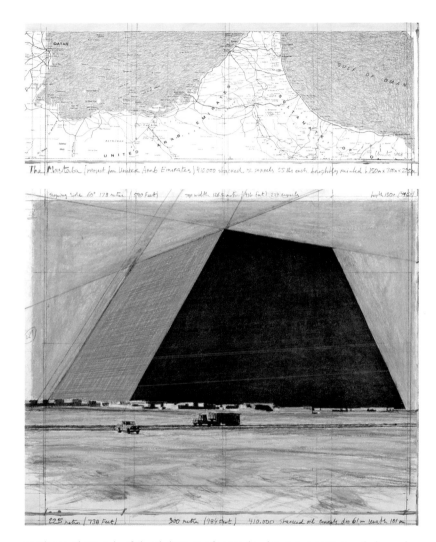

91. Christo, *The Mastaba of Abu Dhabi (Project for United Arab Emirates)*. 2008. Pencil, charcoal, pastel, wax crayon, enamel paint, map, and tape, drawing in two parts: 12 in. × 30½ in. and 26¼ in. × 30½ in. (30.5 cm × 77.5 cm and 66.7 cm × 77.5 cm). © 2008 Christo.

and finally the momentum of Christo and Jeanne-Claude's intervening projects seems to have made it possible to fund and build it. Christo hired PricewaterhouseCoopers, the world's largest multinational financial services firm, to prepare a study to demonstrate the financial feasibility of the project through different methods, and much is still unresolved about how to proceed. But, in the end, this project will make the machinations

of global finance visible in a manner that draws worldwide attention. It will also focus people on the United Arab Emirates and on everything about its society and its evolving role in geopolitics. As Christo said about *Running Fence* in 1977, "The project is teasing society, and society responds, in a way, as it responds in a very normal situation like building bridges, or roads, or highways. What we know is different is that all this energy is put to a fantastic irrational purpose, and that is the essence of the work."[41]

Yet as in all of Christo and Jeanne-Claude's work, the visual power of the idea will be decisive. It will decide whether people become sufficiently engaged to carry the work to fruition and it will determine the scale of its impact. Some people will attempt to stop the project, arguing that it *isn't art*. But why should there be a passionate argument over that? Yet that is perhaps the single most commonly recurrent theme in the heated opposition to every Christo and Jeanne-Claude project, because, fundamentally, the projects of Christo and Jeanne-Claude are abstract forms that bring the irrational into the public sphere, and they are emotionally disorganizing experiences. We argue about whether it is "art" or not because, by putting it into a category or rejecting it, we regain control over an experience that feels out of control.

But without letting go of control we can't innovate. We must continually revise our patterns of thought to be creative or even to see what really exists in the world. The symbolist poet Arthur Rimbaud wrote that "the modern poet comes into his own by a systematic 'derangement of all the senses.'"[42] The works of Christo and Jeanne-Claude engage a broad public, and like Gandhi's "truth force," they let us share in a very public reorganizing of our experience. These are political works of art in the most profound sense of changing the way we meet the world.

4

Desire Lines in the Mind

Looking back forty-five years to the contagious change in consciousness that took place among young people in America at the end of the 1960s, a journalist wrote,

> In a 25-square-block area of San Francisco, in the summer of 1967, an ecstatic, Dionysian mini-world sprang up like a mushroom, dividing American culture into a Before and After unparalleled since World War II. If you were between 15 and 30 that year, it was almost impossible to resist the lure of that transcendent, peer-driven season of glamour, ecstasy, and Utopianism. It was billed as the Summer of Love, and its creators did not employ a single publicist or craft a media plan. Yet the phenomenon washed over America like a tidal wave, erasing the last dregs of the martini-sipping *Mad Men* era and ushering in a series of liberations and awakenings that irreversibly changed our way of life.[1]

The "Summer of Love," the "love-ins," and the "be-ins" at the end of the 1960s altered "the reality of everyday life," as Carlos Castaneda phrased it.[2] In this book I have written about how abstract forms may have a specific iconography, about the grammar by which such forms allow for a discourse on unconscious content, and how charismatic works of art, like charismatic public figures, address and alter the structures underlying social and political perspectives through that discourse in form. Works of art can disrupt our habits of thought, "stop the world" (Castaneda), and give us an opening in which to reorganize our relationship with everything around us.[3] In this chapter I will go right to this elusive border of mind and brain, speculating on how a work of art may affect the brain.

92. *Love In*, Los Angeles. March 26, 1967. © Bettmann/CORBIS.

What happens at that mysterious interface of mind and brain when we "interrupt the flow of interpretation"? What permits us to disrupt our patterns of thought and to create new ones? What entices us to do so? Might this have a bearing on the genesis of creativity? The French philosopher Jacques Rancière begins his little book *The Ignorant Schoolmaster* with the story of Joseph Jacotot, who in the early nineteenth century miraculously found a way to teach students in a language he couldn't speak (Flemish) about a book written in a language they couldn't read (French). Rancière proceeds to unfold a pedagogy around the concept of "emancipating" the students' intelligence by encouraging them to find their own way through the bewildering task of analyzing François Fénelon's twenty-four-volume French novel of 1699, *Télémaque*.[4]

I've titled this chapter "Desire Lines in the Mind" because the term offers an apt metaphor for my theme: desire lines are the paths created spontaneously by people finding their own way through a field. Landscape architects use the term to describe how people may see the existing path perfectly clearly but nevertheless choose to create a different way between two points—their way. We've all seen these shortcuts across a campus or through a park, where the sidewalk is right there

93. A desire line.

but somebody decided to make a new path. Others then followed them, wearing down a line in the grass.

Is it the novelty that motivates someone to create a desire line? Or the practical notion of finding the shortest distance to his or her destination? What is the special appeal of the new, improvised path to those that follow? Is it reassuring that it seems to have been made by another person already and yet attractive for resisting the established rules? Is it meaningful that one chose a trail that has a bodily eccentricity rather than a path laid out with concrete in neatly controlled lines? In this last chapter I want to talk about new mental paths, desire lines worn through the landscape of the mind.

Artists can tell us a great deal about their creative thought processes. The British painter Francis Bacon described the unfolding of his 1946 *Painting* as a sequence of surprises. It "came to me as an accident," he told an interviewer. "I was attempting to make a bird alighting on a field. And . . . suddenly the lines that I'd drawn suggested something totally different, and out of this suggestion arose this picture. I had no intention to do this picture; I never thought of it in that way. It was like one continuous accident mounting on top of another."[5] The

accidents that Bacon describes embody the free discourse that takes place among abstract forms—the mixture of deliberate subjects, free association, and ineffable meanings from the unconscious—that seem to come about when the brain connects one image with another based on criteria other than the expected logic of conscious thought and the established patterns of conscious memory.

The rock musician Keith Richards of the Rolling Stones has talked about performing as though creative invention put one at risk, like leaping off a cliff:

> You put yourself up there on the firing line—give me a blindfold and a last cigarette and let's go. And you'd be surprised how much comes out of you before you die. Especially when you're fooling the rest of the band, who think you know exactly what you're going to do, and you know you're blind as a bat and have no idea. But you're just going to trust yourself. Something's going to come. You come

out with one line, throw in a guitar line and then another line's got to come out. This is where supposedly your talent lies. It's not in trying to meticulously work out how to build a Spitfire.[6]

So, for Richards, one of the features of creative thinking seems to involve taking on a problem one doesn't know how to solve in advance, powering through the anxiety of losing control, and moving toward a solution by intuition. This differs significantly from applying a practiced method to a task that resembles previously solved problems, even though knowledge, experience, and mastery may all help in both predictable and unexpected ways.[7]

Studies by neuroscientists have shown that the brain responds to novelty with a release of dopamine in the so-called pleasure centers, but that is too reductive an explanation for what drives creative innovation.[8] In the working process of artists, however, we can see some indications of what might be going on. The drive of artists to create, despite what Richards and so many others have described as desperate, life-and-death anxiety in the difficult process of doing so, seems simultaneously to involve both fear and pleasure. In the end, there is often the elation and surprise at working it out. For most great artists, the compulsion to make art approaches the power of an addiction, absent the pathology, since it results in a product of great social value and no tangible harm. For a heroin user just the thought of the drug produces so much dopamine that it triggers an irresistible need even without the presence of the drug.[9] For artists the gratification of creating drives an ineluctable need to keep producing more.

Artists never find closure because no work is ever completely finished nor entirely satisfying; each work exists in a continuum of evolving thoughts, and unresolved false starts may fall by the wayside. Cézanne told his household servants to discard abandoned canvases when they found them in the garden (and they did).[10] The Cézanne scholar Richard Shiff commented on "the unprofessional character of Cézanne's enterprise," leaving parts of his paintings unfinished, not signing them, painting over them.[11] The British art critic Clive Bell remarked with astonishment on how Cézanne "tossed them into bushes or left them in open fields."[12]

The painter Elizabeth Murray told a writer for the *New York Times*, "I never finish a painting without hating it first. There's always a point when I want to throw the painting away. But then over time you start to pull it together; you figure out what you've been struggling for. It's thrilling when you feel like you've got the painting, when you really get it. And then it's over. And then all you have . . . well, maybe this isn't a good thing to say. But I'm glad that my dealer can sell my paintings because I don't have any use for them."[13]

Not all artists lose interest in their work when they finish making it (and Murray didn't entirely lose interest in hers either). Some artists even fetishize their past work, but then it takes on a different role. Yet the desire to make new work, once it begins, always seems to overtake everything else.

"When my picture doesn't work well," the French artist Jean Dubuffet reported,

> I'm not happy; I'm tormented, I'm deeply distressed. . . . I demolish it, I redo it, I try all sorts of other things. It sometimes works in the end, something manages to be triggered, a small miracle of an apparition of life produces itself in the painting. Then I am thrilled, filled with delight. . . . However, I never know how I have done it. When I try to do it again, it never works. Once the painting is done, I am happy, I can't pull myself away from looking at it. It enthralls me. I bathe in satisfaction. But not for long, because I want to start again, I am compelled to begin again. Only one successful painting, that's not enough. I want lots of them, I want to fill the house with an entire population of paintings.[14]

Few artists have as rigorously articulated in words the mental processes underlying their visual creativity as Dubuffet did consistently throughout his career. I have chosen to focus on Dubuffet in this chapter not only because he took such pains to tell us what he was thinking as he worked, but because the processes of his thinking are the subject matter of his work. Here he describes the struggle in making a work, the drive that propels the work to continue, then the rush of pleasure at resolving it, and finally the way that pleasure is once again submerged by the need to do more. The artist never feels satisfied or finished for

95. Jean Dubuffet, *Paysage aux ivrognes* (*Landscape with Drunkards*). May 25–27, 1949. Oil, sand, and granular filler on canvas, 35 in. × 45¾ in. × ¾ in. (89 cm × 116 cm × 1 cm). The Menil Collection, Houston. Photo: Hickey-Robertson, Houston. © 2015 Artists Rights Society (ARS), New York / ADAGP, Paris.

long because it is a continual process of integrating the artist's experience of the world, and the artist's encounter with the world is, by definition, in a state of constant change because the world itself is perpetually evolving and so is the mind of the artist.

In an article in *Science* in 2001, Professor Semir Zeki, a neurobiologist at University College London, points out that "a major function of art can . . . be regarded as an extension of the function of the brain, namely, to seek knowledge about the world."[15] Dubuffet says the same thing: "Art makes no sense if it is not a means of seeing and knowing through which man forces himself to perceive reality."[16] But that knowledge is not precisely about seeing what is in the world in an objective sense. Like Zeki, Dubuffet seeks to describe the way in which the brain constructs reality.

96. Takako Tomita (4, Japanese, girl), *A Train Running in the Sunset*. International Museum of Children's Art, Oslo.

"What to me seems interesting," Dubuffet explains, "is to recover in the representation of an object the whole complex set of impressions we receive as we see it normally in everyday life, the manner in which it has touched our sensibility, and the forms it assumes in our memory. . . . My persistent curiosity about children's drawings, and those of anyone who has never learned to draw, is due to my hope of finding . . . the affective reactions that link each individual to the things that surround him and happen to catch his eye.[17]

In Dubuffet's paintings, the artist plays out precisely this investigation as he attempts to render everything in terms of the how he apprehends it subjectively. In *Landscape with Drunkards* the people consist of the same matter as that of their surroundings—the same color, the same texture—and they dissolve into one another. The artist deliberately dispenses with perspective, tipping up the landscape onto the picture plane and drastically simplifying the representation of the café storefront, the figures, the trees, everything in the picture. He emulates the way children process what they see.

In the child's drawing here by a four-year-old Japanese girl, *A Train Running in the Sunset*, the child has flipped the train track up onto the

picture plane and shown it arching over the engine. She has also simplified the engine into a powerful black mass seen in profile—more about how it feels than how it looks—while she gives us a bird's-eye view of the coal tender so we can see the lumps of coal inside. Moreover, she represents only the most salient features of the figure—the eyes and mouth, the limbs and trunk. The child portrays what is subjectively and cognitively most important instead of giving us a detached and detailed picture of what we see (though that is a matter of interpretation too).

"Rather than resorting to mechanical perspective," Dubuffet recommends, in his "Notes for the Well Read,"

> you should superimpose the objects or, in other cases, juxtapose them. My painting should include all the objects haunting my mind; I dislike the shackles imposed by visual perspective—they restrict my freedom. I want to depict the garden that's behind the cottage, hidden from view when we stand in front of the cottage. It's precisely this front view that I intend to paint. So I put the garden over or next to the cottage—it all depends. And in such a way that the viewer will understand as thoroughly as possible that the garden is behind the house. He will also comprehend the painter's perplexity and his improvisational approach. But make sure there's no system: try a different solution next time, according to your mood and whim.[18]

In *Landscape with Drunkards*, Dubuffet demonstrates not what we see in the landscape but how we understand what we see, including the relationship we feel as corporeal beings occupying the same space as other material things. Even though we see in perspective, in our minds we don't have everything set in a perspective space. Rather, things are conjoined by many and various means that might include some aspects of a perspective order but also other logically incompatible structures at the same time.

Unlike *Landscape with Drunkards*, a painting such as Raphael's early sixteenth-century *School of Athens* conforms to the system of one-point perspective that is conventional in the rendering of pictorial space, placing each element in a rational hierarchy. If we look at any photograph that translates a scene from nature with strong recession in space we discover the perceptual conundrum that Dubuffet finds here. We

97. Raphael, *School of Athens*. 1509–11. Fresco, 200 in. × 300 in. Stanze di Raffaello, Apostolic Palace, Vatican. Image from Wikimedia Commons.

know that the trees in the back are the same size as the ones in front, although we see them as smaller because they are farther away. We see in perspective. But we also recognize the objects in back as trees of roughly the same size and description as those in front. If on the one hand we render what we see, we have to shrink distant objects, we may overlap them so we don't see them in their entirety or in accurate proportion to other, similar things, and sometimes we even hide things behind foreground objects so that we can't see them at all. All of this contradicts what we know about the objects in front of us, conclusions already compromised by the dual perspective of binocular vision.

So, one way or another, we force the brain to do things that it doesn't want to do: we show either what we see or what we know. But none of this data is immutably precise. The brain sums up all the views we have seen into a concept of the object. "Cells in the brain," Professor Zeki tells us, "seem to be able to recognize objects in a view-invariant manner after brief exposure to several distinct views, which they obviously synthesize."[19] Dubuffet insists on showing us all the important

98. Park in Copenhagen. 2012. Photo: Jonathan Fineberg.

components—as he says of the garden behind his house—regardless of how they appear in perspective space, even though that contradicts what we actually see. The child's drawing—with the train tracks looping overhead and at the same time showing the coal in the tender seen from above—emphasizes not what she sees but what she considers important to know.

If the concept of the object is of paramount importance, does it matter that an artist can draw what she or he sees? Cézanne could not do an academically credible rendering of a figure, but he dissected the way we see objects in space in a manner that profoundly changed our perception and the history of art. Picasso certainly *could* render the figure; his father put him through rigorous academic training, and by the time he was fourteen years old he was able to do it extraordinarily well. It was on this foundation of learning to see what was in front of him and to render it so well that Picasso could create a tour de force like his 1910 portrait *Daniel-Henry Kahnweiler*, in which he analyzed the way we see, brilliantly parsing the language of visual representation.

99. (*left*) Pablo Picasso, *Study of a Torso after a Plaster Cast*. 1894–95. Artists Rights Society (ARS), New York.

100. (*right*) Pablo Picasso, *Daniel-Henry Kahnweiler*. Autumn 1910. Oil on canvas, 39⁹⁄₁₆ in. × 28⁹⁄₁₆ in. (100.4 cm × 72.4 cm). Art Institute of Chicago. Gift of Mrs. Gilbert W. Chapman in memory of Charles B. Goodspeed, 1948.561. © 2013 Estate of Pablo Picasso / Artists Rights Society (ARS), New York.

In the Kahnweiler portrait, Picasso portrays his Paris art dealer sitting in his apartment (or perhaps it is an amalgam of his apartment and his gallery). In one sense it is the most classical kind of portrait, showing a sitter with his attributes: you can see the mantel of the fireplace behind his right shoulder (we recognize its profile from photographs of his apartment from the period). He has books on a shelf above his left shoulder, a lamp with its neck arching into the large shade with a light shining down onto what is perhaps a library table or desk on his left.[20] Above his right shoulder, hanging on the wall, is an African mask with a hair bun (from Gabon) that Picasso owned and that appears in period photographs of his studio, and in the lower left of the composition a sherry bottle and glass sit on a side table.

Picasso has segregated the artifice of pictorial representation in this portrait—conventions like the shading and perspective distortion—into fragments that stand alone as explicitly represented concepts beside

the concepts of the objects, rather than as invisible devices used to create an illusionistic image of the objects and space. He also reduces the color to focus on the narrower task of defining the volume of things in the painting and their structural relations within the composition and more generally to make us aware of the very artifice of making a painting. He builds this representation of his dealer as an accumulation of significant, remembered parts and relations. But instead of subordinating the elements of the likeness and the objects to the hierarchy of an illusionistic system of representation, he puts them together into a kind of undifferentiated list, allowing for other ways of ordering them. This highlights their equivalence with the objectified, pictorial devices of illusionism (shading, perspective rendering). He transforms time and space into explicit elements in a pictorial language instead of hidden devices to evoke our senses and memory, and in doing so objectifies them as well. The painting is an astoundingly lucid analysis of pictorial language, while it also represents the subject (Kahnweiler) in a fresh way.

As the neurobiologist Eric Kandel has written, "A digital camera will capture an image, be it a landscape or a face, pixel by pixel, as it appears before us. The brain cannot do that."[21] Instead, the eye scans a subject, gathering data, and the cells in the eye transmit that data to adjacent cells in the retina and across the brain over optical fibers to the visual processing centers.[22] What then traverse the visual processing stream from the retina, through the midbrain relays, to the cerebral visual areas are electrical signals that vary scarcely at all in strength but differ greatly in frequency and pattern. While the bits of data may be very limited in and of themselves, hundreds of thousands of different cells contribute to a densely layered and complex whole that is more than the sum of its parts. Once the data is transmitted, each individual's brain makes a breathtakingly creative leap, reassembling the mass of data into a visual experience. Our brains draw on memory and sense experience retrieved from a variety of different areas. The web of connections in the frontal cortex plays an important role as the brain assembles the data into a larger totality that we describe as a thought or an impression.

What is the balance between what is evoked by the senses and what

we construct through the intrinsic connections in the brain? As the neurobiologist Marcus Raichle has written, something like "60 to 80% of the energy budget of the brain supports communication among neurons and their supporting cells," implying "that intrinsic activity may be far more significant than evoked activity in terms of overall brain function."[23] In other words, William James was correct in saying, more than a hundred years ago, that "the general law of perception . . . is this, that whilst part of what we perceive comes through our senses from the object before us, another part (and it may be the larger part) always comes . . . out of our own head."[24] The yin and yang of Picasso and Duchamp as beacons for twentieth-century art has to do with precisely this duality of seeing, where Duchamp represents the abstract concept as the generative source and Picasso the idea of starting with the perceived form.

In his "Landscapes of the Mind," Dubuffet gives us a description of the representational images in his paintings as "no longer—or almost no longer—descriptive of external sites, but rather . . . the immaterial world which dwells in the mind of man: disorder of images, of beginnings of images, of fading images, where they cross and mingle, in a turmoil, tatters borrowed from memories of the outside world, and facts purely cerebral and internal—visceral perhaps."[25] What Dubuffet describes is, he says, a "transfer of these mental sites on the same plane as that of the real concrete landscapes."[26] It is like a superimposition, within the mind, of one on the other.

Zeki points out that "visual art . . . obeys the laws of the visual brain, and thus reveals these laws to us."[27] So, if you want to understand how the brain works, look at what it produces, and because art has no practical purpose it reflects the structure of the visual brain without the variables introduced by functional demands.[28] Works of art offer us a diagram of the laws of the visual brain, which Dubuffet's description helps us to understand.

The incongruous ambiguity that Dubuffet describes is compounded by his sense that with only the slightest shifts in handling or context, a form in painting can represent a variety of objectively dissimilar things. Everything is on the verge of becoming something else. He writes, "I see no great difference (metaphysically, that is) between the paste

I spread and a cat, a trout or a bull. My paste is a being as these are. Less circumscribed, to be sure, and more emulsified . . . foreign to us humans, who are so very circumscribed, so far from the formless (or, at least, think ourselves to be)."[29] Then, just a few years later, he notes,

> The most varied things are taken into my net. . . . But very often—and it is then that the game takes on its full significance—the facts are more ambiguous, susceptible to belonging to any one of these different registers, explicitly demonstrating, in a very troubling manner, what these registers have in common, how accidental their specificity, how fragile and ready to change. Such an image seems equally eager to transcribe a ravine or a complex, tormenting sky, or a storm, or the reverie of someone contemplating it . . . a thing with a strongly marked physical character . . . and . . . the course of a dream, or an emotion.[30]

All the more remarkable is the brain's power to discriminate, driven surely by the evolutionary purpose of knowing the world. These mechanisms of putting together a reliable picture in the mind, however, are also inflected by previous experience and individual subjective traits. Even "technique," Dubuffet tells us,

> is, in the creation of art—at least in that which I aspire to—very closely related to mental functions and in such an interwoven way that, by changing systems of transcription and morphology, one calls up a transfer, along a new axis, of the mind's positions, of the point of view on things and the grasp of the world. From these transfers, with the pleasure many times renewed of identifying new fields of thought, I am conscious of having taken on a kind of vice which has often led me to feverishly open up new work sites before having fully terminated the harvest of those that preceded and provoked them (of which they constituted a kind of corollary).[31]

In the last two years of his life (1983 and 1984), Dubuffet embarked on two extraordinary groups of paintings—first the *Mire* series and then the *Non-Lieux*—in which he extended a career-long preoccupation with the tangential nature of things. He regarded even being itself as a mental concept without a stable reality. Dubuffet painted *Échec au*

101. Jean Dubuffet, *Échec au corps II* June 7, 1984. Acrylic on canvas-backed paper, 26⅜ in. × 39⅜ in. (67 cm × 100 cm). Photo courtesy Pace Gallery. © 2015 Artists Rights Society (ARS), New York / ADAGP, Paris.

corps II, in the *Non-Lieux* series, on June 7, 1984. *Non-Lieux* can mean "without grounds" or "without a ground plane" in the sense of being disoriented in pictorial space; certainly, this work deliberately makes it difficult for the viewer to orient her- or himself in three dimensions. "Dislocations" may better convey the full intent of the title, since Dubuffet was fundamentally interested in the idea that reality, things, even space were all unanchored creations of the mind.

The title of this painting, *Échec au corps*, is also difficult to translate. It literally means "check," as in a game of chess, "checking the body" as the term is used in sports like hockey, or the "defeat of the body." But in the larger context of Dubuffet's work we might do better translating it as "disintegration of the body," since this work disperses the defining contours of forms into a field of markings that seem to be coming apart, becoming transparent and disorganized. Dubuffet was

eighty-three when he painted this and so crippled with emphysema that he couldn't stand up to work at an easel anymore, making the idea of the disintegration of the body apt in another way. It captured the ephemerality of the artist's own existence.

In a letter to his dealer, Arne Glimcher, Dubuffet wrote,

> Here are a few comments on the *Non-Lieux*. These paintings were intended to challenge the objective nature of Being. The notion of Being is presented here as relative rather than irrefutable: it is merely a projection of our minds, a whim of our thinking. The mind has the right to establish Being wherever it cares to and for as long as it likes. There is no intrinsic difference between Being and fantasy.[32] Being is an attribute that the mind assigns to fantasy . . . a secretion of our minds. These paintings are an exercise for training the mind to deal with a Being that it creates for itself rather than one imposed upon it. The mind should get rid of the feeling that it alone must change while Being cannot change; the mind will train itself to vary Being rather than varying itself, the mind will train itself to move through a space in which Being is variable and never anything but a hypothesis, the mind . . . will learn to rely on illusion to create the ground on which it walks. The mind will learn how to move through all the various degrees of Being, and it will feel at ease when Being is undependable, flicks on and off, remains potential and sleeps or wakes at will. Being and thinking are one and the same.[33]

Here Dubuffet enters into dialogue with the French philosopher René Descartes, who insists on the freedom of the mind to create without material constraints or teleology. Descartes asserts that my thought exists and cannot be separated from me, so I exist: "I think, therefore I am."[34]

102. (*top right*) Jean Dubuffet, *Mire G 6 (Kowloon)*. February 13, 1983. Acrylic on canvas-backed paper, 26⅜ in. × 39⅜ in. (67 cm × 100 cm). Photo courtesy Pace Gallery. © 2015 Artists Rights Society (ARS), New York / ADAGP, Paris.

103. (*bottom right*) Jean Dubuffet, *Mire G 102 (Kowloon)*. June 29, 1983. Acrylic on canvas-backed paper, 26⅜ in. × 39⅜ in. (67 cm × 100 cm). Photo courtesy Pace Gallery. © 2015 Artists Rights Society (ARS), New York / ADAGP, Paris.

135

104. Jean Dubuffet, *Mire G 129 (Kowloon)*. September 6, 1983. Acrylic on paper mounted on canvas, 26⅜ in. × 39⅜ in. (67 cm × 100 cm). Photo: Kerry Ryan McFate, courtesy Pace Gallery. © 2015 Artists Rights Society (ARS), New York / ADAGP, Paris.

For Descartes, knowledge derives from reason. Dubuffet argues that Being issues from the mind, and like Descartes, he questions knowledge from the senses. So much of what he says reflects what I have just described above as the physiology of a thought: the complex structures of intrinsic connectivity versus "evoked" activity (as discussed by Raichle).

Among these last paintings are the series titled *Mire*. "Mire" can mean to scrutinize something: in French, "mirer." But it also means to look at oneself, and at the same time it refers to the mirror—"mirroir"— reflecting oneself; these last paintings are very much about the artist, in old age, scrutinizing his own fleeting existence. He subtitled many of these *Mire* paintings "Kowloon" because, as he told Arne Glimcher, they are street scenes in Kowloon, a busy sector of Hong Kong where he had never been—it is a cityscape that existed only in his mind.[35] If you imagine several of these laid out beside one another on the floor as

105. Jean Dubuffet, *Mire G 111 (Kowloon)*. August 4, 1983. Acrylic on canvas-backed paper, 79⅛ in. × 78¾ in. (201 cm × 200 cm). Photo: Kerry Ryan McFate, courtesy Pace Gallery. © 2015 Artists Rights Society (ARS), New York / ADAGP, Paris.

he painted them, the complexity of the patterns of blue and red lines over yellow is busy and disorienting. "It may be that the language of painting has an advantage over that of words," Dubuffet said. "Fewer streets have been laid out, the traffic is freer (and perhaps quicker, more instantaneous)."[36]

To the extent that these paintings map the functioning of the brain, it is a drastically reduced and schematized representation, like the famous diagrams by the physicist Richard Feynman, representing the mathematics governing the behavior of subatomic particles. Reductive, schematic diagrams can enable us to grasp complex structural behaviors by visualizing them. (The one illustrated here shows the scattering

$$N\bar{\psi}(x)ie\gamma^{\mu}\psi(x)\bar{\psi}(x')ie\gamma^{\nu}\psi(x')A_{\mu}(x)A_{\nu}(x')$$

106. Feynman diagram of scattering of fermions and mathematical formula illustrated in it. Image from Wikimedia Commons.

of fermions and below it is the mathematical description of what is illustrated.) The point is that something very difficult to grasp from the abstract mathematical descriptors can be visualized in a radically simplified diagram. Importantly, our ability to visualize the concept, even in reduced detail, also generates new ideas about its implications. In a simpler sense, examples like the ubiquitous Venn diagrams and graphs of the fluctuation in stock prices as contrasted with lists of them also demonstrate the effectiveness of visualizing a concept or data. I'm suggesting we look at Dubuffet's paintings as visual diagrams that render aspects of how his thoughts, or perhaps even how the components of his thoughts, come together and interact.

Following Zeki's idea, we might look at works of art, in this case the *Mire* and *Non-Lieux* paintings by Dubuffet, as expressions of the structure of the brain. *Fluence* (Fluidity), part of the *Non-Lieux* series, was painted November 19, 1984. As the name suggests, the *Non-Lieux* paintings offer no sense of a position in space; they do not "take place"

	1		3	
	What do I love to do?		*What will someone pay me to do?*	

What is in my DNA?

2

Date	Open	High	Low	Close
July 10, 2012	$25.85	$26.42	$25.44	$25.56
July 9, 2012	$26.05	$26.21	$25.81	$26.17
July 6, 2012	$26.44	$26.50	$25.93	$26.16
July 5, 2012	$26.81	$26.84	$26.37	$26.55
July 3, 2012	$26.72	$26.86	$26.56	$26.86
July 2, 2012	$26.51	$26.73	$26.39	$26.67
June 29, 2012	$26.28	$26.65	$26.21	$26.65
June 28, 2012	$26.00	$26.03	$25.45	$25.83
June 27, 2012	$26.11	$26.34	$26.06	$26.22
June 26, 2012	$26.16	$26.28	$25.74	$26.01
June 25, 2012	$26.60	$26.65	$25.88	$26.05
June 22, 2012	$26.88	$26.96	$26.67	$26.94
June 21, 2012	$27.51	$27.59	$26.61	$26.71
June 20, 2012	$27.48	$27.75	$27.38	$27.64
June 19, 2012	$27.59	$27.63	$27.25	$27.51
June 18, 2012	$27.29	$27.61	$27.22	$27.42
June 15, 2012	$27.02	$27.44	$26.88	$27.34
June 14, 2012	$26.58	$27.06	$26.42	$26.98
June 13, 2012	$26.46	$26.87	$26.34	$26.54
June 12, 2012	$26.12	$26.54	$26.05	$26.52
June 11, 2012	$26.55	$26.63	$25.96	$25.92
June 8, 2012	$25.88	$26.48	$25.85	$26.41
June 7, 2012	$26.37	$26.43	$25.89	$25.94
June 6, 2012	$25.51	$26.11	$25.43	$26.07
June 5, 2012	$25.04	$25.57	$25.00	$25.43
June 4, 2012	$25.28	$25.36	$24.84	$25.04
June 1, 2012	$25.40	$25.71	$25.12	$25.14
May 31, 2012	$25.78	$26.07	$25.70	$25.84
May 30, 2012	$25.90	$26.19	$25.80	$26.13
May 29, 2012	$26.04	$26.32	$25.86	$26.09
May 25, 2012	$25.72	$25.85	$25.57	$25.74
May 24, 2012	$25.57	$25.78	$25.31	$25.65
May 23, 2012	$25.47	$25.51	$24.92	$25.44
May 22, 2012	$26.27	$26.28	$25.78	$26.03
May 21, 2012	$26.06	$26.19	$25.68	$26.15
May 18, 2012	$26.24	$26.57	$26.05	$26.07
May 17, 2012	$26.47	$26.66	$26.19	$26.19
May 16, 2012	$26.91	$26.99	$26.49	$26.50
May 15, 2012	$27.05	$27.25	$26.82	$26.88
May 14, 2012	$27.35	$27.40	$26.88	$27.02
May 11, 2012	$27.26	$27.95	$27.20	$27.63
May 10, 2012	$27.34	$27.46	$26.96	$27.24

107. (*above*) Venn diagram.

108. (*right*) Stock price chart and corresponding list of the quotes by number.

Intel Corporation (INTC)

anywhere; rather, they materialize in an aspatial environment that defies concrete description. The layering of the linear networks, the interactions of the strong colors, the variety of brushstrokes—sometimes in dialogue with one another, sometimes not—all come together to create a whole that substantially exceeds the sum of its parts, while at the very same time also disintegrating into a multitudinous cacophony of detached actions. Above all, the structure retains "fluidity."

Perceptually, we can see the yellow web in *Fluence* alternatively as a self-contained narrative or as one that collides with and even engages other systems in the painting. The black background occasionally spills forward as a brushstroke (as in the bottom right and the top center), contradicting its identity as background, coming up and over a patch of white or red; red lines may coalesce into a spot, then attenuate into an empty contour. The content is immaterial, a concept, a kind of mental sleight of hand that is both vividly real and, at the same time, nothing, merely a fragment of the imagination. The definitions of everything seem dynamically in flux. I want to suggest that we're seeing an expression of a structural principle, of the constant processing of data in the mind. Current notions of the "resting brain" from resting-state fMRI show that at baseline the network interactions continue to be highly active.[37]

Neuroscience asks us for an evolutionary motive for what we observe. So what is the evolutionary reason for an abstract painting like *Fluence*? Does it give us knowledge about the world? I think that would be difficult to demonstrate, at least in the direct sense that vision tells us when we are about to walk into a wall. So what precisely *is* the Darwinian raison d'être of this painting? Let's begin with its outstanding traits. I think we can say that the human touch is clear in its gestural composition. Does that build our empathic skills? Does it communicate and exercise empathy? Can our processing of visual forms build neural pathways for such things?

In 1995 Italian scientists discovered "mirror neurons" that respond when we see someone else performing an action, as if we ourselves were performing that action, and they hypothesize that this may be related to empathy.[38] In recent psychological studies different researchers have found that reading good fiction regularly enhances the capacity of the brain to map other people's intentions.[39] It seems that identifying with

109. Jean Dubuffet, *Fluence*. November 19, 1984. Acrylic on canvas-backed paper, 39½ in. × 52¾ in. (100.3 cm × 134 cm). Photo: Ellen Page Wilson, courtesy Pace Gallery. © 2015 Artists Rights Society (ARS), New York / ADAGP, Paris.

the emotional narratives of fictional characters develops the brain's ability to attribute mental states such as beliefs, intentions, desires, frustrations, pretending, and knowing to others and to understand that these states in others may differ from one's own. A 2010 study found that the more that stories are read to preschoolers, the sharper their empathic and intuitive grasp of the minds of others will become.[40]

The underlying principle on which civilization itself depends goes back to the early exchange of good feeling between a mother and infant—the mother provides sustenance, warmth, security, and other good sensations; the infant responds warmly with a smile, a coo, a glow of good feeling. The enhancement of our empathic capacities is strongly correlated to the survival of society in our ability to join in collective efforts and, as individuals, to integrate into the group.

Another outstanding trait of *Fluence* is the complexity of the patterns, making it difficult to organize conceptually and impossible to resolve in its figure-ground relationships. We can make ourselves see the yellow lines, for example, as a net over everything else, or, contradicting this, we may see white forms jutting out in front. For many of us, this puzzling ambiguity is a source of pleasure in itself. Enhancing our ability to embrace and even enjoy ambiguity is a skill that teaches us to adapt and to manage complexity.

Perhaps visual processing itself may bring us pleasure. A friend reported to me that her very verbal six-year-old daughter, Alma, told her that drawing "makes me calm."[41] Zeki "recently found that when we look at things we consider to be beautiful, there is increased activity in the pleasure-reward centers of the brain . . . similar to the states of love and desire. . . . The reaction was immediate."[42] Anxiety also plays a role in the pleasure. We see pervasive evidence of the satisfactions of resolving the structure in a work of art for the artist, as in Elizabeth Murray's remark that "it's thrilling when you feel like you've got the painting, when you really get it," or in Dubuffet's assertion that when he finishes a painting "I am thrilled, filled with delight." Certainly the pleasure provided by works of art and the satisfactions of resolving conflict within them, for both artist and viewer, draw us to them. I have made the argument that as viewers we may also avail ourselves of the working-out process symbolized in works of art for reintegrating our past with the unexpected events of the present.

I also want to suggest one more important evolutionary argument for works of art—and it applies equally to abstract art and representation—namely, what I believe to be the fundamental role played by the visual arts (although not *only* by the visual arts) in developing global capacities for creativity. That also bears directly on our survival, and it is part of what has been lost in the recent emphasis in education on standardized testing.

Dubuffet writes in his collection *Bâtons rompus* (Random conversations) that "I believe that the principle of juxtaposing disparate fragments is productive for creating. Not only for the creation itself; also in the domain of thought. It introduces polyphony within."[43] He goes on to say later in his commentaries, in "Phénomènes' aux 'Non-Lieux,"

I believe one can consistently find in all my works, right from the beginning in 1942, an alternation of disposition that sometimes causes me to accentuate—with an accent that one might call expressionistic, even caricature-like in its excess—the specificity of the represented objects, and at other times, by contrast, to reduce consideration of their specificity, excessively reduce it, imagining a world where everything comes from the same blood, where objects have no individuality, are no longer even distinguishable from one another. These two moods, however contradictory, occur (almost always) in association or short-circuiting one another. . . . The profound aim of all of that . . . is to be given to feel the powerful arbitrariness of the localizing and naming which the mind introduces into the continuity of the world in which it is engaged, and to sense the instability of place, of objects, and of concepts. It may be that this aim, which is perhaps not exactly to abolish the localizing and naming activity of analytic thought but rather to give that activity free rein by opening the field to everything arbitrary, lies, like a constant key, at the foundation of all my work.[44]

What is it that Dubuffet finds in such contradiction to be so "productive for creating"? First, it breaks down the hierarchies of the rigorous French classical education of which he himself was a product. "What cultured people want, in terms of language (and thought)," he tells us, "is to use well-defined, correctly positioned and strictly combined terms, and this is what they call good speech, good thought, and good writing. But they do not realize that they are thereby creating a closed circuit that leaves no room for anything but what was there in the first place."[45] This leaves us, he concludes, with the feeling that all possible thoughts and all possible forms of creation have already been exhausted. You can go to the Bibliothèque Nationale, he says, and get a complete list! People "have an aversion to the innumerable, to endless fields."

"Contrary to what cultured people call good writing," Dubuffet goes on, "it is by *forcing* the meaning of words, or else by shifting them, it is by twisting their usage, also by derailing coherent thought, it is by injecting gaps, disjointedness, margins, and deviations, that we will produce the sole phenomenon worth seeking: the contribution to thought of outside elements, the excess of the final product over the original stakes."[46]

Dubuffet finds no value in "esthetic works that follow preset patterns of production, preconceived plans, and regulatory forms." Instead he celebrates "liberated and informal modes of expression" that culture regards as "incorrect, neglected, *sloppy*."[47]

He seeks a "*degraded culture*" in which "a restricted vocabulary, . . . improper expressions, incorrect grammar, thought and form . . . make up the decayed matter . . . from which thought and writing will regain life and vigor."[48] He advocates the systematic study of "inattention, impropriety, confusion, and all practices likely to accelerate the process of decomposition of words, concepts, and cultural principles."[49]

The short-circuiting of the brain with simultaneously countervailing momentums is precisely what Dubuffet is trying to achieve. "Given the almost completely alienated and denatured state of the *mens* [mind in Latin]," he argues, "it is through a process of *dementia* that we will regenerate our vision."[50] The novelty of it, the utter nonsense in it, is challenging and humorous and addictively engaging all at the same time. This is the appeal of a painting like *Fluence*. It takes you this way and that, and you have no idea where you're going. It makes no logical sense, and yet it's so human and personal, you respond instantly and empathically to the gestures, and in that way it makes all kinds of inarticulate and intuitive sense. I want to put forward the hypothesis that nonsense and the undecidability of a great painting like this one throw us into the predicament of trying to solve an unsolvable problem. It breaks the habits of problem solving that become routinized.[51] It forces us to go searching all over the brain for something that will fit. But nothing *will* fit completely, and we will have to put things together in a way we haven't done before.

I called this final chapter "desire lines in the mind" because the creative process is, I believe, about creating new pathways in order to get somewhere you haven't been before, like starting a desire line in a landscape. Dubuffet paints something we never saw before, and in trying to figure it out—which we can never do completely—we search various paths of memory in the brain. The combination of the disorientation, the pleasure of the novelty, the beauty that makes us feel good about going on, all together, develops our capacity to adapt to the unpredictable, to innovate our patterns of thought. It opens connections

between thoughts that we don't "normally" put together. It allows us to reintegrate childhood into the present, not only by opening our minds to the levels of preverbal logic but by taking us back to the elasticity of the child's mind that is still somewhere within us, back to the time when we extrapolated language and social necessity without knowing the rules. It is a confrontation with the enigmatic object of art, the riddle itself, not the answer, that causes us to construct and venture on new paths. A good painting should leave us baffled but excited, like the Mad Hatter in Lewis Carroll's *Alice's Adventures in Wonderland*, who famously asks Alice, "'Why is a raven like a writing-desk?' . . . 'Have you guessed the riddle yet?' . . . 'No, I give it up,' Alice replied: 'What's the answer?' 'I haven't the slightest idea,' said the Hatter."[52]

epilogue

Recently I visited Sun Studio in Memphis, Tennessee, where Elvis recorded for the first time and where Sam Phillips produced "Rocket '88," the first salvo of rock and roll. Many great blues and pop icons also passed through, and it is still an active recording studio in the evenings after the tours end. It seems like nothing has changed. You can feel the electricity in the air, the same charge that you sense in a great artist's studio: a palpable wave of creative energy that inhabits the space and makes you want to run home and pick up a brush or a guitar. As the reader has seen, this book is about the way in which artistic creativity speaks to us, inspires us, sometimes changes us, and why it is that art has continued to be so important to us since before the beginning of recorded history.

In the preceding pages I have shown how abstract forms articulate a highly specific iconography, bringing much that is normally unconscious into consciousness. At the same time, it becomes apparent that this symbolized content—which nevertheless still resists verbal expression—has a defining role in the structure of individual identity and, as we've seen, the artist can consciously manipulate the relations among visual symbols so as to reorder his or her unconscious organization. Nor does this thought process, conducted in the language of visual forms, remain only in the private space of the artist. The exchange between Calder and Miró underscores how communicable visual thinking can be. The deep content explored in art may tap into the unconscious of another artist, even into the psyche of untrained viewers—many viewers.

The capacity of abstract forms to symbolize unconscious content and reorganize unconscious structures for numbers of viewers gives works of art the force of ideology. Like a charismatic public figure, a work of

art may capture the imagination of viewers, providing an opening and even a template for altering the way viewers meet the world. Before 1983 the average person in Miami scarcely noticed the islands in Biscayne Bay. Yet once the artists Christo and Jeanne-Claude surrounded them with giant, floating skirts of pink fabric, no one could get the images out of their minds, no matter what they thought of it as a work of art, and we're still thinking about those images more than thirty years after the project was removed.

The sensation of surprise that continued to draw Calder and Miró to one another's work figures importantly in the response to the projects of Christo and Jeanne-Claude and to the experience of any engaged viewer with any work of art. It also reveals something fundamental about how the brain works. We see in order to gain knowledge of the world. Yet that knowledge is derived not simply from sensory data but from many complex processes, organizing sensory input as well as remembered patterns of thought and networked interactions within the brain itself into a breathtaking abundance of information that accumulates into highly nuanced moments of consciousness and perception. Our thoughts come in response not only to what the neuroscientists call the "intrinsic activity" of the brain but also to the changing facts of existence and to the infinite and inexplicable ways in which these forces collide. Our experience, our ideas, even our sense of ourselves, come from a constant negotiation and reordering among many layered streams of information.

Dubuffet writes that "being is variable and never anything but a hypothesis." Just as we can never fully resolve the figure-ground relationships in his *Non-Lieux* paintings, our experience of the world is never completely comprehensible. Our brains attempt to mirror experience so as to organize it according to familiar patterns. But that effort always partly fails because reality is constantly changing. That failure forces the brain to make something new in order to "see" the world, and we need to see the world in order to survive.

Some scientists, as they analyze the specific functions of the brain in ever-greater particularity, speculate that our thoughts are determined by our biology and that we have little conscious influence on our actions. The art and writings of Dubuffet point us to the opposite conclusion.

The complexity of our brain and the plenitude of the world introduce an unpredictability that perpetually compels us to adapt our patterns of thought; when a work of art surprises us, we have to accommodate. Encountering what is new in the world, the brain is forced to make something new in apprehending it.

In 1982 the painter Robert Motherwell said, "One of the tasks that modern art set itself was to find a language that would be closer to the structure of the human mind—a language that could adequately express the complex physical and metaphysical realities that modern science and philosophy had made us aware of; that could more adequately reflect the nature of our understanding of how things really are."[1]

Understanding how the brain assembles visual perception and constructs its networks of memory and reason illuminates art. But art also illuminates the brain. All of what we know in the world is a surmise based on our past knowledge, on existing mental constructions, predispositions, and practiced processes of ordering information, tested against sensory input and the novel intersection of these mental processes. The trial and error of reorganizing what is ultimately incomprehensible in a work of art uniquely rejuvenates the elasticity of our creative response to the world. Art mirrors and builds those pathways.

acknowledgments

In 2010 and 2011 I retired from the board of The Phillips Collection and from the University of Illinois to give myself time to catch up on writing projects. In particular, I had long wanted to write a series of essays that synthesized the development of my art theory over the span of my career. I mentioned this project to J. B. Milliken, then president of the University of Nebraska, and to his wife, Nana Smith, over a glass of wine at Art Basel—Miami one year and J. B. invited me to come to Nebraska to write these essays as a series of lectures. Without their encouragement and support this book might never have happened. Marianne and I loved our visits to Nebraska and I scarcely know where to begin acknowledging my debt to J. B. and Nana and to the many wonderful people we met in Omaha and Lincoln.

On my first "reconnaissance" trip to Nebraska in the spring before I started, J. B. called Howard Gendelman (among other things, the chair of pharmacology and experimental neuroscience at the University of Nebraska Medical Center) and asked him to meet with me. Dr. Gendelman and his colleagues at the Med Center generously undertook my education (still very much a work in progress) about the science of the brain. I'm most grateful to all of them, especially Drs. Howard Gendelman, Steve Bonasera, Mike Boska, Bill Lydiatt, Larissa Poluektova, Wally Thoreson, and Tony Wilson. I am also so grateful for the opportunity to have served on the MD/PhD committee of the remarkable young doctor Adrian Epstein, who certainly taught me more than I taught him.

For the opportunity to develop several aspects of these chapters in earlier forms over the years I thank *Artforum*, the Lucy Daniels Lectures

in Art and Psychoanalysis, the Chicago Psychoanalytic Society and Institute, and the Phillips Collection in Washington DC. I also want to note the inspiration of a brilliant exhibition organized by Arnold Glimcher at the Pace Gallery in New York on the late work of Dubuffet that very much influenced my thinking about both Dubuffet and neuroscience, as expressed in chapter 4.

In addition I want to thank a number of people in the President's Office at the University of Nebraska (especially Dara Troutman), who did so much to make Marianne and me welcome, and also those at the University of California—Irvine and the University of California—Berkeley, who gave me the chance to repeat and refine the lectures before I published them. I'm especially grateful to Joe Lewis, then dean of the Claire Trevor School of the Arts at UC Irvine, and to my colleague Whitney Davis at Berkeley. I also thank Ann Baker, Derek Krissoff, Joy Margheim, Courtney Ochsner, Nathan Putens, and the rest of the team at the University of Nebraska Press, who worked so hard to make this book as beautiful as I hoped it would be.

Among the many individuals (some of them now gone) who have over many years contributed to this project in a variety of ways, from helping with images to reading parts of the manuscript and discussing key ideas with me: Bruce Altshuler, Robert Arneson, Rudolf Arnheim, the staff of the Calder Foundation, David Campbell, Roy Campbell, John Carlin, Christo, Jeanne-Claude (Christo), Ralph Clayman, Robert Coles, Erik Erikson, Ted Feder, Henry H. Fineberg, Jack Flam, Andrea Fraser, Jay Gates, Arne Glimcher, Milly Glimcher, Agnes Gund, Kevin Hamilton, Jonathan Hennery, Richard Herman, Janet Hicks, Hannah Higgins, Vladimir Javacheff, Kerrigan Kessler, Henry Klassen, Matthias Koddenberg, Robert Lubar, Armine Kotin Mortimer, Robert Motherwell, Elizabeth Murray, Hubert Neumann, Melissa Neumann, Elisabeth Oltheten, Robert Panzer, Katy Rogers, Sandra Shannonhouse, Johanna Shapiro, Richard Shiff, Ann Sinfield, Charles P. Slichter, Buzz Spector, Bill Tronzo, Georges Van den Abeele, Marissa Vigneault, George and Trish Vradenburg, David Wojnarowicz, Ruth Yontz, Semir Zeki, and Rebecca Zorach.

My brother, Stephen Fineberg, did deeply thoughtful readings that sent me back to the drawing boards when needed, Jack Flam took

the time out to read when I really needed his help, Semir Zeki, with his usual startling precision, pointed me to critical issues that needed fixing, and, as always, I'm so grateful to Marianne Malone Fineberg for her continual support and for the flow of good ideas, and likewise to my sons and daughters: Maya Fineberg and Dave Segal, Noni and Eric Brueckner, and Henry D. Fineberg.

J. B. Milliken (*right*) and Jonathan Fineberg in the Sheldon Museum of Art, March 13, 2013. Courtesy Marianne Fineberg.

notes

Epigraph: Quoted in Terry Teachout, *Pops: A Life of Louis Armstrong* (New York: Houghton, Mifflin, Harcourt, 2009), 14.

1. See A. W. G. Pike et al., "U-Series Dating of Paleolithic Art in 11 Caves in Spain," *Science* 336, no. 6087 (June 15, 2012): 1409–13, doi:10.1126/science.1219957.

2. Robert Farris Thompson in Robert Farris Thompson and Joseph Cornet, *The Four Moments of the Sun: Kongo Art in Two Worlds* (Washington DC: National Gallery of Art, 1981), 38.

3. This essay was published in an earlier form as "Death and Maternal Love: Psychological Speculations on Robert Motherwell's Art," *Artforum* 17, no. 1 (September 1978): 52–57. I particularly want to thank Jack Flam, a great art historian and now president of the Dedalus Foundation, for pointing me to important source material as I revised that essay and for sharing his insights and in all ways encouraging my work on this chapter and on the book as a whole.

4. The neurobiologist Semir Zeki has done pioneering work in mapping aesthetic experience in the brain. In a recent article, he uses Clive Bell's definitions of form to parse the measurable brain functions as the subjects experience beauty. It is my hope that my effort to clarify the definitions and redirect them back into a relationship with specific content may suggest another path to augment the ongoing investigations he has undertaken. See S. Zeki, "Clive Bell's 'Significant Form' and the Neurobiology of Aesthetics," *Frontiers in Human Neuroscience* 7, no. 730 (2013), doi:10.3389/fnhum.2013.00730.

5. *** [Sigmund Freud], "Der *Moses* des Michelangelo," *Imago* 3, no. 1 (1914): 15–36. See James Strachey's introduction to Sigmund Freud, "The *Moses* of Michelangelo" (1914), in *The Standard Edition of the Complete Psychological Works of Sigmund Freud*, trans. James Strachey, vol. 13, *Totem and Taboo and Other Works* (London: Hogarth and Institute of Psycho-Analysis, 1955), 210.

6. Freud, "*Moses* of Michelangelo," *Standard Edition*, 13:211.

7. Freud, "*Moses* of Michelangelo," *Standard Edition*, 13:212. In 1904 Freud also traveled to the Acropolis in Athens, and he recalled that being there felt unreal to him. He later analyzed his experience, suggesting that the trip was something his father was never able to do and that he therefore felt he was surpassing his father in going, a forbidden Oedipal act, and that the sense of unreality he experienced was his internal denial that he was doing it. See Sigmund Freud, "A Disturbance of Memory on the Acropolis" (1936), in *Standard Edition*, vol. 22, *New Introductory Lectures on Psycho-Analysis and Other Works*, 237–48. Originally published in 1936 as an open letter, "Brief an Romain Rolland (Eine Erinnerungsstörung Auf Der Akropolis)," *Almanach*, 1937, 9–21.

8. T. S. Eliot, *The Use of Poetry and the Use of Criticism: Studies in the Relation of Criticism to Poetry in England*, Charles Eliot Norton Lectures (Cambridge MA: Harvard University Press, 1964), 149.

9. This is an argument I first began to articulate with regard to child art in Jonathan Fineberg, "Child's Play and the Origins of Art," in *When We Were Young: New Perspectives on the Art of the Child*, ed. Jonathan Fineberg (Berkeley: University of California Press, 2006), 87–96.

10. Plato, *The Republic*, trans. Paul Shorey, 4.424c, in *Plato: Collected Dialogues*, ed. Edith Hamilton and Huntington Cairns, Bollingen Series 71 (New York: Pantheon, 1961), 666.

11. Mahatma Gandhi, *Satyagraha in South Africa* (1924), vol. 39 of *The Collected Works of Mahatma Gandhi* (New Delhi: Publication Division, Ministry of Information and Broadcasting, 1958–94), 92; cited in Richard L. Johnson, *Gandhi's Experiments with Truth: Essential Writings by and about Mahatma Gandhi* (Lanham MD: Lexington Books, 2005), 71.

12. Erikson's earlier books *Childhood and Society* and then *Young Man Luther* provide earlier formulations of this idea.

13. Semir Zeki, "Artistic Creativity and the Brain," *Science* 293, no. 5527 (July 6, 2001): 51–52, doi:10.1126/science.1062331.

14. Michael S. Gazzaniga, *Who's In Charge? Free Will and the Science of the Brain* (New York: Ecco/Harper Collins, 2011), 14.

1. MOTHERWELL'S MOTHER

1. Robert Motherwell, "Statement," in *Motherwell*, exhibition catalog (New York: Samuel M. Kootz Gallery, 1947 [April]); reprinted in *The Writings of Robert Motherwell*, ed. Dore Ashton with Joan Banach (Berkeley: University of California Press, 2007), 57; cited in Jack Flam, Katy Rogers, and Tim Clifford, *Robert Motherwell: Paintings and Collages, a Catalogue Raisonné*, vol. 1, *Essays and References* (New Haven CT: Yale University Press, 2012), 61.

2. Flam, Rogers, and Clifford, *Robert Motherwell*, volume 1, provides a thorough and thoughtful overview of Motherwell's art and life as a whole; my purpose here is to demonstrate, in the example of Motherwell's work, the existence of a specific iconography in abstract forms.

3. Motherwell began seeing Dr. Hans Kleinschmidt in January 1963. Tim Clifford, "Chronology," in Flam, Rogers, and Clifford, *Robert Motherwell*, 1:197, 217.

4. Hans J. Kleinschmidt, "The Angry Act: The Role of Aggression in Creativity," *American Imago* 24, nos. 1–2 (Spring—Summer 1967): 99.

5. This is the classic dynamic outlined in Ernst Kris, "Psychology of Creative Process," in *Psychoanalytic Explorations in Art* (New York: International Universities Press, 1952).

6. Kleinschmidt, "Angry Act," 117–19.

7. Kleinschmidt, "Angry Act," 120.

8. Kleinschmidt, "Angry Act," 127.

9. Freud, "*Moses* of Michelangelo," *Standard Edition*, 13:211.

10. Robert Motherwell, draft of a letter to Guy Scarpetta, 1977, in the Dedalus Foundation Archives; cited in Jack Flam, "Introduction: Robert Motherwell at Work," in Flam, Rogers, and Clifford, *Robert Motherwell*, 1:3. "Enrichens" is not a typo; he wrote this probably knowing that what he sent Scarpetta would be translated into French, and he may have had in mind the French *enrichir*.

11. Robert Motherwell, "On the Forties," interview by Bryan Robertson, 1965, transcript, Dedalus Foundation Archives; cited in Flam, "Introduction: Robert Motherwell at Work," 1:19.

12. Robert Motherwell, "The Modern Painter's World," 1944, first written as a lecture entitled "The Place of the Spiritual in a World of Property" and then retitled and published in *Dyn I*, no. 6 (November 1944); reprinted in Motherwell, *Writings*, 34–35; cited in Flam, Rogers, and Clifford, *Robert Motherwell*, 1:170n28.

13. Robert Motherwell in H. Arneson, *Robert Motherwell* (New York: Harry N. Abrams, 1977), note to plate 58.

14. See Jack Flam, "Paintings, 1948–1958: Elegies to the Spanish Republic," in Flam, Rogers, and Clifford, *Robert Motherwell*, 1:173, chapter 4, note 1.

15. Mejías was associated with the so-called Generation of '27 that centered on a group of ten Spanish writers, most famously Federico García Lorca himself and the poet Rafael Alberti, whose verses on painting inspired Motherwell to create his 1972 illustrated edition of Alberti's *A la pintura*.

16. See Flam, Rogers, and Clifford, *Robert Motherwell*, vol. 3, *Collages and Paintings on Paper and Paperboard* (New Haven CT: Yale University Press, 2012), 441.

17. Mejías was also a poet and playwright and a friend of Lorca. He was gored in the ring August 11, 1934. Jack Flam pointed out the resemblance of the implied repetition in the *Elegies* to the repetition of the phrase in the poem, which occurs twenty-eight times in the fifty-two lines of the first section. Flam, "Paintings, 1948–1958," 1:66–67.

18. In the catalog to his 1950 exhibition at Kootz Gallery, he renamed the entire series *Elegies to the Spanish Republic* and three years later began numbering them, although inconsistently. See Flam, "Paintings, 1948–1958," 1:70.

19. Robert Motherwell said, "There is in my early work a remnant of Cubism in what painters call the absolute insistence on holding the picture plane." From an unpublished interview with Arthur Cohen, Provincetown MA, August 18, 1969; cited in Harry B. Titus, "The Collage," in *Robert Motherwell: Recent Work*, exhibition catalog (Princeton NJ: Princeton Art Museum, 1973), 22.

20. Jack Flam has written perceptively that "Motherwell's *Little Spanish Prison* is an extraordinarily imaginative rendering of what it *feels* like to be confined. It is at once a political picture, a moving historical document, and also no doubt a deeply personal image of Motherwell's own sense of suffocation and confinement during his childhood. . . . Sometime between 1946 and 1959, he changed the horizontal rectangle from red to black. In doing so, he changed the metaphorical signification of the painting; it was as if the 'prisoner,' instead of being alive and struggling, were dead. In 1969 he had the black paint removed." See Jack Flam, "Paintings, 1941–1944: Finding a Voice," in Flam, Rogers, and Clifford, *Robert Motherwell*, 1:28. Flam also pointed out that *Pancho Villa, Dead and Alive*, a collage of Villa dead and riddled with bullet holes in one half and alive with pink genitals hanging down in the other, was painted immediately after the death of Motherwell's father. See Flam, "Introduction: Robert Motherwell at Work," 1:5.

21. Robert Motherwell, exhibition catalog (New York: Sam Kootz Gallery, 1950), n.p.

22. Robert Motherwell in *Robert Motherwell: Recent Work*, 14; Robert Motherwell, "Robert Motherwell: A Conversation at Lunch," in *An Exhibition of the Works of Robert Motherwell* (Northampton MA: Smith College, 1963), n.p.

23. Robert Motherwell, conversation with the author, January 10, 1976, in the artist's studio, Greenwich CT. I recount the details here exactly as they were told to me.

24. Robert Motherwell, conversation with the author, January 8, 1977, in the artist's studio, Greenwich CT.

25. Motherwell, conversation, January 10, 1976. It may surprise some readers that an abstract symbol could have such evocative power. The mechanism resembles what more commonly happens in a gripping film; the characters,

setting, and events are nothing more than constructs of a writer's imagination, but in them the audience members see a likeness of their own present, past, or hypothesized emotions and consequently find the fiction on the screen entirely believable. Robert Motherwell remarked—as have many artists—that his paintings sometimes evoked feelings with such authority that they actually seemed more real than people. Robert Motherwell, lecture (Art Institute of Chicago, November 4, 1976). If the forms in a painting are more abstract than in a film, the difference is only a relative one since neither is "real" in the commonly understood sense. In both instances, the artist must transform the wide world of his or her experience and emotions into a system of metaphors that provide a convincing alternative universe. The affective power of the work of art rests on the credibility of the artist's aesthetic fantasy, and this in turn relies on the completeness, the consistency, and the imagination with which he or she elaborates his or her metaphorical world.

26. See Clifford, "Chronology," 1:196.

27. Motherwell, conversation, January 8, 1977.

28. Frank O'Hara, *Robert Motherwell*, exhibition catalog (New York: Museum of Modern Art, 1956), 79.

29. O'Hara, *Robert Motherwell*, 79.

30. Motherwell, conversation, January 8, 1977.

31. Motherwell, conversation, January 8, 1977.

32. Robert Motherwell, conversation with the author, November 5, 1976, Chicago IL.

33. Robert Motherwell, telephone conversation with the author, November 18, 1976. This description came up in a discussion of this essay's content, which suggests a further association of the bleeding head with the red of *Red Open No. 3*. Joseph Masheck suggested to me that the phrase "Je t'aime" may be addressed by the painter to the painting itself, that perhaps the artist even identified the painting that he loved with himself. To be sure, these paintings reassert for the artist his capacity to love as well as his own sense of self-worth. The artist's family name, Motherwell, seems almost ironic in this context. Motherwell recounted the same story about his mother beating him until his head was bleeding in an interview in 1987: James E. B. Breslin research archive on Mark Rothko, 1900–1994, box 5, folders 15–23, transcripts of interviews, June 30 and July 4, 1987, and handwritten notes by Breslin, James Breslin Papers, Getty Research Institute, 2003.M.23.

34. Montague Ullman, "Factors Involved in the Genesis and Resolution of Neurotic Detachment," *Psychiatric Quarterly* 27, no. 2 (April 1953): 237.

35. Ullman, "Factors Involved"; and Kleinschmidt, "Angry Act," 98–128.

36. Kleinschmidt, "Angry Act," 118.

37. For a clear and concise explanation of the Oedipus complex, see Sigmund Freud, *Introductory Lectures on Psycho-Analysis (Part II)* (1915–16), in *Standard Edition*, 15:207–9; and Freud, *Introductory Lectures on Psycho-Analysis (Part III)* (1916–17), in *Standard Edition*, 16:329–38.

38. Motherwell, conversation, January 8, 1977.

39. Robert Motherwell, "Notes on Mondrian and Chirico," *VVV*, no. 1 (June 1942): 60.

40. Robert C. Hobbs, "Robert Motherwell's Elegies to the Spanish Republic," in *Robert Motherwell*, exhibition catalog (Dusseldorf, Germany: Städtische Kunsthalle, 1976), 31.

41. Robert Motherwell, conversation with the author, November 4, 1976, Chicago IL.

42. Arneson, *Robert Motherwell*, note to plate 58.

43. Motherwell wrote this in a note next to plates 59, 60, and 61 in the 1977 first edition of Arneson, *Robert Motherwell*, 98–99, accompanying illustrations of *Personage (Autoportrait)* (in this 1974 edition titled *Surprise and Inspiration*), 1943; *Ulysses*, 1947; and *Pancho Villa, Dead and Alive*, 1943. In the second edition of Arneson's book (New York: Harry N. Abrams, 1982) this note appears on page 104 with the additional comment that *Surprise and Inspiration* was not Motherwell's title but one given the work by Peggy Guggenheim. Motherwell later wrote to Robert Mattison that his original title for this work was *Wounded Person*. See Katy Rogers, "Collages, 1943–1949: A New Medium," in Flam, Rogers, and Clifford, *Robert Motherwell*, 1:46.

44. For the imagery of the Lorca poem, see Federico García Lorca, *Collected Poems*, bilingual edition, ed. Christopher Maurer (New York: Farrar, Straus and Giroux, 1988), 813–27.

45. The association of red and white, the rose and the lily, the blush of the maiden against her white skin, and the blood running down the white thigh of the wounded Menelaus (in the *Illiad*) pervades Western literature from its beginnings. Even more remarkable is the equally ancient and consistent association of anger and death with sexuality (as in the passage from the *Illiad* referred to above).

46. See Jack Flam, "Paintings, 1967–1974: Opens and Signs," in Flam, Rogers, and Clifford, *Robert Motherwell*, 1:123.

47. Sigmund Freud, *Civilization and Its Discontents* (1930), in *Standard Edition*, 21:64–72: "a feeling which he would like to call a sensation of 'eternity,' a feeling as of something limitless, unbounded—as it were, 'oceanic.'"

48. Jack Flam discusses this in "Paintings, 1959–1967: Two Figures," in Flam, Rogers, and Clifford, *Robert Motherwell*, 1:142. See also Clifford, "Chronology," 1:234, in which Clifford writes, "On October 2 Motherwell undergoes a series of five operations at Mt. Sinai Hospital in New York to remove his

gallbladder, repair a hiatal hernia, and have his stomach and esophagus sewn together. In the days that follow, his heart rate is over 160 beats per minute, and his doctors decide to install a temporary pacemaker. During the procedure he nearly dies. Two weeks later he is well enough to return home."

49. Robert Motherwell, conversation with the author, May 1976, in the artist's studio, Provincetown MA.

50. Motherwell read and was intrigued by Winnicott's *Playing and Reality* and wrote about it in a 1990 letter to his former analyst, Montague Ullman, in the archives of Motherwell's Dedalus Foundation in New York.

51. Robert Motherwell, interview by Jack Flam, November 5, 1982; cited in Jack Flam, *Motherwell* (New York: Rizzoli, 1991), 13.

2. THE INEFFABLE, THE UNSPEAKABLE, AND THE INSPIRATIONAL

1. See Elizabeth Hutton Turner and Oliver Wick, "The Correspondence of Alexander Calder and Joan Miró," in Calder/Miró, ed. Elizabeth Hutton Turner and Oliver Wick, exhibition catalog (Riehen, Switzerland: Fondation Beyeler; Washington DC: Phillips Collection, 2004), 258: "Calder and Miró conducted their correspondence in French and Spanish. Neither was a native French speaker. Miró's first language was Catalan and he never learned English. They did not share a common tongue and their polyglot exchanges are rife with mistakes."

2. Alexander S. C. Rower, Emilio Fernández Miró, and Joan Punyet Miró, foreword to Turner and Wick, Calder/Miró, 13.

3. Louisa Calder, from a 1958 conversation related by George Staempfli and cited in Jean Lipman, *Calder's Universe*, ed. Ruth Wolfe (New York: Viking Press and the Whitney Museum of American Art, 1976), 266.

4. Alexander Calder and Jean Davidson, *Calder: An Autobiography with Pictures* (New York: Random House, 1966), 271.

5. Nicholas Guppy, "Alexander Calder," *Atlantic Monthly*, December 1964; cited in Albert Elsen, "Calder on Balance," in *Alexander Calder: A Retrospective Exhibition* (Chicago: Museum of Contemporary Art, 1974), note 28.

6. Elsen, "Calder on Balance."

7. Margaret Calder Hayes, *Three Alexander Calders: A Family Memoir* (Middlebury VT: Paul S. Eriksson, 1977), 14.

8. Hayes, *Three Alexander Calders*, 7–8.

9. See Jonathan Fineberg, *The Innocent Eye: Children's Art and the Modern Artist* (Princeton NJ: Princeton University Press, 1997), in which I discuss the importance of childhood and child art as an opening into the most sophisticated level of the central concerns of many of the major masters of twentieth-century art.

10. Hayes, *Three Alexander Calders*, 18; Calder and Davidson, *Calder*, 15.

11. Calder and Davidson, *Calder*, 54–55. Calder had a particular interest in the systems apart from the specificity of the objects, as he explained: "For though the lightness of a pierced or serrated solid or surface is extremely interesting, the still greater lack of weight of deployed nuclei is much more so. I say nuclei, for to me whatever sphere, or other form, I use in these constructions does not necessarily mean a body of that size, shape or color, but may mean a more minute system of bodies, an atmospheric condition, or even a void." See Alexander Calder, "A Propos of Measuring a Mobile," manuscript, Archives of American Art, Smithsonian Institution, 1943; reprinted on the Calder Foundation website: http://calder.org/life/selected-texts. Calder also noted a specific memory with respect to planetariums: "A very exciting moment for me was at the planetarium—when the machine was run fast for the purpose of explaining its operation: a planet moved along a straight line, then suddenly made a complete loop of 360° off to one side, and then went off in a straight line in its original direction." See Alexander Calder, "What Abstract Art Means to Me," *Museum of Modern Art Bulletin* 18, no. 3 (Spring 1951): 8–9; reprinted on the Calder Foundation website: http://calder.org/life/selected-texts.

12. Edmund Burke, *A Philosophical Enquiry into the Origin of Our Ideas of the Sublime and Beautiful*, ed. J. T. Boulton (1756; repr., Notre Dame IN: University of Notre Dame Press, 1968), 57: "The passion caused by the great and sublime in nature, when those causes operate most powerfully, is Astonishment; and astonishment is that state of the soul, in which all its motions are suspended, with some degree of horror. In this case the mind is so entirely filled with its objet, that it cannot entertain any other, nor by consequence reason on that object which employs it. Hence arises the great power of the sublime."

13. See Catherine Freedberg, *The Spanish Pavilion at the Paris World's Fair* (New York: Garland, 1986), 504–5; and Alexander S. C. Rower, *Alexander Calder, 1898–1976* (Washington DC: National Gallery of Art, 1998), 137. I also want to thank my colleagues Jordana Mendelson and Rob Lubar for sharing with me their thoughts on the pavilion. The Almaden mine was also a contested site at the time. Calder reported that Sert, "explained to me that it was the intention of the Spanish government to make a feature in its exposition of the mercury mines of Almaden situated in the southwest of Spain, and decidedly an objective of the Rebel attacks at that time. To do this, a fountain had been made which would spout mercury, and sent up to Paris, together with the machinery to operate it. . . . I discovered that pitch would resist corrosion. That was fine, for pitch with a flat black surface would give a colour which is the greatest possible contrast to the shining metallic mercury, . . . Once

everything was in position, I had the upper surfaces covered with pitch and the rest painted black." See Alexander Calder, "Mercury Fountain," in *Stevens Indicator* 55, no. 3 (May 1938); reprinted on the Calder Foundation website: http://calder.org/life/selected-texts."

14. Michel Leiris, "Joan Miró," *Documents* 5 (October 1929): 264–65.

15. André Breton, *Génèse et perspective artistique du surréalisme* (1941), reprinted in *Le surréalisme et la peinture* (New York: Brentano, 1945), 94; cited in Robert Goldwater, *Primitivism in Modern Art*, enlarged ed. (Cambridge MA: Harvard University Press, 1986), 128.

16. Anne Umland, "Miró the Assassin," in *Joan Miró: Painting and Anti-Painting, 1927–1937* (New York: Museum of Modern Art, 2008), 2–3.

17. Joan Miró quoted in James Johnson Sweeney, "Joan Miró: Comment and Interview," *Partisan Review*, February 1948; cited in Margit Rowell, ed., *Joan Miró: Selected Writings and Interviews* (Boston: G. K. Hall, 1986), 208. For a larger discussion of Miró and childhood, see Jonathan Fineberg, "Miró's Rhymes of Childhood," in *Innocent Eye*, 150.

18. Joan Miró quoted in Dean Swanson, "The Artist's Comments: Extracts from an Interview with Joan Miró (19 August 1970, St.-Paul-de-Vence)," in *Miró Sculptures* (Minneapolis: Walker Art Center, 1971), n.p.; also quoted in the webtext for this work at the Tate Gallery, London, www.tate.org.uk/art/artworks/miro-the-tightrope-walker-t03402.

19. Calder and Davidson, *Calder*, 92.

20. The first postcard pieces by Miró are the 1933 *Drawing-Collage* works. Calder's reference might be to any of three *Spanish Dancer*s (now in the Neumann Collection, the Musée Nationale d'Art Moderne in Paris, and the Raina Sofia in Madrid). Thanks to Anne Umland of the Museum of Modern Art in New York for help sorting through this problem. For an examination of the first postcard pieces, see Jordana Mendelson, "Joan Miró's *Drawing-Collage*, August 8, 1933: The 'Intellectual Obscenities' of Postcards," *Art Journal* 63, no. 1 (Spring 2004): 24–37.

21. *Landscape (The Hare)* and several other "summer landscapes" of 1926–27 by Miró were shown at Bernheim's gallery in Paris in May 1928.

22. Joan Miró quoted in "For a Big Show in France, Calder 'Oughs' His Works," *New York Times*, April 3, 1969; cited in Turner and Wick, *Calder/Miró*, 29.

23. Joan Miró quoted in Yvon Taillandier, "I Work Like A Gardener," interview with Joan Miró, *XXe Siècle* (Paris), no. 1 (February 15, 1959): 4–6, 15; cited in Rowell, *Joan Miró*, 248.

24. Joan Miró, quoted in Dora Vallier, "Avec Miró," Cahiers d'Art 33–35 (1960): 174; reprinted in Dora Vallier, L'intérieur de l'art (Paris: Éditions du Seuil, 1982), 144.

25. Joan Miró quoted in Gaëton Picon, Joan Miró: Carnets catalans, vol. 1 (Geneva: Albert Skira, 1976); cited in Werner Schmalenbach, "Drawings of the Late Years," in Joan Miró: A Retrospective (New York: Solomon R. Guggenheim Museum, 1987), 51.

26. Hayes, *Three Alexander Calders*, 7.

27. Joan Miró, "Statement," Minotaure (Paris), December 1933, in Rowell, Joan Miró, 122.

28. Freud, "*Moses* of Michelangelo," *Standard Edition*, 13:211.

29. Roland Barthes, Sade, Fourier, Loyola (Berkeley: University of California Press, 1989).

30. J. J. Winckelmann, Geschichte der Kunst des Altertums (History of the Art of Antiquity) (Dresden: 1764), 393; cited in Alex Potts, Flesh and the Ideal: Winckelmann and the Origins of Art History (New Haven CT: Yale University Press, 1994), 127.

31. Max Kozloff, "Art," *Nation* (New York), 148, no.7 (February 10, 1964): 151.

32. Charles Baudelaire, "The Salon of 1846," in *Art in Paris: 1845–1862; Salons and Other Exhibitions*, trans. and ed. Jonathan Mayne (London: Phaidon, 1965), 94.

33. Miró, to Roland Tual, Montroig, July 31, 1922, in Rowell, *Joan Miró*, 79.

34. Sigmund Freud, "Creative Writers and Day-Dreaming" (1908), in Standard Edition, 9:153.

35. Kris, *Psychoanalytic Explorations in Art*, 318.

36. Samuel Weiss sums up the literature well in his review of *The Creative Process: A Functional Model Based on Empirical Studies from Early Childhood to Middle Age*, by Gudmund J. W. Smith and Ingegerd M. Carlsson, Psychoanalytic Quarterly 63 (1994): 599. He also notes that Smith and Carlsson "even suggest that the sensitivity, coming close to projection, allows internal threats to be experienced as outside."

37. Miró to Michel Leiris, Montroig, September 25, 1929, in Rowell, *Joan Miró*, 110.

38. Ross Feld, "Philip Guston: An Essay," in *Philip Guston*, exhibition catalog (New York: San Francisco Museum of Modern Art and George Braziller, 1980), 29; also cited in Musa Mayer, *Night Studio: A Memoir of Philip Guston by His Daughter* (New York: Viking-Penguin, 1988), 182.

39. Lipman, *Calder's Universe*, 32.

40. See, for example, Sigmund Freud, *The Ego and the Id* (1923), in Standard Edition, 19:26–27. Freud defines the ego as an integrating mechanism between inner drives and the demands of the outer world; it modifies, redirects, represses, and disguises aspects of the unconscious in order to navigate external reality successfully and at the same time satisfy inner urges or quiet them to a tolerable level.

41. D. W. Winnicott, "Ego Distortion in Terms of the True and False Self," in *The Maturational Processes and the Facilitating Environment: Studies in the Theory of Emotional Development* (London: Hogarth, 1965), 148–49.

42. Robert Motherwell, "Painting as Existence: An Interview with David Sylvester" (1962), in *Writings*, 205.

43. Sigmund Freud, Introductory Lectures on Psychoanalysis (Part III) (1917), in Standard Edition, 16:374–75.

44. See Jacques Lacan, Les complexes familiaux dans la formation de l'individu: Essai d'analyse d'une fonction en psychologie (1938; repr., Paris: Navarin, 1984).

45. Jacques Lipchitz with H. H. Arnason, My Life in Sculpture, Documents of Twentieth Century Art (New York: Viking, 1972), 195.

46. Arnheim argued this point of view for half a century, most recently in Rudolf Arnheim, "Beginning with the Child," in Discovering Child Art: Essays on Childhood, Primitivism, and Modernism, ed. Jonathan Fineberg (Princeton NJ: Princeton University Press, 1998), 16. "The child meets the world mainly through the senses of touch and sight, and typically it soon responds by making images of what it perceives. . . . The picture, far from being a mere imitation of the model, helps to clarify the structure of what is seen. It is an efficient means of orientation in a confusingly organized world."

47. Charles Baudelaire, "The Painter of Modern Life" (1863), in The Painter of Modern Life and Other Essays, trans. and ed. Jonathan Mayne (London: Phaidon, 1964), 8; Charles Baudelaire, Oeuvres Complètes (Bruges: Gallimard, 1961), 1159.

48. For an interesting discussion of this issue, see Jonathan Lear, Love and Its Place in Nature (New Haven CT: Yale University Press, 1990).

49. Willem de Kooning quoted in Harold Rosenberg, "Interview with Willem de Kooning," Art News, September 1972; reprinted in Harold Rosenberg, Willem de Kooning (New York: Harry N. Abrams, 1973), 47.

50. Willem de Kooning, "Content Is a Glimpse," excerpts from an interview with David Sylvester broadcast on the BBC, December 3, 1960; published as a transcript in Location, 1, no. 1 (Spring 1963); reprinted in Thomas B. Hess, Willem de Kooning, exhibition catalog (Greenwich CT: New York Graphic Society, 1968), 148.

51. See Henry F. Smith "Analytic Listening and the Experience of Surprise," International Journal of Psycho-Analysis 76, pt. 1 (February 1995): 71. "Like Freud's notion of the uncanny," Smith observed, "behind most surprises that I have examined lie reminders of something almost known or once known and long forgotten, something that comes to life again."

52. Nietzsche wrote,

> For man, no question whatever, is sicker, less secure, more changeable, more unfixed than any other animal,—he is the sick animal. And why so? Certainly he has also dared more, innovated more, defied more, challenged fate more than all other animals taken together,—he, the great experimenter, the unsatisfied and insatiate one, struggling with animal nature and the gods for final supremacy,—he, the still unconquered, the eternally futurous one who finds no rest from his own thronging power, so that his future like a spur inexorably rakes the flesh of every Now of his. How could it happen that such a courageous and rich animal should not also be of all sick animals the one more jeopardised, the one with the longest and deepest sickness? Man is satiated to surfeit, often enough; there are entire epidemics of this satiety (—for instance, about the year 1348, the time of the "dance of death"). But even this nausea, this weariness, this self-annoyance,—all this becomes so powerfully apparent in him that at once it turns into an additional fetter.

Friedrich Wilhelm Nietzsche, The Genealogy of Morals, in The Works of Friedrich Nietzsche, vol. 10, ed. Alexander Tille, trans. William A. Hausemann (New York: Macmillan, 1897), 166. See also Friedrich Wilhelm Nietzsche, Thus Spake Zarathustra: A Book for All and None, in The Complete Works of Friedrich Nietzsche, vol. 11, ed. Oscar Levy, trans. Thomas Common (New York: Macmillan, 1911), 260–61. If the psyche is too overwhelmed to be able to reorganize, somatization may be the result, and somatization itself is linked with regression.

53. William S. Burroughs, Naked Lunch (New York: 1959), v.

54. Freud, Ego and the Id, 19:21: "It is possible for thought-processes to become conscious through a reversion to visual residues, . . . [but] . . . the relations between the various elements of this subject-matter, which is what specially characterizes thoughts, cannot be given visual expression. Thinking in pictures is, therefore, only a very incomplete form of becoming conscious. In some way too, it stands nearer to unconscious processes than does thinking in words, and it is unquestionably older than the latter both ontogenetically and phylogenetically."

55. Sigmund Freud, The Interpretation of Dreams, in Standard Edition, vols. 4–5, esp. 5:467–68.

56. Works of art have both the dialectic and the internal strife to which Heidegger alluded in his famous essay "The Origin of the Work of Art." Martin Heidegger, "The Origin of the Work of Art" (1935–56, revised 1950), in Poetry, Language, Thought, trans. Albert Hofstadter (New York: Harper and Row, 1975), 63–64.

57. Francis Bacon, October 1973, in David Sylvester, Francis Bacon Interviewed by David Sylvester (New York: Pantheon, 1975), 100.

58. Denis Hollier, Against Architecture (Cambridge ma: mit Press, 1989), 31.

59. On the pleasure principle, see Sigmund Freud, "Formulations on the Two Principles of Mental Functioning" (1911), in Standard Edition, 12:218–26. On the introduction of fundamental instability, see, for example, Sigmund Freud, "New Introductory Lectures on Psycho-Analysis" (1933 [1932]), in Standard Edition, 22:96.

60. See Lacan, Les complexes familiaux, 33.

61. Gerhard Richter, The Daily Practice of Painting (Cambridge ma: mit Press, 1995), 35.

62. See Joyce McDougall, The Many Faces of Eros: A Psychoanalytic Exploration of Human Sexuality (New York: W. W. Norton, 1995).

3. THE NATURE THEATER

1. Using the language of crystallography, Robert Smithson would have referred to this as an enantiomorph—a reference of which Buzz Spector was acutely aware.

2. Buzz Spector, conversation with the author, January 8, 2000.

3. Erik H. Erikson, Gandhi's Truth: On the Origins of Militant Nonviolence (New York: W. W. Norton, 1970).

4. Erikson, Gandhi's Truth, 12.

5. The neurological basis of such an empathic leap, which succeeds even though mediated through visual form, is an interesting subject to which we will return in chapter 4.

6. Adolf Katzenellenbogen, The Sculptural Programs of Chartres Cathedral (New York: Norton, 1964), vii; Katzenellenbogen, Sculptural Programs of Chartres Cathedral, 28–36; Wilhelm Vöge, Die Anfänge des Monumentalen Stiles in Mittelalter (1894), translated and reprinted in Robert Branner, ed., Chartres Cathedral (New York: Norton, 1969), 127 (quote). Thanks to Professor Bill Tronzo for his help in thinking about Chartres.

7. Jane Welch Williams, Bread, Wine, and Money: The Windows of the Trades at Chartres Cathedral (Chicago: University of Chicago Press, 1993), 22. I want to thank my colleague Professor Anne D. Hedeman for sending me to this book.

8. Williams, Bread, Wine, and Money, 19.

9. Williams, Bread, Wine, and Money, 25.

10. Abbot Suger, Liber de Rebus in Administratione Sua Gestis, ca. 1144–49, reprinted in Erwin Panofsky, ed., Abbot Suger, 2nd ed. (Princeton nj: Princeton University Press, 1979), 75.

11. Suger, Liber de Rebus, in Panofsky, Abbot Suger, 49.

12. I want to thank Professor Mysoon Rizk, one of the acknowledged experts on Wojnarowicz's work, who graciously went through the iconography of this painting, identifying the individual sources for me.

13. These images also appear in two of Wojnarowicz's *Sex Series (for Marion Scemama)*, a group of eight photographic compositions from 1988–89.

14. The smaller black-and-white pictures sewn into the top center of *Why the Church Can't/Won't Be Separated from the State* contain homophobic slogans in photographs: "Keep All Sodomy Laws on the Books" and "Fight AIDS Kill All . . . Queres" [*sic*], layered over a landscape backdrop, echoing the use of landscape as a unifying ground for the painting as a whole. In the upper right hand corner is the infamous two-page brochure produced by the Reverend Donald Wildmon's American Family Association, defaming Wojnarowicz as a pornographer. Wildmon excerpted inflammatory details from Wojnarowicz's works in the pamphlet, wrote a diatribe against the artist and the National Endowment for the Arts, which had awarded him a grant, and leafleted Congress with it. Wojnarowicz sued for copyright infringement and won a symbolic one-dollar judgment. The photograph of Wojnarowicz in a mask on the bottom right comes from a performance entitled *A Formal Portrait of Culture*, and to the left of that is an untitled lithograph of 1990 with a mummified voodoo doll in it, referring to the censorship and culture wars of 1989. At the center right the artist drew an ancient terra-cotta figure—a Mexican god of death—surrounded by another set of circular insets of a blood cell, the now-famous image of ants swarming over a crucifix, a chained male torso, a snake capturing a frog, a policeman's holster, turning gears, a human brain, a homeless figure sleeping in a cardboard box, and a figure from a museum diorama of a primitive society.

15. Katie Stone, "Andrea Fraser and Friedrich Petzel," Art Seen, *Brooklyn Rail*, July—August 2004, online edition, http://www.brooklynrail.org/2004/07/ artseen/andrea-fraser-and-friedrich-petzel.

16. Alexander Alberro, "Introduction: Mimicry, Excess, Critique," in *Museum Highlights: The Writings of Andrea Fraser*, by Andrea Fraser, ed. Alexander Alberro (Cambridge MA: MIT Press, 2005), xxix—xxx.

17. Performed again in 2003 for an exclusive dinner in a private dining room at the Museum of Modern Art in New York, dialogue noted at the time by the author from this performance. A printed text of the first version of this piece is in Fraser, *Museum Highlights*, 211–28.

18. Andrea Fraser in Delia Bajo and Brainard Carey, "In Conversation: Andrea Fraser," *Brooklyn Rail*, October 2004, online edition, http://www.brooklynrail. org/2004/10/art/andrea-fraser.

19. Andrea Fraser in Gregg Bordowitz and Andrea Fraser, "What do we want from art, anyway? A conversation." This text was developed as an email

correspondence between Bordowitz and Fraser in the weeks following the opening of Andrea Fraser's exhibitions *Um Monumento às Fantasias Descartadas (A Monument to Discarded Fantasies/Costumes)* at American Fine Arts, Co., and *Untitled* at Friedrich Petzel Gallery, both in New York City, in June 2004. The artist sent this text to the author in an email of October 1, 2012.

20. Bordowitz and Fraser, "What do we want from art, anyway?"

21. Susan E. Cahan, "Regarding Andrea Fraser's *Untitled*," *Social Semiotics* 16, no. 1 (April 2006): 7.

22. Andrea Fraser in Bordowitz and Fraser, "What do we want from art, anyway?"

23. Cahan, "Regarding Andrea Fraser's *Untitled*," 9.

24. Andrea Fraser in Bordowitz and Fraser, "What do we want from art, anyway?"

25. Andrea Fraser in Bordowitz and Fraser, "What do we want from art, anyway?"

26. Andrea Fraser in Bordowitz and Fraser, "What do we want from art, anyway?"

27. Morton Feldman, "The Anxiety of Art," in *The Music of Morton Feldman*, ed. Thomas DeLio (New York: Excelsior Music, 1996), 205.

28. Claudia Mesch does a nice job of summarizing the many threads of what she calls "grass roots" political art over the last quarter century. See Claudia Mesch, *Art and Politics: A Small History of Art for Social Change since 1945* (London: I. B. Tauris, 2013), 1–13.

29. See: Ben Austen, "Chicago's Opportunity Artist," *New York Times Magazine*, December 20, 2013, online edition, http://www.nytimes.com/2013/12/22/magazine/chicagos-opportunity-artist.html?pagewanted=all; and Theaster Gates, *12 Ballads for Huguenot House*, video filmed in 2012, White Cube, http://whitecube.com/channel/in_the_museum/theaster_gates_12_ballads_for_huguenot_house_documenta_13_2012/.

30. Manuel J. Borja-Villel, "Museums of the South" (lecture at a symposium on museums of modern and contemporary art sponsored by Illinois at the Phillips and the Center for the Study of Modern Art, Phillips Collection, Washington DC, September 15, 2007).

31. Richard Feynman, in *Six Easy Pieces: Essentials of Physics Explained by Its Most Brilliant Teacher*, by R. P. Feynman, ed. R. B. Leighton and M. Sands (New York: Basic Books, 1995), 135; cited in Gazzaniga, *Who's In Charge?*, 126.

32. Carlos Castaneda, *Journey to Ixtlan* (New York: Simon & Schuster, 1972), 14.

33. Christo, interview by the author, April 16, 1983, in the artist's loft, New York.

34. "Jeanne-Claude," *London Telegraph*, November 20, 2009, online edition; cited in "Christo and Jeanne-Claude," *Wikipedia*, http://en.wikipedia.org/wiki/Christo_and_Jeanne-Claude.

35. Jeanne-Claude, lecture (Harvard Law School, Cambridge MA, September 23, 2008); cited in the book produced for her memorial, *Jeanne-Claude* (New York: Metropolitan Museum of Art, April 26, 2010).

36. Christo, interview by the author, 1977, at the University of Illinois at Urbana-Champaign, edited and published in Jonathan Fineberg, *Christo and Jeanne-Claude: On the Way to the Gates* (New York: Metropolitan Museum of Art; New Haven CT: Yale University Press, 2004), 130.

37. Robert Arneson, comment made to the author during a visit to Benicia CA, February 19, 1989.

38. Adjusted for inflation, $3.2 million in 1976 would be equivalent to about $13 million in 2014.

39. Franz Kafka, *Amerika: The Missing Person*, trans. Mark Harman (New York: Schocken, 2008), 272.

40. Christo, conversation with the author, 1983; cited in Jonathan Fineberg, "Meaning and Being in Christo's *Surrounded Islands*," in *Christo: Surrounded Islands* (New York: Harry N. Abrams, 1986), 27.

41. Christo, interview by the author, 1977, 130. See also Jonathan Fineberg, "Theatre of the Real: Thoughts on Christo," *Art in America*, December 1979, 96.

42. Rimbaud *Lettre du voyant* (addressed to Paul Demény, May 15, 1871), in *Oeuvres*, ed. H. Matarasso (Paris: Fernand Hazan, 1956), 19.

4. DESIRE LINES IN THE MIND

1. Sheila Weller, "Suddenly That Summer," *Vanity Fair*, July 2012, online edition, http://www.vanityfair.com/culture/2012/07/lsd-drugs-summer-of-love-sixties. *Mad Men* is an American television drama series depicting the lives of Madison Avenue advertising men and their families in New York around 1960. Directed by Matthew Weiner, it premiered in 2007.

2. See chapter 3. Castaneda, *Journey to Ixtlan*, 14.

3. The daily action of seeing causes us to adjust our thinking about the world, too, but generally on a different order of magnitude.

4. Jacques Rancière, *The Ignorant Schoolmaster: Five Lessons in Intellectual Emancipation*, trans. Kristin Ross (Stanford CA: Stanford University Press, 1991).

5. Francis Bacon, October 1962, in Sylvester, *Francis Bacon Interviewed*, 11.

6. Keith Richards, *Life* (New York: Little Brown, 2010), 305.

7. This process applies to creative work in other fields beyond the arts. Johanna Shapiro and her colleagues at the School of Medicine at the University of California—Irvine have been using works of art to train physicians to find a "way to relate to the chaotic and the unknown" and "recognize the anxiety as simply the price of doing business." She and others want to teach young doctors to focus on the process of problem solving, recognizing that they may not find absolute truths and perfect solutions. "Anxiety is a constant companion of the physician, managed in large part through formal structures and protocols" which attempt to establish control over not knowing. But, she suggests, "every time they gaze at a patient, or decide what matters in a

patient's story, they are constructing a reality; and it would be great if looking at paintings could help them see that!" (From comments on a draft of this manuscript of October 4, 2013. I want to thank Dr. Shapiro for her many thoughtful observations on this text.) At Irvine and elsewhere, teaching art is a means for teaching doctors to observe with a more open mind and to embrace the complexity before them. William Lydiatt MD, a head and neck cancer specialist at the Nebraska Medical Center, and his colleague Virginia Aita, PhD, MSN, created an art residency for a gifted portrait artist named Mark Gilbert (The Portraits of Care Project) with the idea of portraying patients and caregivers in the hospital. At first what was learned had to do with what the artist observed—his interpretation—that differed and augmented what the specialists saw. But gradually it became clear that the patients became engaged in the process. They enjoyed being involved, it affirmed their identity as whole persons in the midst of devastating illnesses, and some even found a way to process and triumph over their own illness as the artist visualized their appearance. See *Here I Am and Nowhere Else: Portraits of Care, Works by Mark Gilbert* (Omaha NE: Beamis Center for Contemporary Art, 2009).

8. Dopamine is a chemical transmitter that activates a network of receptors, affecting motivation and learned motor programs. See Brian Knutson and Jeffrey Cooper, "The Lure of the Unknown," *Neuron* 51, no. 3 (August 3, 2006): 280–82, doi:10.1016/j.neuron.2006.07.017; G. V. Rebec et al., "Regional and Temporal Differences in Real-Time Dopamine Efflux in the Nucleus Accumbens during Free-Choice Novelty," *Brain Research* 776, no. 1–2 (November 21, 1997): 61–67; R. M. Krebs, B. H. Schott, and E. Düzel, "Personality Traits Are Differentially Associated with Patterns of Reward and Novelty Processing in the Human Substantia Nigra/Ventral Tegmental Area," *Biological Psychiatry* 65, no. 2 (January 15, 2009): 103–10, doi:10.1016/j.biopsych.2008.08.019. I want to especially thank two colleagues at the University of Nebraska Medical Center in Omaha, Professor Steve Bonasera, MD, and Adrian A. Epstein, for all their help guiding me to the literature and helping me grasp the science on this and other neuroscientific issues in this essay. See also the comment by Semir Zeki quoted in the *London Telegraph*, "When we look at things we consider to be beautiful, there is increased activity in the pleasure reward centres of the brain." Cited in Richard Alleyne, "Viewing Art Gives Same Pleasure as Being in Love," *London Telegraph*, May 8, 2011. The weight of evidence currently suggests that pleasure responses involve subcortical regions (such as the nucleus accumbens and ventral pallidum) and cortical regions (orbitofrontal cortex and anterior cingulate cortex) and that it is a complex mix of motivations and emotions. See Morten L. Kringelbach, *The Pleasure Center: Trust Your Animal Instincts* (Oxford: Oxford University Press, 2008).

9. See, for example, B. J. Watson et al., "Investigating Expectation and Reward in Human Opioid Addiction with [11 C]raclopride PET," *Addiction Biology*, July 5, 2013, doi:10.1111/adb.12073.

10. David W. Galenson, *Artistic Capital* (New York: Routledge, 2006), 11. Galenson cites Ambrose Vollard, *Cézanne* (New York: Dover, 1984), chap. 8, 48–63, 77.

11. Richard Shiff, *Cézanne and the End of Impressionism* (Chicago: University of Chicago Press, 1984), 162; cited in Galenson, *Artistic Capital*, 11.

12. Clive Bell, "The Debt to Cézanne," in *Modern Art and Modernism*, ed. Francis Fraseina and Charles Harrison, 75–78 (New York: Museum of Modern Art, 1982), 77; cited in Galenson, *Artistic Capital*, 11.

13. Elizabeth Murray in Deborah Solomon, "Celebrating Paint," *New York Times Magazine*, March 31, 1991, 46.

14. Jean Dubuffet, "Entretien radiophonique avec Georges Ribemont-Dessaignes, mars 1958," in *Prospectus et tous ecrits suivants*, vol. 2, pt. 6, *Enquetes, Interviews, Entretiens* (Paris: Gallimard, 1967), 204–5. I particularly want to thank my colleague Armine Kotin Mortimer, professor of French emerita at the University of Illinois, for helping with the French translations in this text. I benefited enormously from her gift for shaping a translation with the full spirit of the original.

15. Zeki, "Artistic Creativity and the Brain." See also Semir Zeki, *Inner Vision: An Exploration of Art and the Brain* (London: Oxford University Press, 1999), 4: "We see in order to be able to acquire knowledge about this world."

16. Jean Dubuffet, "Honneur aux valeurs sauvages," in *Catalogue des travaux de Jean Dubuffet*, ed. Max Loreau, fascicule 6, *Corps de dames* (Paris: Jean-Jacques Pauvert, 1965), 109; cited in Reinhold Heller, "'A Swan Only Sings at the Moment It Disappears': Jean Dubuffet and Art at the Edge of Non-Art," in *Jean Dubuffet: Forty Years of His Art*, exhibition catalog (Chicago: Smart Gallery, University of Chicago, 1984), 24.

17. Jean Dubuffet, "Vaches, Herbe, Frondaisons (Cows, Grass, Foliage), Summer 1954," in "Memoir on the Development of My Work from 1952," trans. Louise Varese, in *The Work of Jean Dubuffet*, by. Peter Selz (New York: Museum of Modern Art, 1962), 97–102.

18. Jean Dubuffet, "Notes pour les fins-lettrés" (1966), in *Prospectus et tous ecrits suivants*, vol. 1 (Paris: Gallimard, 1967), 75. Translation from "Notes for the Well-Read," in *Jean Dubuffet: Towards an Alternative Reality*, by Mildred Glimcher (New York: Pace and Abbeville, 1987), 79.

19. Zeki, "Artistic Creativity and the Brain."

20. John Richardson identifies the mask as a Mikuyi mask (Punu, Gabon) from Picasso's collection (now in the Musée Picasso, Paris). This clearly matches the painted image. John Richardson, *A Life of Picasso*, vol. 2, *1907–1917: The Painter of Modern Life* (New York: Random House, 1996), 176. This corrects

a misinterpretation by William Rubin. Rubin read the books on a shelf as a tribal mask on the wall but wasn't able to identify the mask. He did, however, misidentify the figure to the sitter's right as a roof finial figure from New Caledonia that was in Picasso's collection and is now in the Musée Picasso in Paris. See William Rubin, ed. *"Primitivism" in 20th Century Art: Affinity of the Tribal and the Modern*, vol. 1 (New York: MoMA, 1984), 300, 301, 310.

21. Eric R. Kandel, *The Age of Insight* (New York: Random House, 2012), 234.

22. Alfred Yarbus first described saccadic movements in the 1960s. The foveal system consists of the line of sight from the outside world, through the lens, onto the fovea (the highly sensitive center of the retina), and Yarbus charted the foveal shift in the subject's line of sight across salient features of objects, depending on the task. Saccades require subconscious routing across the visual field and are particularly good at targeting the relevant features as learned through development and predisposition, such as the elements of a face. Micro-saccades keep the focused object moving across the retina to stimulate quiescent cells; otherwise the image perception is lost. Interestingly, in people with autism the saccadic patterns are not toward the typical, socially patterned norms. They don't saccade at the eyes of a picture or the mouths in a scene of a kissing couple. See A. L. Yarbus, *Eye Movements and Vision*, trans. Basil Haigh (New York: Plenum, 1967); and "Yarbus," http://www.homodiscens.com/home/ways/perspicax/active_vision_sub/yarbus/index.htm. There are somewhere between 80 and 175 million receptors on the retina but only around a tenth that many optic nerve fibers. So some processing and bundling of this information must happen in the retina before it is transmitted across the brain.

23. M. E. Raichle and M. Mintun, "Brain Work and Brain Imaging," *Annual Review of Neuroscience* 29 (2006): 449; cited in Marcus E. Raichle, MD, "The Brain's Dark Energy," *Science* 314, no. 1249 (2006), doi:10.1126/science. 1134405; A. Peters, B. R. Payne, and J. Budd, "A Numerical Analysis of the Geniculocortical Input to Striate Cortex in the Monkey," *Cerebral Cortex* 4 (1994): 215; cited in Raichle, "Brain's Dark Energy."

24. William James, *Principles of Psychology* (New York: Henry Holt, 1890), 2:103.

25. Jean Dubuffet, "Landscaped Tables, Landscapes of the Mind, Stones of Philosophy," in Selz, *Work of Jean Dubuffet*, 71.

26. Dubuffet, "Landscaped Tables," 71.

27. Zeki, "Artistic Creativity and the Brain."

28. Semir Zeki, conversation with the author at the conference Art and the Brain, organized by the author at the Center for the Study of Modern Art, Phillips Collection, Washington DC, September 9, 2006.

29. Dubuffet, "Landscaped Tables," 63.

30. Jean Dubuffet, "Empreintes," *Les Lettres Nouvelles* (Paris) 5, no. 48 (April 1957): 507–27; translated by Lucy R. Lippard in Herschel B. Chipp, *Theories of Modern Art: A Source Book by Artists and Critics* (Berkeley: University of California Press, 1968), 613.

31. Jean Dubuffet, "Deuxième lettre à Jean-Jacques Pauvert, Paris, 23 [ou 24] juin, 1966," in *Prospectus et tous ecrits suivants*, vol. 3, pt. 5, *Commentaires du peintre* (Paris: Gallimard, 1995), 309.

32. He uses the word "fantasme."

33. Jean Dubuffet, letter to Arnold Glimcher, April 19, 1985, in *Jean Dubuffet: The Last Two Years* (New York: Pace Gallery, 2012), n.p., and in Glimcher, *Jean Dubuffet*, 301.

34. "Je pense, donc je suis" or "Cogito ergo sum" (in Latin). René Descartes, *Discourse on the Method* (1637, written in French but with inclusion of "Cogito ergo sum"), pt. 4, and *Principles of Philosophy* (1644, written in Latin), sec. 7, pt. 1. See René Descartes, *Discours de la méthode: Suivi des méditations métaphysiques* (Paris: Flammarion, 1927) 22; René Descartes, *Discours de la méthode / Discourse on the Method: A Bilingual Edition with an Interpretive Essay*, ed. and trans. George Heffernan (Notre Dame: University of Notre Dame Press, 1994), 52; and René Descartes, *Principles of Philosophy*, trans. Valentine Rodger Miller and Reese P. Miller (Dordrecht, Holland: D. Reidel, 1983), 5.

35. See the introductory essay by Harmony Murphy, "Jean Dubuffet: The Last Two Years," in *Jean Dubuffet: The Last Two Years*, n.p. The paintings in red and blue over yellow were subtitled *Kowloon* and those in red and blue over white, *Bolero*. *Mire G 14* of February 23, 1983, has red and blue over yellow with a little white and is subtitled *(Bolivar)*.

36. Jean Dubuffet, "Lettre à Gaiano, Paris, 4 juillet, 1978" in *Prospectus et tous ecrits suivants*, vol. 4, pt. 7, *II. Correspondance (1966–1985)* (Paris: Gallimard, 1995), 374.

37. Marc Raichle has shown that the same patterns of brain networks activated during specific tasks are similarly activated during rest or sleep and even under anesthesia. This organization at baseline, in the signal "noise," suggests that brain activity elicited during tasks and molded during learning reacts spontaneously and underlies subsequent brain reactions.

38. Mirror neurons in humans "are thought to be the neural basis of not only action understanding but emotional understanding." Gazzaniga, *Who's In Charge?*, 161. See Giacomo Rizzolatti et al., "Premotor Cortex and Recognition of Motor Actions," *Cognitive Brain Research* 3, no. 2 (1996): 131–41.

39. See Keith Oatley, "Effects of Fiction on Empathy," *OnFiction: An Online Magazine on the Psychology of Fiction*, January 21, 2013, http://www.onfiction. ca/; R. A. Mar et al., "Bookworms versus Nerds: Exposure to Fiction versus Non-fiction, Divergent Associations with Social Ability, and the Simulation of

Fictional Social worlds," *Journal of Research in Personality* 40 (2006): 694–712; and R. A. Mar, K. Oatley, and J. B. Peterson, "Exploring the Link between Reading Fiction and Empathy: Ruling Out Individual Differences and Examining Outcomes," *Communications: The European Journal of Communication* 34 (2009): 407–28.

40. Annie Murphy Paul, "Your Brain on Fiction," *New York Times*, March 17, 2012, online edition, http://www.nytimes.com/2012/03/18/opinion/sunday/ the-neuroscience-of-your-brain-on-fiction.html?pagewanted=all.

41. Alma de Ugarte, then six, made this comment to her mother, Kari Dahlgren, the fine arts editor at the University of California Press, who in turn relayed the comment to the author, April 23, 2011.

42. Alleyne, "Viewing Art."

43. Jean Dubuffet, "17," in *Prospectus et tous ecrits suivants*, vol. 3, pt. 2, *Bâtons rompus* (Paris: Gallimard, 1995), 104.

44. Jean Dubuffet, "Quatre notes sur les 'phénomènes' et peintures du même cycle," in *Prospectus et tous ecrits suivants*, vol. 3, pt. 5, *Commentaires du peintre* (Paris: Gallimard, 1995), 313–14.

45. Jean Dubuffet, "Demagnetization of Brains," in *Asphyxiating Culture and Other Writings*, trans. Carol Volk (New York: Four Walls Eight Windows, 1988), 99–100.

46. Dubuffet, "Demagnetization of Brains," 100.

47. Dubuffet, "Demagnetization of Brains," 98–99.

48. Dubuffet, "Demagnetization of Brains," 97, 98–99.

49. Dubuffet, "Demagnetization of Brains," 98.

50. Dubuffet, "Demagnetization of Brains," 100–101.

51. See Benedict Carey, "How Nonsense Sharpens the Intellect," *New York Times*, October 5, 2009, online edition, http://www.nytimes.com/2009/10/06/ health/06mind.html. Carey refers to an article by Travis Proulx and Steven J. Heine in *Psychological Science* in which the authors argue that in an abreaction to uncomfortable feelings of disorientation we sharpen our intellectual responses and become more vigilant: "We're so motivated to get rid of that feeling that we look for meaning and coherence elsewhere," Dr. Proulx is quoted as saying. They argue that maintaining meaning or coherence motivates the brain, when familiar patterns break down, to grope "for something, anything that makes sense. It may retreat to a familiar ritual, like checking equipment. But it may also turn its attention outward, the researchers argue, and notice, say, a pattern in animal tracks that was previously hidden. The urge to find a coherent pattern makes it more likely that the brain will find one." In a more recent study by Heine and Proulx, they had students read an absurd story by Kafka and then perform a memory task. "The fact that the group who read the absurd story identified more letter strings suggests that

they were more motivated to look for patterns than the others," Dr. Heine said. "And the fact that they were more accurate means, we think, that they're forming new patterns they wouldn't be able to form otherwise." Carey goes on, "Brain-imaging studies of people evaluating anomalies, or working out unsettling dilemmas, show that activity in an area called the anterior cingulate cortex spikes significantly. The more activation is recorded, the greater the motivation or ability to seek and correct errors in the real world, a recent study suggests. "The idea that we may be able to increase that motivation," said Dr. Inzlicht, a coauthor, "is very much worth investigating."

52. Lewis Carroll, *Alice's Adventures in Wonderland* (1865), in *The Complete Illustrated Works of Lewis Carroll* (London: Chancellor, 1982), 66, 68.

EPILOGUE

1. Robert Motherwell, from an interview by Jack Flam, November 5, 1982; cited in Jack Flam, *Motherwell* (New York: Rizzoli, 1991), 13.

index

F with numeral indicates figure number